the human figure

in art from prehistoric times
to the present day

CHARLES WENTINCK

CHARLES WENTINCK

the human figure

in art from prehistoric times to the present day

*translated from the French
by Eva Cooper*

Livingston Publishing Company
Wynnewood, Pennsylvania

Livingston Publishing Company
18 Hampstead Circle, Wynnewood, Pennsylvania 19096

Printed in the Netherlands by Smeets Lithographers, Weert

ISBN 0-87098-037-8
LC 72-167747

Contents

Foreword

In our own time, as in the earliest of times, the artist has turned to the human figure to express his version of the condition of man. Neither landscape, still life, nor the most monumental of sculptured forms has held the recurrent fascination for the artist as has the figure of man.

One can sense it in the work of those most primitive of artists - the children of any age and any civilization who, when given a lump of clay or a drawing instrument, will turn to the difficult task of reproducing those remarkable beings who surround their immediate world. Ineptly, yet sometimes with great insight, their drawings and sculptings capture truths about their peers and their elders. Instinctively, it seems, the eye and the hand of the artist cannot turn away from the challenge of the human figure.

Anyone who has made the least effort to sculpt, paint, or draw the human figure, realizes almost immediately that this challenge comes as a test of the imagination and of the true skill and diligence with which he is endowed. Students through the centuries have labored to the point of exhaustion to capture the essence of a hand, a forearm, the set of a neck, the infinite intricacies of the human anatomy.

Yet in no era has the artist abandoned this labor. We must be eternally grateful for that. Because of his diligence, and his vision, we are able to see man and woman as he saw them in his own time. Far more important than the mere representational, we are also able to see the vision of the human figure idealized, abstracted, eroticized, mysticized, deified, and emotionalized.

In this volume, which does not pretend to be complete and exhaustive, one can study the finest and rarest examples of that labor - from the Venus of Willendorf done in 21,000 B.C. to the explosive destructuring of a Picasso and the chaotic work of de Kooning.

So much richness lies between. One is tempted to rhapsodize as he studies the carefully selected examples contained within this volume. The reader is at first struck by the geographic universality of the artist's attempt. Minoan, Paleolithic, Indian, Chinese, Egyptian, African, Flemish, Micronesian. In every age and every culture, the human figure has taken on a significance that is woven into the fabric of the culture. It is always there, center stage.

Barely a century ago this treasure of man's own concept of man was the province of art historians, curators, collectors and antiquarians. More recently, the search for heritage of man and its application to lessons for the present and future has led an army of anthropologists, cultural historians, and sociologists back to these works of art to divine the true nature of man and his representation of self.

There is much to learn. And one can hardly have a better introduction than in the text of this volume. One can see in the evolution of the earliest forms the most symbolic crudities that carry with them the vitality and power they were intended to evoke - the mysticism, the primitive religiosity and fear, the grotesque imaginings of deities that pervaded the temples and places of worship, the burial sites, and the dwelling of our forebears.

Moving on, in the wall paintings of Egypt, the mosaics of Rome, the frescoes, tapestries, friezes, one is struck by the continuing evolution of the artistic approaches to the male and female figures. Again and again one reads the spirit of the age. The two-dimensional simplicity of the Egyptian, gradually evolving to the perfection of the Greco-Roman marbles, the idealization of the gods and goddesses and the insistence on the perfectibility of man himself.

Beyond primitivism, one is continually impressed by the refinement of the artist's concept of the human figure as a religious inspiration. Adam and Eve, the Madonna and Child, the saints, the pure spirituality of the deified human figure dominated the early Mediaeval and Romanesque periods.

And in other cultures, particularly the Eastern, equally refined figures emerged.

Then the Renaissance, which in its worship of beauty for beauty's sake, humanity for humanity's sake, led to the daring reality of the body, not as an icon, not as an idealization, but as a living, suffering, erotic, emotionalized soul, an earthling, subject to the frailties of humankind.

One has only to evoke the names of Botticelli, Correggio, Da Vinci, Michelangelo, Titian, to realize what is meant by the secularization of the representation of the human figure.

In Western culture, the inspiration of the Renaissance at its most fruitful spread to Spain, the Netherlands, to France and Germany. The warm cradle of the Mediterranean had sent its rays of artistic liberalism westward and northward, with astonishing results. El Greco, Dürer, Rembrandt, Rubens, Boucher - each in his own way and within his own genius brought that liberalization to bear on his civilization.

The illustrations in this volume are primarily and understandably limited to solitary representations of the human figure, for that is what Charles Wentinck has chosen as his theme. Yet through these singular representations from all ages, one cannot help but recognize the style and essence of the representations that appear in odd corners of frescoes, tapestries, illuminated manuscripts, cathedral façades, triptychs, stained glass windows, sculptures and monuments, friezes and etchings.

Moving into our own time, it is clear that the author's enthusiasm wanes at the time of the impressionists, whom he accuses of "pure sensualism," and the current flight from reality, which in Mr. Wentinck's opinion leads to the "humiliated" man.

Despite this view, the volume remains faithful to its purpose, which is to depict for us the full sweep of man's artistic devotion to the human figure.

Robert B. Luce, Editor-in-Chief: The Seven Arts Society

Preface

When the Greeks built a torso as a geometric composition...
when the painters of Fontainebleau elongated the limbs till refinement became metaphorical...
when the Egyptians held rigidly to a frontal representation of the human form...
when the flesh of Rubens' women blurred the line between abundance and redundancy...
when Picasso took man apart and joined him together in no pattern ever intended by Nature...

these were all more than mere optical distortion; they were man recording, through his art,
his vision of man.

Art has recorded how man saw man through the centuries. Art, above all, makes it clear how
little is expressed by this word "man"—merely a remote relationship between beings of the
same species.

Life after death counts with one: he sees beyond the rough and tumble of his days to gaze at the
unseeable. Another places so small a value on life that a living being is sacrificed every morning
so that the sun may rise.

Man creates man in different guises in different times, in different places, among different races,
different tribes.
He creates woman. Peasant, hunter, nobleman, each one gives to her the shape of his ideals.
She is—in turn—guarantee of continuance, primordial mother, symbol of fertility.
She is priestess and guardian of a divine mystery. She is courtesan; she is enraptured and
enfolded in the wings of a swan; she stands at the barricades, daggers in her belt.
He creates man: hero or saint. On horseback or on foot; crucified or quartered. Pillaging or
raping. In radiant nudity or hesitantly unclothed. Mighty or humiliated; inspired or expired.
In drunken revelry. In carnage and in execution.
Man's body did not change; he was an anatomy with but few variants. Heart and brain, cranium
and pelvis. But through the eye of the artist man varied from age to age: a different being in
Athens and Sparta, in Etruria and Rome. He differs in Gothic art and in Rococo. He is dryly
ascetic; he is comfortable and well-fed. He longs nostalgically for the peace of heaven; he desires
the riches of this earth.

Throughout the ages he represented himself. In the caves at Lascaux, the temples of Sumer, the
catacombs of Rome. In breviaries, in the stained-glass windows of Chartres, in the sculpture
of cathedrals. On fountains and palaces; in pleasure-gardens and cemeteries.

The Lord destroyed Babylon.

Atlantis was submerged.
The water retreated from the Sahara.
An icecap covered the fields of Europe.
Entire nations were sold as slaves, exterminated for gold, expelled from their hunting-grounds.

But man continued. Whether as peasant or warrior, lord or bondsman, hero or villain,
patrician or plebian, subject or ruler: man made his own image of himself—carved in wood,
hewn in stone, painted on linen.

And out of respect for his origin he fashioned it in the likeness of God. Then God withered
for the theologians, and philosophers announced His death. And man, freed from God, freed
himself from himself, and fell apart into his separate functions. An industrialist here, an astrologer
there. A headwaiter, a bank clerk. A urologist, an atomic scientist. A journalist, a psychiatrist.

Man had fled. What remained? Brains, bellies, muscles, and—everywhere—sexual organs.

The time had become ripe for Picasso. At first man maimed himself beyond recognition. Then,
with later artists, he gradually disappeared from the work of art.
Man: a memory; a nostalgia—sometimes. More and more a stranger. The heart and cornea
transplanted, brains washed and the soul conditioned.

The vertebrate animal with ovaries—man—became acquainted with psychoanalysis and the
history of art. Externally there was no change from the days of Nebuchadnezzar. But the animal
vanished from the arts, to be available henceforth in cardiogram and encephalogram.

Until further notice...

Chapter I. Ritual and Magic
Prehistoric Man

▶ Forty-one reddish houses in horseshoe formation on terraces that dip toward the Danube: thus did the great archaeological discovery of 1967, the hamlet of Lepenski Vir in northern Yugoslavia, introduce itself. At least 8,000 years old, it called into question the accepted history of our civilization. Champollion, one of the specialists who accompanied Napoleon to Egypt and the man who deciphered the Rosetta Stone, considered that civilization had originated in Egypt 3,000 years before Christ. Half a century later, in 1849, Loftus, an Englishman, put the origin 2,000 years earlier on the basis of his explorations in Lower Mesopotamia. This was the land of Sumeria, the cradle of civilization, and it was the Sumerians who, 5,000 years ago, developed farming communities and invented cuneiform writing.

In 1961, the English archaeologist James Mellaart and his wife, Arlette, were excavating on the Anatolian plateau. Their discoveries led them to believe that the first agrarian communities, organized into large villages, lived at Çatal Hüyük 6,500 years before Christ. This still did not contradict the theory of the "fertile crescent", according to which the first organized communities originated in an arc stretching from the Persian Gulf to Turkey, and from the eastern shores of the Mediterranean to the threshold of Asia. This theory holds that civilization only reached Europe at the beginning of the Bronze Age, some time about 3000 B.C.

So the discovery of Lepenski Vir was a real challenge to the "fertile-crescent" theory. Eight thousand years ago, when Çatal Hüyük had scarcely taken shape, man had already built the village of Lepenski Vir.

The whole of this area of the Danube is rich in remains; Roman, Byzantine, and Mediaeval, and at a lower level traces exist of a Neolithic settlement about 5,000 years old—one of the oldest in Europe. And then, in 1967, with a few strokes of the archaeologist's pick, European civilization aged by 30 centuries. The 41 houses constituted a perfectly ordered village, the layout of which was obviously in keeping with a rigorous plan. Within the houses, the archaeologists found a total of 33 sculptures. These had been hewn in stone from the Danube and were all heads of men or animals; there were none of the complete body. They were up to 60 cm in height—comparable sculptures in Mesopotamia were never taller than 15 cm—and in all probability had a religious significance as

they were always found beside the rectangular blocks of stone that formed the hearths.

However, the most famous prehistoric human figures are those of the Aurignacian period: the steatopygous Venuses sculpted in stone or ivory (Lespugue, Willendorf, Laussel, and elsewhere). From the Pyrenees to Siberia, over northern Italy and Central Europe, sculptors—already possessing a precise technique and a true artistic tradition—were fashioning figures in the round, mostly in ivory, and chiefly to a common pattern with only slight variations: obese women with highly developed pelvises and sexual organs; massively framed torsos and hips contrasting with the slenderness of the limbs. No stamp of individuality can be recognized. Prehistoric sculptors paid no attention to faces; they were concerned only with the features of the body. In all probability these statuettes were idols—images of goddesses of motherhood or childbirth.

The Magdalenian era—the latest Palaeolithic period named after the cave of La Madeleine, in the Dordogne, France—with its cold, dry climate that obliged men to seek refuge in caves and rock shelters, saw a magnificent flowering of art. Then portrayals of the human figure and sculpture-in-the-round were rare. Three-dimensional work was restricted by the limitations of hand tools made of reindeer antlers; it tended to resemble the flattened bas-relief, as if to prove its dependence upon the art of drawing, the major form of expression of the period.

Cave art—comprising engravings, drawings, and paintings in a naturalistic style—was concentrated in southwestern France and northern Spain. Masterpieces of this style are to be found in the Altamira cave on the Cantabrian coast.

The cave at Lascaux, rediscovered in 1940, contains a large number of paintings representing the fauna of a warm climate and hence appear to date from the Aurignacian age. It is undoubtedly the finest and richest of all the painted prehistoric caves, and its art work—some 20,000 years old and now scientifically preserved—is as fresh as the day it was created. Lascaux man was a species of "Homo sapiens", as distinct from Neanderthal man and other hominids. The Vezère valley was a privileged place in which to live, and Lascaux man took advantage of all it had to offer; he lived his life to the full and his achievements represent the pinnacle of the age. One of the out-

standing drawings shows a rhinoceros and, a short distance away, a bison in the throes of death, its entrails spilling on the ground. Between them lies a man, naked and with the head of a bird. His arms are flung wide and his hands outstretched as if he, too, had just been mortally wounded. This sketch, one of the first known portraits of a human being, is naively simple and in striking contrast to the detailed drawing of the bison. The significance of the contrast is unclear.

During the Capsian era (so called after ancient Capsa, now Gafsa in Tunisia) the black races of Africa produced an equally rich cave art. This era corresponds roughly with the Aurignacian and Magdalenian eras in Europe, but dating of early art from the Sahara, Nubia, and South Africa is extremely difficult; it may even have continued into historic times. Among the finest work from the Sahara which, in those days, was probably as populated as other regions, is a group of women whose crested hair-styles resemble those of the Fulani in West Africa. Their faces are strikingly beautiful with pure lines and profiles that are more akin to those of the people of the Nile than those of the Negro race. Not until the Greek civilization was the human form again depicted with such skill as by these talented prehistoric artists.

Chapter II. In the Margin of History
Primitive Man, Africa, Oceania, Mexico, Peru

▶ Until the beginning of this century the representation of the human figure in African sculpture was regarded as "primitive". The Negroes were supposed to be incapable of doing better because some thought they lacked culture and—consequently—skill and talent. This judgment was modified when artists such as Picasso and Derain discovered beauty in Negro concepts of form—a form that is an interpretation, not an imitation, of nature. African sculpture exists in space, independent of conventional likeness, and therein lies the affinity between the work of the "primitives" and the Cubists. In neither is the figurative representation intended to be a repetition of other existing forms; it bears its meaning within itself.

A conspicuous characteristic of African art is the deformation of the human body. In most African sculpture a greater-than-life-size head is set upon a body that is too long in proportion to its legs. Emphasis is laid on the head—not from considerations of style, but because the head is where the powers of the spirit are thought to reside. This emphasis is most clearly illustrated by the Ba-Kota (Gabon) grave images. The natives call these figures "Mbulu Ngulu", or "image of the spirit of the dead man", and it is generally assumed that they were placed on, or partly in, baskets containing the bones of an ancestor. An exceedingly curved forehead—as in many "Mbulu Ngulu"—probably indicates an emphasis on the mental powers. Ornamentation above the head is explained as emanations of the spirit present in the figure. To the African it is not symbolic and certainly not ornamentation in the usual sense of the word. The spirit is the only part of the dead man that remains; the mortal body exists no longer and hence is merely indicated in an abstract, greatly simplified form.

The African representation of the human figure is seldom sensual. If, as is often the case, the male or female genitals are exaggerated, the deformation is not with erotic intent but is solely a means of expressing vital force, creative power, or fertility. Emphasis is thus laid on those parts of the body that, in the artist's vision, are significant. His conception of man determines the shape he gives to the sculpture. He is concerned with an inner reality—an image conceived in the spirit—not with the visual truth.

While excavating at Ife in Nigeria in 1910, the German ethnologist, Leo Frobenius, found a number of portrait heads of the Ife culture (believed to have originated in the 12th and 13th centuries). These had little in common with the anaturalistic sculpture of the surrounding tribes and indeed their surface finish and Classical appeal seemed to have an affinity with Greek statues of the fourth century B.C. Such a purity of style could only be explained as the result of a long tradition culminating in the classicism of a civilization at the height of its splendour, and Frobenius found himself forced into postulating a European influence. However, the later find, made by Bernard Fagg, of terracotta heads dating from an earlier period completely destroyed Frobenius's theory.

On the basis of an examination of sedimentary deposits and the weathering of the sculptures it was possible to date Fagg's finds between 1000 and 300 B.C. A stylistic resemblance to the Ife heads and to sculpture produced in this Yoruba country at a later date showed that it was unnecessary to presume a non-African influence to explain the Ife art. It was no isolated happening but a high-point in the cultural and artistic continuity of this part of Africa.

The naturalism of the Ife bronzes was inspired and indicated an exceptional mastery of the technique of casting. With the so-called "cire-perdue" process the Ife achieved an excellence comparable to the best of Antiquity and later. Certain details of the Ife bronzes do, however, indicate their African character. The hair, for instance, was not cast in bronze; instead holes were made in the head, lip, and chin and there are good grounds for assuming that these served for the attachment of hair—an extremely common device in African statuary. When, in 1957, finds were made in the same region of human figures in their entirety, it became even more apparent that the Ife tradition was purely African. For these showed the disproportion between the head and the rest of the body so characteristic of other African art.

Benin sculpture is another important art form of this part of the world. It is supposed to have originated as the court style of Benin, the capital of West Nigeria, at the end of the 14th century and is assumed to have evolved out of the Ife style. It is still uncertain whether the "cire-perdue" technique was practised from the beginning at Benin, but in view of the excellence rapidly attained such was probably the case. The Benin artists adopted the naturalism of the Ife and this, coupled with the fact that their efforts were less contrived although perfectly modelled, is used as a criterion for dating. Their later work be-

came more stylized and more roughly cast and gradually diverged from the classical naturalism of Ife art. The variations of style ranged from a remarkable feeling for the physical appearance of the individual to highly abstract forms that were not based on observation but were preconceived and therefore more typical of African art.

The great appreciation for Benin art can be explained by its affinity with the naturalism in the tradition of European art. Even those for whom a true understanding of African sculpture is a closed book appreciate Benin art because of its less "primitive" nature. For a similar reason the Baule art of the Ivory Coast also enjoys a certain popularity. Of all African wood-carving styles that of the Baule corresponds most closely to Western European ideas of beauty. The Baule wood-carver had an eye for the pleasing effects of the image and was less inclined to symbolism—this was particularly the case after the French colonized the area. In general the artist expressed the humanity of his sculptures with dignity as well as refinement, and many statuettes of his ancestors possess an elegance that is almost sophisticated. However, the same people living further inland produced a more rustic and more severe form of art.

An overwhelming wealth of sculpture has been produced in black Africa. The extent to which the art was practised is indicative of the functional meaning of the sculptures. Every aspect of the life of the African Negro was expressed in a language of images: agriculture, hunting, fishing, war, sickness, recovery, birth, death—in all the rites accompanying these events the image played a role. Each tribe evolved a style of its own and there were many sub-styles among the villages; the variety is boundless. And since the birth of a style is in itself evidence of the intensity of a culture, the multiplicity—and the high standard—of the styles that have originated in Africa bears witness to the creativity and inventiveness of the peoples of this great continent.

The figure most frequently shown in Oceanic art was the man-eating giant or ogre. Carved from a single block, his trunk was round or oval, his shoulders barely defined, and his upper arms close to the body. His forearms were carefully folded across the belly so that the hands, with outstretched fingers, rested on the navel. As with African art, many of these works show that the sculptor concentrated on what he considered to be the essentials—the feet and legs were unimportant; a few lines sufficed to indicate the shoulders, but the genitals, particularly of the male, were exaggerated. The head was placed naturally, but on a very short neck. The eyes were staring and widely spaced, oval or round, and carved in concentric lines; the nose was generally convex, with curved, jutting nostrils.

Human figures in the sculpture of Malaysia, the Pacific Islands, and Australasia (but not of Australia itself) were carved differently. The arms fell straight from the shoulders, hanging free from the body, and reached the level of the hips, or even the feet. The head sat naturally on the neck, but the face was flattened and elongated, so that the chin sometimes reached the navel.

Unfortunately, the only period in the art of the Pacific Islands that has survived belongs to its decadence and dates from the beginning of European influence. The islanders' artistic activity, originally emanating from an intense religious stimulus, was practically destroyed by the arrival of the white man. Instead of the plastic qualities that distinguish African art, preference was given in the art of Oceania to a magical content that expressed the power of immediate feelings.

Throughout their countries, the inhabitants of ancient Mexico and Peru left towns with magnificent religious monuments, such as the pyramids, the character and role of which were quite distinct from those of other civilizations. But they also left temples, palaces, and tombs decorated with sculptures, bas-reliefs, and wall frescoes. The originality and the monumental character of the sculptures are comparable with those of other peoples known in history for this type of artistic expression.

Several civilizations developed in Mexico and Peru at different times over a period of about 3,500 years. At the base can be seen a public and religious exposition of the principle of a final cause that resulted in a collective and impersonal means of expression. This principle created a certain over-all unity. Pre-Columbian art was essentially a dialogue between priests and their gods. These initiates—whether they were scholars, architects, painters, or sculptors, and whose knowledge still astonishes us today—complied with the demanding archetypes of a completely solar religion, according to which the gods of fertility—the god of the rain and the goddess of corn—were allied with those of fire and of death in the regulation of the time of the creation and that of the destruction of man. Everything was significant in these sculptures that were the backdrop to a grandiose and often cruel ritual. We have difficulty today in deciphering the signs of an incomprehensible magic whose beauty is nonetheless disturbing. Plunderers may have despoiled them of their gold and jewels and thus changed their nature; but the patient, eternal funeral masks come down to us despite all, more perfect in their nakedness, punctual at their immemorial appointment. Their fixed stares arrest our attention in a dialogue from which there is no escape.

In the domain of the great plastic arts, Peruvian art did not reach the intensity of that of Central America. Apart from the monolithic sculptures of Tiahuanaco, hardly any large stone figures have been found. Even the Incas, who

may be considered as being, with the Egyptians, the greatest builders in the world, did not possess large-scale sculptures. The art of Peru was limited to the techniques of pottery, metal-working, weaving, and embroidery. However, their pottery attained an intense plastic realism in certain Mochaca modelled vases, justly termed "portrait vases". Sometimes, also, an archaeological site, such as that of Chancay, furnishes us with large statuettes in which can be appreciated a deliberate seeking of the volume that, in these exceptions, makes Peruvian art the equal of other well-known schools of American sculpture.

Chapter III. In the Face of Eternity
The Near and Middle East

▶ Lascaux, Altamira, and a very few other caves contain the only traces of naturalistic prehistoric art left to us. All other Franco-Cantabrian and African art completely disappeared at the end of the Palaeolithic Age, perhaps after an African invasion.

Some thousand years later there occurred one of the most important developments in the history of technical invention. By learning to smelt and to hammer metals man brought first gold and silver, then copper, into his service, and his discovery of alloys—pewter and bronze—marked the beginning of an almost industrial use of metals.

Creative effort was centred in the eastern and central Mediterranean regions where the rise of the Hittite, Sumerian, Egyptian, and Aegean civilizations coincided with the advent of bronze. Here man made his first tentative efforts to reach beyond himself—to establish political, cultural, religious, industrial, and commercial systems. The peoples of these civilizations were fired with the desire to perpetuate their conception of the world and their everyday lives provided a constant source of inspiration for their great talents and imagination.

In Mesopotamia, modern archaeologists at first searched for the sites of the ancient cities of Babylon, Assur, and Nineva, since they had no reason to suspect the existence of another—and earlier—civilization. But the carvings and works of art discovered indicated that this was indeed so and little by little the Sumerian civilization was uncovered.

Despite the discovery of bronze, earth, clay, and stone remained the foundation of the fast-developing Sumerian civilization. A number of figures found in the village of Jarmo represent women, most of whom are squatting on their heels; their heavy-breasted bodies are moulded on generous lines. None of the figures bears any individual traits—a characteristic of all works of the period, and doubtless based on the fear of giving a face to mother-goddess figures, whose bodies, picked out in colours, were symbols of fertility. Incomplete, they remained impersonal. By way of contrast, the dansers of Lei seem about to break into a gay farandole; their gestures are ritualized and, unashamedly naked, they are inspired by a religious fervour. Dancing, from its very origins, was sacred and many a temple had its "corps de ballet".

The work of the early inhabitants, both in building and art, was continued by their successors, and statues dating from 3000 to 2500 B.C. found in the Tell Asmar sanctuary, leave no doubt that they were the expression of a people whose main inspiration lay in the unknown: their hands are clasped and their eyes are lifted to the heavens in prayer—Mesopotamian art of the third millennium B.C. was almost wholly religiously inspired.

The images of the faithful in the temple of Nintu at Khafaje, with their geometric lines, were obviously created in the same spirit. With their enormous eyes and their heads shrunk into their rounded shoulders, they lean in ecstasy toward the Invisible.

The ensuing artistic phase was in marked contrast. Men and women were still depicted at worship, but the impression of anguish and of fear of the sacred seems to have evaporated and been replaced by a certain peace and good humour. At this period, too, scenes from daily life began to appear, as in the temple of Ninshursay at Al 'Ubaid which dates from 2500 B.C. A limestone frieze here shows simple down-to-earth scenes of herdsmen milking and working with their animals. Preoccupation with the unknown faded as the people came to grips with reality. The same simplicity is found in a mosaic, "The Standard of Ur", dating from the same period. On its two facades shells inlaid in sandstone tell of four-wheeled chariots, drawn by wild asses, setting out to war; an attack by lancers; the battle and the capture of prisoners; the looting; the preparation of fish, sheep, and oxen for the feast; and the bacchanalian orgies before the triumphant king. Cylinder seals show Gilgamesh and Enkidu fighting with savage beasts, the ascension of Etanas, and the victory of the goddess, Ishtar. Everything seems natural and true, and full of life.

The portraits of princes often show quite individual faces, and the expression in the eyes can sometimes be interpreted as a will to dominate the world and to understand the relation between material things, rather than as the light of religious devotion. Eyes like this reveal lucidity of expression and liberty of thought. The head of Gudea has that same expression. The face and headdress may be skilfully decorated and the eyebrows stylized, but the eyes are unusually alive. Gudea is not contemplating the secret or the mysterious; he looks with serenity upon a familiar world.

In its architecture and sculpture, in its creation of works of art, and in its concentration of permanent armies of

workers dedicated to massive constructions, ancient Egypt bore many resemblances to the Mesopotamian civilizations. Mathematical mastery, simplicity of planning, and authoritative command arose from social conceptions corresponding to vast artistic ideas. As with any nation touched by the same thirst for greatness, a sort of despotic heroism cannot be denied. Egyptian sculpture was architectonic, full of verve and moral force, and expressed this heroic spirit in all its strength.

Archaeologists speak of the "frontal convention" in connection with Egyptian statuary. The expression comes from the Latin noun "frons", meaning a forehead—given this etymology the "frontal convention" signifies that Egyptian sculptures were orientated in relation to the position of the forehead. The body of a figure presented in observance of this law is, at the level of the thighs or of the cervical vertebrae, neither inclined from the vertical nor turned to the left or right. The law permitted no exceptions—it applied as much to the statue of a king as it did to that of the head of a village. The only digression lay in the posture of the figure: a scribe might be represented squatting but a king, never. A king must stand, or, at the most, sit erect on his throne.

The frontal law was not peculiar to the plastic arts. All Egyptian art observed this almost liturgical rule, so strict that it dictated the form of a headdress or the line of a costume. The problem of profile was resolved by showing the legs in a walking position and the nose, chin, and forehead in full profile; but the eye and the torso, from the width of the shoulders to the hips, were represented from the front. This artifice made it possible to preserve the frontal law in bas-reliefs. The Egyptian bas-relief caught the human being in what was thought to be his most significant aspect—the breadth of his shoulders.

However, the consequences of the campaigns conducted in Asia by the first pharaohs of the XVIIIth Dynasty (c. 1400 B.C.) soon became apparent and brought about a fundamental change in Egyptian aesthetics. In an atmosphere of opulence, taste grew more refined. The austere strength characteristic of the Old Kingdom art (the art of the Middle Kingdom was its academic phase) was regarded as a kind of antiquated simplicity, even poverty. The concept of physical beauty arose in the middle of the XVIIIth Dynasty and beauty was cultivated for its own sake. It became the supreme ideal of Egyptian art, and achieved its highest moments in the representation of the female figure; its charm was communicated down to the smallest detail.

Representative of this new outlook are the wall-paintings on the tomb of Nakht, a vizier in the reign of Akhenaten and a most important and privileged person who lived in a grand house at Tel-el-Amarna. He was allowed to have an imposing tomb adorned with a magnificent series of paintings—some of which possess an unusual charm and informality that would probably have been considered undignified in a royal tomb.

Chapter IV. Mythos and Idea
Crete and Hellas

▶ Just as the evolution of an art reflects the evolution of the rigour and the character of a people, so does the manner in which the gods are represented reflect the destiny of that people. This is not to imply that the representations of the gods are only the projections of human ideals; indeed, a human explanation cannot suffice. These representations may be images formed in the human mind—but they are images dependent on the extent that the gods reveal themselves to man and on the extent that man is capable of conceiving the gods. The images of god and of man are formed reciprocally, each in its turn; nevertheless we remain human beings and therein lies the limitation of our access to the gods. Throughout Greek history the face of the gods was determined by current opinion; it reflected the evolution of that land—the period of the Nobility, of the Tyrants, the Persian wars, Pericles, the Peloponnesian wars, the fourth-century Bourgeoisie, Alexander, and the Greek sovereigns.

When, from the end of the third millennium B.C. until about 1200 B.C., the Greek tribes emigrated to what was to become Hellas, they came into contact with the Minoan world of Crete with its rich culture and its flourishing religions in which female divinities predominated.

The frescoes are among the revelations of Cretan art; the themes are infinitely more varied than those found among the monuments of Egypt and Asia. A courtly, refined civilization appears before us in which woman occupies an important place. She is lively and perhaps slightly affected; she delights in animals and flowers, in nature both free and domesticated. Man happily immerses himself in this life—in Greek painting it is man, almost exclusively, who triumphs. When the theme was religious, it was treated with an astonishing freedom of manner, although during the last period when palace life was more dominated by officialdom a certain restriction became apparent. Everywhere the sensual prevailed over the intellectual. The imaginary scenes created by the Minoan painter had a completely individual vivacity and unexpectedness, the free play of colour being preferred to the moving silhouette. There before us we see recreated a conventional life but one with very strong poetic overtones. Admittedly, though, it is far from the perfection of Greek drawing.

Not only did two civilizations confront each other, but also two schools of thought. Cretan art was characterized by the total absence of the grandiose, plastic art that had already been current in Egypt and Mesopotamia for some time at the period of the second Cretan Palaces. The majesty of this plasticity, however, was to triumph among the Greeks whose genius was sculptural "par excellence". The Cretans seem to have had little liking for translating forms into volumes; they contented themselves with works of small dimensions—for instance a height of about 30 cm in the case of the snake goddesses. These goddesses are attractive and also interesting from the clothing and religious points of view. However, as works of art they adhered strictly to the frontal convention and lacked any special plastic quality. The feeling of movement was correctly portrayed but it was unexciting and there was little variety between the models.

Despite the extent of its culture, Cypriot civilization seems not to have influenced the West. Troy, in contrast, exerted tremendous influence in all directions, mainly because it was a metallurgical centre. Its emigrant population was the bearer not only of metal but of a refined, urban civilization.

The civilization of the Cyclades was, like that of Troy, one of town-dwelling artisans. Before the days of Crete, many a small fortified town, by the sea or on a hill-top, in the Cyclades acted as a link for commerce between Anatolia and the continent. Cycladic art is renowned especially for its marble idols that foreshadowed the awakening of plastic forms in the Aegean world. The artists were fond of depicting nude women representing the goddess of fertility who was also the patroness of the dead. The stylistic processes were varied; there were rough, violin-shaped idols in which the lower half of the body was rounded off and the neck and head reduced to a cylinder. More frequently, however, the constructions were light and harmonious; simple forms were superimposed with, for example, schematic heads surmounting a long neck. The heads themselves were triangular, the only detail being the bridge of the nose. The torso was a trapezoid.

We could easily imagine how a Classical plasticity might have developed out of this geometry, which resembles that of the beginning of the first millennium; but in fact it never did. These Cycladic idols are certainly older than the third millennium, but it is impossible to date them more precisely.

The immigrants to Greece who brought with them the Mycenaean civilization were responsible for the art forms

and also for certain religious motifs. Nevertheless religious scenes generally gave way to those showing the world of the aristocracy: fighting, lion-hunting, and chariot racing. We use the term "geometric style" to describe the first compositions. Its appearance was a major innovation that can be explained in many ways; for instance by intervention from outside or by a movement of population. Forms inherited from Mycenae survived for some time. Then came others that were constructed with a certain clumsiness. But it was these, as they became progressively better balanced, that developed into the principal forms of Greek pottery.

In the eighth century B.C., at a time when many vases were still being decorated with a linear pattern, isolated motifs such as a horse or a bird were introduced, soon to be followed by scenes in which the human figure appeared. At the start, these scenes were completely subordinate to the geometric principle, the human body being broken up into simple geometric shapes; for example, the triangle formed by the bust and the arms folded at right-angles above the head. These shapes themselves were repeated as inanimate triangles. Nevertheless the vase attained a harmony, although one that was as yet unbalanced. Before long the rigidly immobilized human subject was begging for relaxation and a relief from stiffness. The rumps of the horses and the rounding of the legs and of the curves of the shields were already starting the trend and it could no longer be resisted.

By the second half of the eighth century the nascent taste for movement meant that subjects began to be depicted running, wrestling, or in some form of motion. From then on the artist tried to give the appearance of reality, filling out the bodies and softening the gestures. But from the period known as the "late geometric"—about 730 B.C.—the move toward liberation became really active. Forms were less rigid and decors were readily broken into metopes which ended the monotony of the continuous friezes. Athens was the first to create a geometric style, pushing it to its limits. The first contributions from the East were forced to conform and were assimilated until they no longer appeared Oriental. We know of no Greek sculpture before the second half of the seventh century B.C., but we do have works in metal, ivory, and terracotta that date from the ninth or eighth or the beginning of the seventh century. A certain amount of animation was even then recognizable; there was a feeling for the shapes of the body and a taste for variety and detail that were specifically Hellenic, and more especially Ionian, qualities.

The most ancient of the Greek statues—discovered in Crete, Peloponnesos, Attica, and Boeotia—were modelled in the Dorian tradition. Their structure was simple and geometrical; yet in spite of their apparent immobility, they were endowed with a tangible vitality and a sort of momentum toward action. At one time it was believed that the primitive Dorian model in both architecture and sculpture was short and thickset, but we now know this to be incorrect. The Apollo of Thebes (the "Mantiklos-apollon") with its long, slim legs and slender waist is a Doric sculpture, dating from the first quarter of the seventh century B.C. and composed of geometric shapes. The trapezoid trunk rests on the thighs and is surmounted by another long trapezoid representing the neck; in its turn, this supports the inverted triangle of the head. The simple conception is emphasized by horizontal and vertical lines that seem to link the different parts of the body.

The slender Doric columns of the narrow temples of this period were only hesitant variations on the wooden pillar; as soon as the Doric builders felt competent to construct large buildings of stone, they supported the heavy copings with thick columns. In like manner, the sculptors who worked in stone and marble, rather than bronze or ivory, developed a need to fill out the geometric and almost abstract forms in order to satisfy the new taste, naturally born from the feel of their materials.

The statue of an Apollo-like youth (the Kouros of Attica) is typical of the transitional stage—the full face and the profile still seem independent of each other. However, the softer planes and contours, especially of the face, indicate the progress that was taking place. The unusual proportions of the figure—long neck and stocky thighs—probably represent the aesthetic conceptions of the period. The ornamented long neck supports a head full of dignity and quiet pride. The jaw no longer slants abruptly toward the ear with animal force, but curves upward suggesting, rather than delineating, the cheeks. This statue is a masterpiece in which the elegantly serene and dignified head dominates the body. It belongs to the Archaic period of Hellenic art but gives a foretaste of what the Classical period was to bring.

The legend of Cleobis and Biton, the two sons of a priestess of Hera, made them ideal subjects for later powerful, muscular carvings. Out of devotion to their mother, Cleobis and Biton took the place of the sacred oxen, yoked themselves to her chariot, and drew it to her lonely temple. The priestess, in recognition of this act, prayed to Hera to grant them the best gift to mortals—they died in the temple while asleep. These larger-than-life-size statues, from the sanctuary of Apollo at Delphi, catch the very essence of youth; the figures are vigorous, ready for action, and supple, with faces open and joyful. A new humanity emanates from the powerful tension of the forms and thus gives them a more personal existence. These two brothers are, in a sense, portraits. Admittedly,

their total nakedness, the fact that they are larger than life-size, and their traditionally adolescent features place them in the impersonal, mythical universe of the heroes. Yet their nudity, adolescent character, and youth have a fresh meaning. To a much greater extent than is apparent in Archaic statues, they appear to be youth incarnate, real and hot-blooded; a youth elevated from the dust of the arena to the level of an eternal image.

The Greeks considered the human body in an anatomical light, thus differing from the Egyptians who conferred a stiffness of attitude on their subjects to express an aristocracy without time. The rigid and unreal carvings of the Egyptians were cut symmetrically from the front to give an impression of order and calm; they were also supported at the back with a stone block. Greek plastic art abandoned this support and replaced the rigidity with fluid lines, showing the figures turned slightly to one side. These different forms belonged to two contrasting worlds— Egyptian sculpture was the expression of a State built on submission of the people and of a religion devoted to awe-inspiring gods. Greek sculpture expressed high spirits, a profound love of freedom, and the joy of living the present moment.

However, it would be wrong to judge Greek sculpture purely by its exterior beauty. In comparing it with the Impressionist period, we see that it aimed at, and achieved, a higher goal. Renoir painted voluptuous, mature women who lack exactly that tension and movement that is the essence of Greek sculpture: Greek figures were captured in an instant between movement and rest—studies of simultaneous concentration and relaxation. The Greek sculptors did not content themselves with a charm that flattered only the senses; they knew that liberty was the animating force of man. The Egyptian showed us a people oppressed by an exterior rule, a dominating and unearthly force.

The liberation of Greek art, even in the Archaic period, from Egyptian rigidity was more than a mere formal change. The Greek statue was freed from all imposed laws and attained a spontaneous intrinsic movement. This art shows us, for the first time, emancipated beings; it bestowed on the world the realization of human freedom.

It was about 500 B.C. that Greek art began to surmount the Archaic rigidity and it is significant that this period was devoted to the problem of the standing and the free leg, the solution of which was soon to find its highest achievements in Classical art. This aspect of statuary (the "pillar" leg bearing the weight of the body while the free leg was simply a support) is witness to the pleasure that the Greeks took in the free play of the limbs as well as in the harmonious equilibrium of the movement of the body.

This turning point continued to develop until about 450 B.C. The spirit that animated the victors of the Persian wars and their marvellous courage were rediscovered in art. The bronze statue of the charioteer at Delphi and, above all, the sculptures on the temple to Zeus at Olympus (between 470 and 456 B.C.) were incarnations of the heroic seriousness of the century. As in the Archaic period, fine examples of the female are found, and these works refute the idea that the Greeks were blind to the charms of the feminine figure.

The role that the magnificent prosperity of Athens under Pericles (500-429 B.C.) played in art is difficult to estimate because many works disappeared in the turmoil of the Great Invasions. But works such as the bas-relief of Demeter and Triptolemos and that of Orpheus and Eurydice prove that the Greeks were aware of the gifts of grace and of the enigma of death. The whole body expressed the feeling of the soul. Polyclitus was a leading sculptor of the time but we possess only Roman copies of his work, most of which was in bronze.

Myron, who also worked in bronze, has left us the "Discus Thrower" and the groups of "Athene and Marsyas". In the "Discus Thrower", he caught the athlete in the instant of balanced tension between the wind-up and the throw.

In the Classical period (460 to 330 B.C.) we can distinguish between the aristocratic style of the fifth century and the beautiful style of the fourth century, and there is no doubt that Praxiteles was the outstanding representative of the latter. "Hermes" is the only original sculpture of his that we possess. In this and his "Aphrodite of Cnidos", Praxiteles captured the texture of the living skin in the iridescence and slight transparency of the marble. Aphrodite lets slip her clothes with natural, innocent movements and climbs into her bath with an absorbed, absent look. The statues of Skopas of Paros were more passionate; the features were tormented by the forces of inner emotion, and the uncertainties of life were reflected in the depths of the expression. These new elements were the precursors of a decisive turning point that was to come about in Hellenism.

The increasing importance of the sensual aspect of things, of passion, and the refinement and taste for movement broke the Classical harmony and prepared the way for a new, less balanced style. A fundamental feature of Greek art—the tendency to go beyond the limits of the individual—was questioned. The essence of the art of Praxiteles appears very clearly in the celebrated "Apollo Sauroktonos". The young boy has crept near a tree on the trunk of which a lizard is climbing. He stops and looks around; the tip of his left foot rests lightly in front of his right. He leans forward to take up a good shooting position for his right hand which holds the arrows. This

subject seems to have been chosen with the deliberate intention of showing in detail the flexibility and grace inherent in a young body.

But at the end of the fifth century B.C. Greek sculpture became rather less energetic. Nevertheless, Praxiteles was the first to succeed, due to an evenness in rhythm, in demonstrating the forces dormant in a supple body. Nothing, apart from a certain nonchalance in the face, gives a clue to the divinity of his Apollo. The artist worked, not for the sake of his subject but thanks to his subject; thus he created a young, supple body in an harmonious pose. This refinement was art for art's sake. But a certain concept of human greatness, of all-powerful gods, and of a fabulous destiny had disappeared. Nothing could be further apart than this gentle child of the gods and the powerful fifth-century images of Apollo in which the divine forces ruling the world were incarnated.

Adolescence was deified in the features of Apollo, femininity in those of Aphrodite. Aphrodite, a goddess of Oriental origin, was a favourite subject of the period. She was at one and the same time the goddess of beauty, of generation and fertility, of heaven, of earth, and of the sea. She, the elemental, rose from the waves surrounded by the elements, the sea still running from her clothes. Her expression was one of courage and victory. The outline of her face was severe; and, as this was the height of the Classical period, she was neither attractive nor pretty, but imbued with a fighting spirit—shining, strong, and venturesome. In the later statues of Aphrodite, we can glimpse—beyond the Classical forms sometimes deliberately sought—the Hellenic naturalism that the artist was consciously trying to avoid. The softened, almost woolly forms of the body were typical. A superficial sensuality pervaded both the head and the body. The internal force that gave the subject its life was broken. The plastic intensity was reduced to mere decoration. However, the play of the folds of the garments continued to hide the weakening of organic unity.

Nevertheless, a bronze statue from Naples proves the continuance of successful Hellenic creations. It reminds us of the Classical works although it was not restricted to any one style. The body is of softened form, while the head is more strict. This work conjures up the romantic atmosphere of later centuries rather than the statues of Apollo.

Chapter V. Mysticism and Philosophy
The Far East

Indian culture seems to have been attracted more to sculpture than to any other art—even to the point of allowing it to dominate architecture completely—and there was little attempt to create free-standing human figures. For the Greeks, the statue served to define man, to give him an identity, an ego that to the Greek mind was the aim and end of existence. To the Indian, this ego was only a transitory incarnation destined, in the perfect human being, to be annihilated, merged in the Supreme Self, the Universal One, the Absolute. In Indian art the sculptured figure was rarely treated as an isolated entity; it emerged from the stone yet remained part of the background—a background as lacking in space and as indeterminate as the Infinite. The figure was usually linked with others, but even when it was alone the pulsations of the ecstatic state that twists the body suggest its interdependence with the sky above.

The naturalism that is found at the beginning of Indian art was already present in the art of the prehistoric Indus-Valley culture of 2500-2000 B.C. where it contrasted strongly with the utterly hieratic approach to art that predominated in the Mesopotamian civilization even though this was the source from which the artists of the Indus Valley largely drew their forms. Statuettes from Harappa (an important city of the Punjab) were also distinguished from contemporary Middle Eastern works by their sensuously delineated nudity. From the beginning, this ingenuous sensuality was characteristic of Indian sculpture. As in Greek culture, the human figure was glorified.

But, unlike the Greek artist, the Indian showed little interest in anatomical structure and represented it only very approximately. Yet in spite of this the body of an Indian figure is shot through with a vital impulse, the breath of life. In Hindu philosophy the body is not an enemy; rather, it is the medium through which the spirit is liberated. Ascetism is not the mortification of the flesh, but rather the mastery of life, obtained through a complete awareness of body and soul. As for sexuality, one of the yoga methods exploits eroticism as a path to transcending the ego and attaining unity with the Supreme Self.

In contrast to Greek sculpture where the virile type predominated, the ideal in Indian sculpture tended to be feminine. The characteristic female forms influenced the representation of the male body, as can be seen in the statues of the Buddha. In female figures themselves, the female attributes—breasts, hips, fleshy folds—were strongly accentuated, and were emphasized by the S-curve in which the body was twisted. In the Mediaeval temple sculptures of Bhuvaneshware, Khajuraho, and Konarak the female bodies were seized with an erotic frenzy, generally interpreted as a symbolic union of essence and substance.

The Western influence over Indian art has been referred to as Greek; yet this has been contested on the ground that at the time of the "Greco-Buddhist" art of Gandhara, Rome, not Greece, held sway in the East. For the Indian, however, Romans and Greeks were alike in their artistic approach which was based on anthropomorphism; moreover, what Rome, especially on the Eastern frontiers, had to offer as an art form was Hellenism. The Greeks showed how heads and bodies should be presented in order to emphasize the monumental aspect of a figure, and they taught the Indian artists how to exploit draperies so as to accentuate a gesture or to give the composition a feeling of rhythm. The capacity to give the face a profound sense of life was another gift of Hellenism; previously, the head of an Indian sculpture had been only a part of the body, but now it became, as for the Greeks, the mirror of the soul. And Apollo lent his features to the Buddha.

In the fourth and fifth centuries A.D. a true Indian style developed in the north based on the art of Gandhara. In this Gupta art—so called after the Gupta Dynasties—the model of the Buddha was defined; the attitudes and gestures were classified. Of all the images of the divine that man has created, these are among the most perfect in their expression of a theological belief. They incarnate the state of Perfection, of the Supreme Self, the depersonalized being who has extinguished his will to exist and has therefore realized himself fully. Nowhere else has art invented a formula that so adequately expresses a conception of what lies beyond life.

Not long after Northern India created these images of silence, another religion was being elaborated—Hinduism, under the Pellava Dynasty, in the Deccan. India eventually turned away from the religion of Buddha, but Buddhism, and with it the art it had created, spread throughout Asia in various forms; Ceylon, Siam, and Burma adopted the Hinayana, while Cambodia, Java, China, and Japan took up the sense and imagery of the Mahayana. In Java, the bodies that Gupta stylization had

dematerialized were now brought back to life and roundness, though lacking the Indian sensuality.

In Cambodia, Buddhism and Hinduism intermingled in an extraordinary synergism that provided artists with a very rich iconography. The Khmers, unlike the Indians, isolated the human figure in space—that is, they made true free-standing statues. Their figures stood vertically, in proud autonomy, not flexed in the contorted attitudes—possible only in relief—of Indian figures. The Khmers also modelled the body firmly, and polished its forms to suggest a dense muscularity.

Monumental sculpture was introduced into China with Buddhism. Under the Han Dynasty human burial sacrifices were abandoned and a whole range of terracotta objects and figures, destined to furnish the tomb, took their place. Art thus helped man to free himself from the unmerciful rites made necessary by the belief in an afterlife that duplicated life on earth.

The Buddhist figures of the T'ang period demonstrate a revival of feeling for solid form. In quality, however, none of the T'ang sculptures even remotely approached the rare paintings preserved from that period. Some fragments of a painting of a spring festival and other paintings, found at Turfan, show us the new T'ang ideal of feminine beauty—a more massive form, compared with the slender elegance of preceding periods; a full, rounded face, with hair heaped around and above the head; and an air of smiling health. Precisely the same types are found also in the few pictures that survive from this period in Japan. And it is from the early painting in Japan, closely modelled on Chinese prototypes, that we can most safely infer the great style of the T'ang period, the grandest works of which were inspired by Buddhism.

Buddhism reached Japan in the sixth century where it found a people who tended toward a realism that was reflected in their artistic spirit. The Japanese painted portraits and were inspired by warlike themes. These themes had already appeared, with strong magical overtones, in some of the Jomon figurines of the proto-historic period.

From the sixth century onward, Japanese art was dominated by the Chinese influence, a fact clearly seen in its techniques and aesthetics. Yet at the same time, as history has repeatedly shown, the foreign elements were assimilated to provide a fresh stimulus for the development of national characteristics.

Chapter VI. From East to West

Etruscans and Romans

▶ Greek Antiquity is incomprehensible without a knowledge of its art. Not so the world of ancient Rome. The army, administration, statute law, and history are much more important to an understanding of Rome than are its painting and sculpture. It was only after contact with Greek civilization that Rome became a city of art. Many Greeks, especially from the time of Augustus, settled in Italy and if the Romans valued their work it was for cultural reasons and not on account of a natural bent for art. Magnificent buildings were erected, designed for purely practical purposes, that represented more than mere architectural skill—they were symbols of the power and the majesty of the Empire. Roman sculpture, besides its numerous copies of Greek originals, also gave birth to three types of work in its own right—statues of emperors and generals, the historical relievo, and the bust. The statue of Augustus, in front of the Prima Porta in Rome, is the most important among those of the emperors, and although it was doubtless executed by Greeks its style is wholly Roman. In contrast to the idealized style of the Greeks, the precise sober features, imbued with a resolute virility and a distrust of the imagination, were in keeping with the mood of the times. The historical relievo was displayed primarily on columns and triumphal arches. The Roman conception of supremacy found its most striking religious outlet in the triumphal feasting that, originally, was not so much the glorification of the victor as an act of thanksgiving to the gods who had granted the victory.

Roman art was indiscriminate in recording the important and the trivial, in both persons and events. The artist fathered statues without the slightest metaphysical overlay, but often with a frightening realism; he did not retreat before the repugnant. The mole on the chin of the Neapolitan banker, Lucius Cacilius Jucundus, his projecting ears, his expression of cunning and of impatience to acquire and to enjoy were noted most exactly by an art that conformed to facts and not to ideas. The portraits in stone and bronze that were so wholly faithful to reality were at the same time magnificent witnesses to the Roman ethic. Dignity and sobriety were expressed in the representations of men who lived in an atmosphere of constant stress and strain.

Yet the Romans were not satisfied with a life that consisted solely of the fulfilment of one's duty and of the satisfaction, pure and simple, of basic needs. They attempted to achieve a standard of living elevated by beauty and leisure. Roman writers have given us a highly-coloured picture of their town life. A meal accompanied by gay conversation was much appreciated. Varro advised the limiting of the number of guests so that each could take part in the conversation. "Preference should be given", he said, "to a number between that of the Muses and that of the Graces." Cicero considered that the Latin word for a feast, "convivium", was particularly suitable, since it implied living together, not just eating and drinking.

The paintings that decorated the Roman towns were, in the main, copies of Greek works and thus contributed to the diffusion of Greek civilization. But the frescoes at Pompeii contained fresh elements that presaged the centuries to come. There was a turning away from the plastic and from humanity. The quest of the plastic and the concentration on man were the foundations of the art of Antiquity. But these were now challenged. The figures portrayed became light, and floated on air. The goddess picking flowers herself resembled a flower. She danced along lightly as in a dream. The very substance of the bodies changed. They became transparent and their contours dissolved into the light and shadow. The silhouettes of the gently moving garments were blurred and blended into the air. Thus the human being began to play a less important role while space gradually assumed greater significance. The hovering shadows that were man moved in an infinite space unknown to Antiquity. The Maenads glided in a new light, appearing happy in the joyful contemplation of an extra-terrestrial divinity. This was the last utterance of the great painting of Antiquity. Following the religious and pictorial trends, the concrete forms reached such a degree of transcendence that a new and infinite space surrounded them in which their bodies were weightless. If we are to pursue this painting in Pompeii to its conclusion, we must seek its impressionistic lightness and the infinity of its new metaphysical space in the catacombs of Rome and the mosaics of Ravenna.

In the sequence of archaeological discoveries, Etruscan art arose late from its slumber. The Italian poet Gabriele d'Annunzio was one of the first to excite European emotions with images from the Etruscan world. Sadness, death, a sense of fatality and anguish—these were at the heart of the message sent forth by d'Annunzio in the name of the

Etruscans. Then in 1932, the Etruscans were once again in the literary limelight, thanks to the English novelist D. H. Lawrence. The image that he retained of the Etruscan people was quite different from that of d'Annunzio. For Lawrence, the poet of sex, of the unrestricted life, of liberty, and social non-conformism, the Etruscan was above all the anti-Puritan, oppressed by the wicked, avid, hypocrital, and brutal Roman. He wrote, in "Etruscan Places", "It is useless to seek a moral elevation in Etruscan art. If that is what you want then go to the Greeks or the Romans."

For the Etruscans, life, joy, and sensuality united in the vast, moving panorama of the universe; "the natural blossoming of life is not as simple as it appears. At the base of Etruscan ardour was a creed of life for which the chiefs were responsible. Behind all these dances there was a vision, and even a science, of living, a conception of the universe and of man's place of this universe, which caused them to live at their most profound. Everything was alive for the Etruscans and the duty of man was to live also. He had to be pervaded by everything living in the world. The cosmos was alive, like a living creature. The whole universe breathed and moved."

The Etruscans, however, merely served a purpose for both Lawrence and d'Annunzio. Their interpretations were distortions of historical and archaeological data. But that phase of history is open to all manner of interpretations as the Etruscans left no literature. Nevertheless, Lawrence was not completely mistaken. Later interpretations of Etruscan art agree curiously with his image of it. Descriptions of the decorations of the tombs of the Triclinio, the Orvieto, the Vulci, the Cerveteri, and the Chiusi draw attention to the pervading lightness of atmosphere; it is a happy life that is depicted with dancing, feasting, music, and joyous drinking.

The Romans called the Etruscans the "oboesi Etrusci", or stupid Etruscans, but they admired their knowledge of the planets and the future, and their interpretation of symbols. They referred to these arts as the "disciplina etrusca". The entire life of Etruria was strewn with mythical customs. The founding of a town was a sacred act; sacrifices and the celebration of rites were the order of the day. Tombs were more magnificent than the houses of the living. The living had to be satisfied with perishable wood; but for the dead, nothing but stone would do. Imposing necropolises were built as beautiful and joyful places, imbued with a quiet sense of fate that accentuated the presence of the hereafter.

This State, with its haphazard organization, proved increasingly powerless in the face of the disciplined and rational politics of Rome. The Romans resorted to incredibly destructive violence and annihilated the Etruscan

language to its very roots. It is true that they revived certain customs for their own benefit, but they mutilated them in the process. They revived necromancy and rejected the omens. The consultation of the liver and the flight of the birds were nothing more than ornamental magic. When in doubt, it was the interest of the State that was the decisive factor.

According to Herodotus, the Etruscans originated from Asia Minor. Many authorities today agree with this opinion because the civilizations of Asia Minor and Etruria have many factors in common. The oldest Etruscan objects possess a Mediterranean style—we cannot be more precise; objects are usually referred to by the place where they were found (Sardinian, Cypriot, etc.)—with, here and there, a feeling of Egyptian or Assyrian influence.

The Etruscan bronzes of the first period appear, in a word, to be completely international. But the funeral urns with their full shapes, almost human or decorated with human totems, were typically Etruscan. These urns have a considerable strength yet, at the same time, they hint at the exotic. The clasps, the decorative plates, and the gilded gudgeons, in all of which are inserted tiny detailed sculptures where light and shadow play with a refined subtlety, put one in mind of certain Asiatic works. It has been said, and quite rightly, that nothing in the West reaches such perfection.

Etruscan painting is a valuable and, in a sense, unique source for understanding the art of Antiquity. It forms the only comprehensive body of direct evidence that we possess of large-scale painting in the Classical world before the Roman period. Moreover, it is not a matter of simple decoration but of works of powerful style. The actions expressed in these paintings are very much alive in their boldness of line and freshness of colour, at once naive and refined, distant in time, yet close to modern taste.

The first examples of painting known in Etruria date from the end of the seventh and the beginning of the sixth centuries B.C. The Greek centres had at that time already begun to impose innovations in style that totally transformed the Southern artistic tradition, but we can fairly say that Etruscan artists re-created in their own surroundings those stylistic motifs that had been diffused by the Greek world. During the first half of the sixth century, relations between Etruria and the Greek colonies of Southern Italy and Sicily had a certain importance and the thesis that there were Greek artists living in Central Italy seems to be confirmed by the nature of the buildings.

But toward the middle of the century there occurred an event that was basic to Etruscan evolution. To its dealings with Western Greece were added direct and intensive contacts with the Eastern Greek world; that is, with the culture and artistic forms fashioned in the Greek colonies of

the western coasts of Asia Minor. The Greco-Oriental, or Ionian, artistic current dominated Etruscan production till the end of the sixth century. There then came a fresh development of taste from the artistic centres in Greece, properly-speaking, and especially from Athens. This was the final period of Archaism.

Among the most noble works left by Antiquity are the decorations of the tomb of the Triclinio preserved in the Tarquinia museum. These paintings date from about 470 B.C. A young man playing on the flute is practically dancing from among the flowering shrubs in the garden, toward the table of his masters. His black hair is short and curly; his firm, supple body, painted in a reddish-brown tone, is covered by a mantle of white voile with a spotted edging that shows, as it slips from his shoulders onto his arms, the outline of his body. One has the impression of viewing a dream—a dream figure in a dream landscape. It is the transposition onto a pictorial plane of a musical caprice, not only on account of the subject, but also, and especially, on account of its formal realization. The choice of the motifs, the terse dynamics of the exuberant silhouettes, the exquisite finesse of the drawing and of the colours are so many factors that reveal the inventive spirit and the refined degree of pictorial maturity of the artist. This ornamentation has affinities with the works of the greatest artistic civilizations that the history of the human figure has known.

Chapter VII. Heaven in View
Christianity in Europe

▶Christian art owes its first large-scale works to the Roman State; its beginnings date from the edicts of tolerance of the emperors. In its early days it continued the pagan tradition and remained linked to the old workshop where fruitful exchanges with the various currents of pagan art influenced both its themes and its style.

It is the world neither of the Bible nor of Holy Writ that is the centre of early Christian compositions, but the philosopher, the image of the "Homo Christianus" to whom heaven was revealed through the Gospels. There are several variations of this theme among the sarcophagi of the Via Salaria, at St. Maria Antica, and at La Gayolle. The philosopher is seated between the Good Shepherd and the Woman Praying—the two original symbols of early Christian art borrowed from the paintings in the catacombs. He was usually shown as a Cynic with a long beard and bushy hair: his broad chest is naked, his face ecstatic. This is not a wise philosopher of academic life but an apostle of poverty, who philosophizes and preaches because death is at his heels. He is aware of the void of this life and wishes to help man overcome the world and, at the same time, death. The face of Christ does not appear on the oldest sarcophagi.

After the peace with the Gauls, the subjects of the philosophical and Christian compositions gained in scope. Christ in person was depicted as described to us in the Gospels. He is the Saviour. In the scene of the raising of Lazarus, Christ has the facial expression and hairstyle of a philosopher. He is wearing a mantle and has sandals on his feet; in one hand he holds the Gospel scrolls that are his philosophical symbols. But in the other he holds the magic rod with which the apostles performed their miracles during their wanderings. This philosopher-Christ became the model for the future. The Christ of the Sermon on the Mount on the polychrome fragments of the National Museum in Naples went beyond the popular image. The Saviour's face commands respect. His dignity is accentuated by His beard. This Christ, Man of the people, amid the people, forces men to follow Him by curing the sick and promising eternal life.

The Christ of the miracles on the friezes of the fourth-century sarcophagi was never given a beard, as He was on those of the third century. He was much nearer to the incarnation of a young man without time. The pupils of the eyes were not deep-set, a feature that gave the Christ of

the polychrome fragments the peculiarly fixed stare. The immutability of the Christus Philosophicus had given way to the new ideal of a man of calm, eternal youth. The unruly hair of the Cynic philosopher has been replaced by a neatly-ordered curling style. But we already know these curls well, as they date from the time of the Tetrarchies. They were used for the Dioscuri and the heroes on mythological sarcophagi. It is therefore permissible to term this second type of Christ found in Roman sculpture, the "Heroic Christ". Art depicted Him as the all-powerful creator of the new life. In the Apocryphal Christian literature— the result of the peoples' imagination—the image of Christ had features of the ideal, of the "kalos kagothos", and of the Apollonian representation of God. Each time one of His miraculous interventions in human life was depicted, it was not the Cynic philosopher nor an ill-favoured ascetic who appeared in the heavens but a handsome adolescent, radiant as Apollo, whose years knew no end and whose youth was the key to His fascination.

The model of the "Heroic Christ", however, did not last long. It was replaced at the beginning of the Constantinian period by a new model whose original is to be found in the representations of the spirit at the close of Antiquity. The head of Christ became rounded, His features human. Toward 330 A.D. this humanizing process went so far as to give the miracle-working Christ the features of a young boy. A softness replaced the firmness; a plastic rounding-off of the profile and a dreamy, elegiac expression appeared in place of the seriousness. A touching and innocent youth chased the austerity of timelessness. The inner grandeur was replaced by an expression of faithful love. The impression of inaccessibility gave way to one of love for all men.

In 330 A.D. the emperor Constantine moved to Byzantium, later known as Constantinople. The Hellenic world of the Mediterranean thus became divided into a Latin West and a Greek East imbued with many Oriental influences. Byzantium was to play a leading role in art, even in early Christian Italy. The new style was born of the encounter of Christianity with Hellenism and the Orients of Syria, Persia, and Egypt. And the influence of the Orient led to the disappearance of the plastic approach of Antiquity. In its place an art grew up that reached its climax in the cupola and the mosaic. Byzantine art borrowed the latter from the Greeks and the Romans but

permeated it wholly with its own style. In the Orientally-influenced mosaics, Christ sat enthroned, bearded, in the splendour of the purple. He was Emperor of Heaven and Earth. Over and above all men, looking toward earth from afar, He was the Incomparable, the Indescribable, and of a terrifying majesty. The human forms were no longer terrestrial. They no longer stood naturally but instead rose up motionless, like monuments, in ceremonial obedience to a supernatural law.

The spirit of Antiquity nevertheless lived on in the broad, simple gestures, the silence, and the calm stare; in an indefinable nobility and majesty. It survived, indeed, because of these figures, in front of which the people could pray. Although arrogant in their immobility and Asian in style, they remained primarily Greek because they expressed something that could be transformed, corrupted, or bastardized, but never destroyed. They appealed to the instinct that drove the people to call on the shapes of nature for the education of the spirit. However, the Doric calm and the Ionian smile had deserted them. Terror and anxiety lurked in their staring pupils, and around them the obscurity of the chapels attracted, in place of broad daylight and the limpidity of space, those magic phosphorescences that linger on rubbish heaps and fetid waters. Beyond the haze of burning incense and 10,000 lighted candles, Christ, Pantocrator, the Virgin, the apostles, and the saints crowned in gold and dressed in glowing robes retained their distance.

All the blood sweated in the Middle Ages, all the gold amassed, smothered Constantinople. Its part was played. Other centres were coming into focus. Islam was nearing the summit of its glory. And since the end of the 11th century, the muddied waters of the Crusades had been flowing eastwards from Europe. The Barbarians from the West threw themselves on the fabulous cities of the East, as those of the North had marched on Rome. One hundred years after pillaging Jerusalem, city of the Infidel, the Franks were looting Christian Byzantium. Europe threw down the barrier that protected her from Asia.

Roman art recovered its original aspect in Romanesque art, at the hands of its naive Gallic and Germanic inheritors. (In this context it is not out of place to reflect on the fact that the typical ponderousness, simplicity, and monumental aspect of Romanesque art were part of an imperial, hierarchical period; that is to say, a period governed not only by an emperor, but also by a highly organized church, based on an hierarchy of powers. We find herein certain similarities with Roman times—not only with Rome, but also with the forms of the old Orient. Nevertheless, the Christian spirit conferred on the Roman style both rhythm and humanity.)

The encounter between the Barbarians and the tra-ditions of Antiquity was the source of considerable tension that gave birth in primitive Roman sculpture to works of a bewildering nature. The master who created the capital decorated with Salome remained, despite the delicate intertwining of Byzantine influence, a man of an animal violence. The master who carved the tall stone figures that decorate the royal portal at the cathedral of Chartres was quite another. These subjects, whose bodily height is equal to at least nine or 10 heads are, in a manner of speaking, freed from the burden of the flesh. They are little more than garments of stone with long aristocratic folds the purity, dignity, and elegance of which have become the infinite expression of life in the Holy Spirit. The figures are motionless, vertical, and shown straight on, not for reasons of Archaic strength but to give an air of Archaic humility by means of an attitude of profound spirituality. Their backs are to the wall, like tall candles.

The sculptures in Bamberg Cathedral—the most beautiful of late Romanesque art in Germany—marked the culminating point of Romanesque art in the German Middle Ages. They date from about 1250 when the Romanesque period gave way to the Gothic. Contrary to appearances, there was more to Gothic sculpture than works on church portals; throughout its development, it showed a steadily increasing leaning toward sculpture for its own sake and ceased to be an integral part of the wall but partly detached from it. The important masters of German carving, Veit Stosz, Tilman Riemenschneider, and Michael Pacher, made their appearance. In France of the 15th century, the tomb of the knight, Philippe Pot, was a masterpiece. This admirable work in stone shows the mourners carrying the dead man, his head hidden, but with his military equipment restored to him. The finest equestrian statue of Gothic Italy was that of the tyrant of Verona, Can Grande della Scala. The master of Pisa, Giovanni, known as Pisano, worked in the last quarter of the 13th century and the first of the 14th. He created, at Prato, the Madonna for the Arena Chapel at Padua. Although he did not deny the eternal Italian Classicism he came close to the Gothic spirit.

The path trodden by Gothic sculpture led to naturalism, a development in keeping with the increasing autonomy of the sculptural form and the popularity of wood as a material in the late Gothic period—it was more personal in character than stone. This naturalistic development was also to be seen in the representation of the human nude. It is true that the Romanesque Christ had already been shown naked, but only toward the end of the Romanesque period when it was in transition to the Gothic style.

The representation of the nude attained a high degree of formal perfection in the carvings by Riemenschneider who was already indicating the grain of the skin. But Gothic

art never attained a Classic naturalism. A certain stiffness that could be termed Gothic tension persisted. Nevertheless it was a tension of marvellous beauty for it was a sign of human longing for a spiritual God in a distant hereafter, and of the human anguish endured for this God. Its origins were metaphysical and represented the search for a supernatural meaning in Christianity.

In the painting of the Middle Ages we can also see the same development as in its sculpture. Early in the Romanesque period, the fresco was added to the mosaic and these two arts evolved parallel to one another. Although the North possessed both Romanesque and Gothic frescoes, it developed its own style of applying decoration in colour to the wall: stained-glass windows.

Italy continued for some time to be dominated by the Byzantine influence. This style, with its solemn breadth and rigour, yet with its delicacy too, was still a feature of the paintings of Cimabue at the end of the 13th and beginning of the 14th centuries. As in mosaics and illuminations, backgrounds were gilded. Faces were not individual and figures were almost abstract: it is difficult to believe that there were living bodies beneath the fine folds of the robes. The hands of the Madonnas were as if carved in ivory. But even before Cimabue, Giotto had started to free Italian painting from the Byzantine influence. He based his work on direct observation of life and his figures, modelled on the bourgeoisie of Florence, moved and turned naturally. The profiles were distinct; each face was individual and personal.

Chapter VIII. The Conquest of Reality
The Renaissance, Baroque, and Rococo

▶ The Renaissance began as a movement led by artists and intellectuals in Italy. Ethically as well aesthetically they freed themselves from the ties of the Christian conception of life. To them art was no longer an anonymous service, rendered to God and the Church, but a very personal hymn in praise of beauty; so, for the first time in history, the person and life of the artist assumed significance.

The pivot of the Renaissance was Florence. Naturally, painting was not completely freed of the Gothic influence in an instant, but gradually there evolved a new conception of beauty. Bodies adopted their natural forms and became plastic. Tommaso di Giovanni di Simone Guidi, better known as Masaccio, gave them fullness and substance. Facial expressions were particularly studied and from time to time revealed the darkest troubles of the soul: the despair of Eve in Masaccio's "The Expulsion of Adam and Eve from Paradise" is unforgettable.

At the beginning of the 15th century the portrait came into fashion. The upper classes sat for artists and sculptors to be portrayed in a bust or on a medallion—a large number of highly individual personalities were captured in wood carvings. Not only did man's appearance change, but his character also; eyes lowered in humility and submission gave way to expressions of defiance. On these energetic faces the spirit of the age of the condottieri is clearly visible. This naturalistic trend encouraged even the monks to claim their right to a life of the senses. The sensuality of Fra Filippo, for example, explains why his pictures have almost nothing in common with those of Fra Angelico da Fiesole. Only a few works of his youth hold something of the divine love painted by Fra Angelico.

The Gothic style of the painting of the Middle Ages was preserved only in the North. A painter like Stefan Lochner was still close to the spiritual love known as mysticism. Martin Schongauer, in his famous "Mother of God" in the church of St. Martin at Colmar, continued the style that he had already used for a Mary with Child and a flowering shrub. Everything in these paintings expresses love. There is an atmosphere of profound humanity.

Among the proliferation of Virgins and saints were very few nudes. Only with exceeding discretion did a reflection of worldly sensuality succeed in stealing into Ecclesiastical art—representations of sin or martyrdom for example.

Tradition permitted the symbolic representation of vices and perverse desires, but unambiguous delineation of the sins of the flesh first appeared on the fringes of large, decorative scenes and in the margins of illuminated manuscripts where the artist had always been less constrained. The 14th century, all-faithful to the teaching of the Church, chose to represent them by means of the unclothed body of a woman.

Many saints had been tortured and painters illustrating their lives eagerly depicted their sufferings in detail. Blood and torn flesh abound in the art of this period. In about 1425, Master Francke was working in Hamburg and Lubeck for the religious brotherhoods. His patrician clients, the most uncouth of men who had grown rich on the maritime trade of the Baltic and the North Sea, nevertheless discerned the qualities of elegance that gave the Parisian courts their brilliance. This was why Master Francke decked out the executioner like one of the Three Wise Men; but he also undressed the princess. By means of her youthful body, stripped for the whip and the knife, the notion of worldly pleasures crept into the devotional images. But the voluptuous life was obviously included among the vices. The beauty of the Devil, which the artist did not depict without a certain uneasiness, was revealed in the scenes of sensuality. However, in the scenes of "nature"—that is to say those in which he had to show bodies free from sin as God had intended when creating Man and Woman—the artist was allowed a greater licence in portraying the perfection of the human form. And some religious themes could very well serve as a pretext for extolling the flesh.

About 1400, the household artists of Duke Jean de Berry managed to link the linear decoration of the Parisian aesthetic with the charms of Classical Italy. Thus, in the "Garden of Paradise" of the "Très Riches Heures", the Limbourg brothers' exultation in the joy of this newfound freedom was expressed in the suppleness of the adolescent Adam and in the body of the blonde Eve.

Jacopo della Quercia saw the Eve of the Temptation as strength and not charm. In her body he glorified the rustic robustness of the mother goddesses, and all the vital forces that can be felt arising in the earth. The work of Piero della Francesca was also distinguished by a certain terrestrial clumsiness of which the "Madonna del Parto" was characteristic. While angels drive away the keepers

of a tent, a pregnant woman within, halo-less, places her hand in a magnificent gesture on her sanctified belly.

The two double portraits he painted of Frederigo da Montefeltre and Battista Sforza are considered to be the first in which perspective and space replaced the sculptured relief. He was thus able to give his profiles a greater precision. Behind his figures, to shoulder height, stretches a landscape that takes up a third of the surface area. It is a vast, flat, country scene, above which stretches a sky of a luminous blue. A decisive step had been taken—the portrait, until then closely bound to the style of bronze medals, was freed. Piero localized his portraits, placing them in defined space. The school of Gaudenzio Ferrari brought other innovations. There is an "Autumn" of Francesco del Cossa showing a peasant girl, her skirts tucked back, holding a spade and fork, with clusters of ripe grapes on her shoulders. She stands alone in the field like a statue, a proud image of labour.

Andrea Mantegna, a contemporary of Piero's, painted in the north of Italy and was remarkable for his research into perspective. Piero had already turned his attention to the theory of perspective and had expressed his concepts in his paintings. But with Mantegna, this problem of perspective became a passion. His fanaticism went so far as to make him thrust aside, or forget, the religious aspects and to use the sacred figure of the dead Christ to demonstrate a purely aesthetic problem.

Christianity thus played only a secondary role in his work. As far as was possible, he transposed Christian subjects onto a pagan plane. He resuscitated the world of Bacchus, the gods of the sea, and the fauns. Tritons blow on their trumpets of shells to soothe the waves, while beautiful women ride on the backs of Centaurs.

By turning away from Christian subjects to themes from Antiquity, Mantegna became the first to study movement in naked bodies; he was the first to show the contraction and extension of muscles. In particular, his engraving of Hercules strangling Antaeus must have been a revelation to the artists of his time—the nude figures that crowd together and are intertwined so vigorously had never before been painted with such realism.

Mantegna's followers continued to paint nudes in which the naked body was painted for its own sake. Antonio del Pollaiuolo also drew a Hercules fighting with Antaeus. Movement and violence were again shown with ease and vigour. Pollaiuolo "understood the nude", explained Giorgio Vasari, the 16th- century Florentine artist and historian, "better than any other of his predecessors, because he had learned anatomy at the dissecting table, and he was the first to reproduce the play of muscles faithfully."

This phase was brought to its climax in the 15th century by Luca Signorelli. In one picture we see the ruins of a triumphal arch with two men and two adolescents naked in the foreground. Nude adolescents, standing, seated, or recumbent, that are to be found even in works where they have not the slightest reason to be, are tantamount to Signorelli's signature. In his most famous work, the series of the Capella Nuova in the cathedral at Orvieto, executed when he was 60, we witness a grandiose and imposing recapitulation of all his researches. His strength approached the colossal in the "Last Judgment" which is peopled, almost entirely, by nudes and in which he was in no way hindered by restrictions of size. The whole "Dies Irae" was transformed into an anatomy theatre. "Hell", the last painting in this series, became an exhibition of athletes. The spirit of the Renaissance was awakening in Signorelli's figures—their destiny was not submission to Heaven but a struggle with life. It is difficult to realize that only one generation separated him from the period of Fiesole and Lochner, and that Memling was still painting in the North. The quest undertaken by Mantegna and pursued by Pollaiuolo reached its apogee in Signorelli. His works were the most vigorous representations of the nude in the history of Christian art until 1543, when Michelangelo's "Last Judgment" was unveiled in the Sistine Chapel.

However, in 1470 a new epoch had already begun under the patronage chiefly of Lorenzo and Julius de Medici. The lively portraits accurately represented their young, slim, elegant models. "Allora bellissimo giovinotto" was how Vasari described the male figures at the end of this century. The previous character, energy, virility, and defiant strength were superseded by a feminine grace and charm. Women were preferred with downcast eyes that gave their expressions the wistfulness of a most aesthetically affected fatigue. Enigmatic inscriptions such as "Noli me tangere" remind us that these youthful beings were only delicate flowers. The athlete was replaced by the intellectual, strength by elegance and refinement. After Michelangelo, sculpture returned to smaller dimensions.

The irreproachable technique and perfection of naturalism of Benvenuto Cellini did not reach the heights of sensibility despite his being a prince among founders and goldsmiths. He was a virtuoso in art, as he was in life. His fine autobiography shows us the brilliance and the triumphant flexibility of Cellini the man.

Between the late Renaissance and the early Baroque, Giovanni da Bologna, a Fleming from Douai, was a pleasant, second-rate sculptor. But the figures in his fountain of Neptune at Bologna are no closer to touching the heart than are the langorous or exaggeratedly slender women of the fountain in front of the Palazzo Vecchio in Florence.

At the time of Lorenzo the Magnificent, paintings of the Madonna were fashionable pieces. Mary had become a woman of the world and able to clasp her hands most elegantly. The subject of Tobias also made its appearance. Since adolescents pleased, the young Tobias was often portrayed holding the arm of the angel for protection. Although the "David" of Donatello retained some of the rustic grace of a young shepherd, that of Andrea del Verrocchio (like Cellini, a smith) was a refined young aristocrat. His delicate hands, his unmuscled arms, and his long, soft thighs have an effeminate grace, later the ideal of the da Vinci school.

Sandro Botticelli gave flesh and bones to the dream of that glorious century. Before him, the only woman shown naked and life-size, was Eve. But Botticelli broke with tradition and painted the Greek goddess of love in the scene, described by Homer, where Aphrodite, born of the sea-spray, was carried by the breeze to the shores of Cyprus, to be welcomed by the goddesses of spring. Nevertheless the atmosphere is perhaps not quite fitting to the subject as there seems to be contradiction between the symbolic and joyous legend painted by Botticelli, and the melancholy with which he worked. We feel no Olympic serenity, but rather Christian melancholy. The ancient concept of beauty was again opposed by Christian asceticism, and at the end of the 15th century these two forces clashed more violently than ever. At the beginning of the century of the Medicis, no one thought very seriously about heaven, hell, or purgatory, and Lorenzo's words, "Facciamo festa tuttavia", expressed this attitude very well. But then a shadow of doubt appeared and the Dominican friar, preacher, and reformer, Savonarola, became the vehement witness to the spirit of the times.

It is claimed that Leonardo da Vinci ridiculed Savonarola in the cathedral at Florence where, in 1495, thousands of the faithful had crowded to hear him preach. Leonardo alone remained standing when everyone else fell to their knees. Although this story is not historically accurate, it is nevertheless in keeping with Leonardo's attitude. After a period of renunciation he gave back to men the right to self-enjoyment. When he painted Saint John, he did not depict him as an ascetic in the desert living on locusts, but as a radiant young man who stands out from the obscure depths of a mysterious cave. A crown of vine leaves surrounds his head. In his hand he holds the rod of Thyrse. The locust-eater of the Bible becomes, under Leonardo's guidance, Bacchus or an Apollo who, with an enigmatic smile on his lips and with his slim legs crossed, stares at the spectator in a disturbing manner. Leonardo removed the sad, ascetic, and pessimistic aspects of art and restored to it the joy and serenity of Antiquity. His Christian figures were imbued with the spirit of Antiquity.

Correggio, although the most limited, is the most appealing of all those who gathered round Leonardo. His Christianity was touched with an earthly gallantry. All the figures rejected by Savonarola returned triumphant. Only those paintings in which he turned away from religion to praise the greatness of love, are truly his. The inner discords between the theme and the spirit have disappeared. Inspiration is human rather than divine. In the picture of the tormented but delicate body of Christ on the cross, some would claim to read Eros, instead of the inscription INRI.

His "Danaë" is a small, fragile, and responsive Tanagra-like figure reclining on a white couch; ready to be loved she smilingly allows a Cupid to remove her shift. Apart from Correggio, the Rococo painters (18th century) were alone in painting the graceful movements of a young girl's body with such pleasure. Correggio's sensuality, however, became somewhat mannered in the later paintings by Parmigianino of Parma. But he was a master of charm and subtlety—one only has to think of his "Madonna con Figlio e Angeli". The charm of the Madonna and the indeterminate sex of the angel are proof of a refinement that came with Raphael but is here exaggerated. One of the angels is staring at the little boy's sex. The Madonna, whose over-delicate hands scarcely touch the young chest, seems to be floating rather than sitting.

The most vigorous personality of the Venetian Cinquecento was Titian. In 1516, at the age of 39, he was the official Venetian painter, a position he inherited from his master, Bellini. His favourite background was a landscape on a sunny day in October with its gentle light, warm colours, and ripe fruit. His predilection for the autumn of the year was echoed in his preference for twilight. Titian's favourite hour was the evening when everything is bathed in a deep harmony of colours. His feminine ideal corresponded to this. For, although they are not autumnal, the vigorous women who never seem to languish and who radiate eternally an impressive beauty, nevertheless in their full-blown magnificence do not suggest the spring but rather the height of summer. He painted the proud brilliance of woman in her maturity.

The profane spirit of the Cinquecento celebrated its final triumph in the art of Veronese. In his decorative paintings, naked, vigorous creatures in audacious poses fill the niches and are stretched out along the cornices. Graces and Cupids frolic around Venus, joyous fauns crowned with vine leaves surround Bacchus. Christian and pagan motifs, naked and clothed figures, were all mixed together. The women in his portraits are of a vigorous, triumphant beauty surrounded by heavy damask and golden reflections; their blonde tresses are bedecked with diamonds and their necks hung with sparkling jewels.

Raphael and Michelangelo are difficult to place in the history of art for it was they who directed it much more than it influenced them. Michelangelo marked the transition between the Renaissance and the Baroque while Raphael remained Classical; and although Michelangelo created his last works when Raphael had been dead for more than 40 years, Michelangelo's work influenced that of Raphael.

Raphael was the last Umbrian to go back of his own free will to the subjects of Antiquity. Sienna, where he was an assistant to Pinturicchio, had one of the finest sculptures of Antiquity known to the 15th century—"The Three Graces". Raphael drew it and then, from the drawing, painted it. In the little painting, "Apollo and Marsyas", the Antiquity of Umbria appears timidly fragile. The figure of Apollo is marvellous.

Michelangelo devoted himself above all to portraying the human nude. The nude and art were equally important to him and, as he was essentially a sculptor, painting gave him the chance of conjuring up a whole world of stone beings. Mostly his figures were male and when he did create women they were devoid of charm. For him, woman was either the original mother, as in the flood, protecting her offspring like a lioness, the food-giving figure with powerful thighs, or else the man-woman like the Fates or the Cumaean sibyl, whom he showed with well-muscled arms and the face of a man.

Whenever the subject permitted he avoided introducing the female body. Just as women had no part in his life, not a single woman is to be found among the slaves of the Sistine Chapel. Michelangelo only appreciated the beauty of the male body. The eternal feminine that Titian and the masters of Leonardo's group had extolled was set against the eternal male, not in the hermaphroditic beauty that certain paintings of Sodoma show, but in the form of muscular men with mighty chests, arms of steel, and legs like marble columns. To find something similar in Antiquity, it is not to the easy forms of Praxiteles that we must return, but to the solid bodies of Polyclitus. However, even in the male figures it was rare (Bacchus perhaps excepted) for Michelangelo to consider his model with a joyous sensuality. To state that, when he portrayed male beauty, he was continuing the tradition of the Quattrocentists, Pollaiuolo and Signorelli, does not mean much. Ultimately, it was not the human being or the nude that counted for him, but the form which he thereby expressed.

With Michelangelo it is not enough to note that he used the subject of the Last Judgment only to show naked bodies in all possible positions. His Christ is not a Christ but a mighty Olympian, a sort of thundering Jupiter with a colossal body and the head of a Nero. The Devil and the angels are the agents of divine punishment. No matter how powerful the gesture of Christ, like a flash of lightning piercing the universe, the condemned are not struck down. Michelangelo could not conceive of humility, fear, servile submission, or acceptance. No matter how powerful this all-powerful God, the athletes challenge Him. They do not yield. They know neither repentance nor submission. They come nearer and nearer in increasingly serried ranks, their bodies becoming more powerful and gathering into a mass of an incredible strength. These are not sinners meeting with the retribution of their acts but rebel giants who are assaulting Heaven. In his hands, the Christian punishment became a twilight of the gods, a scene from the end of the world.

Michelangelo's sculptures were close, to begin with, to Florentine realism. His well-known "David" still retained something of the precision of the style of the Florentine sculpture of the Quattrocento. However, in the sculpture of the great Donatello, who liked rigid forms, there was at times a momentum that even became excessive as, for example, in the exuberance of the young musicians in the gallery of the cathedral in Florence. So it is scarcely surprising if this marvellous quality that was soon to fill the whole of his being—the sense of the infinite—was already apparent in the young Michelangelo. His tomb for Pope Julius II was to remain unfinished; that of the Medicis at Florence did not attain the immensity of the original plan. His work remained unfinished because it surpassed the bounds of the society in which it wished to participate.

The inclusion of France in Renaissance culture was due to Francis I, who ruled over Genoa and Milan. It was he who invited Leonardo to France and ensured that his stay there should be worthy of his old age. French 16th-century painting was neither very rich nor very important. The two Clouets stood out as portraitists. The first two great masters of Classical art, Nicolas Poussin and Claude Gelée or Lorrain, succeeded them, but their work was the art of French Romans. They spent their whole lives in Rome; other French artists, too, owed at least a part of their artistic culture to the South, for instance Jean Goujon, one of the most important sculptors of the French Renaissance. Nevertheless, his two main works, the "Fountain of the Innocents" and the "Diana with Stag" were typically French works. The extreme elegance of the figures is obviously Parisian, and his art reveals a degree of kinship with the Mannerism of the School of Fontainebleau. We find therein the same charm that typified Primaticio's female heads.

A celebrated sculpture of Diana came from the School of Fontainebleau during the time of Diane de Poitiers. Diana, accompanied by her dogs, is off to the chase, bow in hand. She does not possess the powerful limbs of the Italian heroine, but instead is slim and supple with long

legs. Poussin's subjects, in contrast, seem much more "primitive" and less mannered. They were serious and dignified even though portrayed against a pastoral background in all its pagan magnificence. Handsome, naked figures crowned with laurels and roses reclined in the meadows or took their places, draped in light garments, for a dance of measured, aristocratic tread.

In Italy, the Renaissance was a period of republics and of tyranny in the towns. In France, it marked the culmination of a despotism that subdued the whole nation. And what happened in the France of Francis I also occurred in the Spain of Philip II.

The Renaissance brought a change in spiritual life and fresh artistic inspiration to the Northern countries. Yet does Jan van Eyck belong to the Middle Ages or is his art the first great triumph of a Northern Renaissance? This is a question very difficult to answer. The subject of his altar at Ghent was Gothic—as was the severe Christ by Rogier van der Weyden or the piety in the faces of Flemish paintings before 1500—but his "Adam and Eve", in their frank nakedness, were the first big nudes in the history of Northern painting. The painters in the North had no knowledge of Antiquity and had no chance to see the beauty that life in the South offered the eye of the artist. The man from the North who removed his clothes was undressed, rather than naked. The rhythm of spontaneous movement was lost. The nudes of Jan van Eyck would seem offensive to an eye accustomed to Italian Classical statues and paintings, and he did nothing to lessen this impression. With unbounded respect, he contemplated the poverty of human nature as he saw it in his country. In "Adam and Eve" he painted two nudes in the pose automatically assumed by models when nudity is something strange to them. Adam, as well as Eve, hides his nakedness—and before the Sin at that. He has a bony chest and the large hands of a worker. Eve has shrunken breasts, pointed knees, sinewy legs, and a heavy, wrinkled belly. Moreover, van Eyck painted the wrinkles on Adam's neck and the hairs on his chest and legs. In all ages, art has respected the tradition of not painting the female pubic hair but van Eyck seemingly painted with care every hair on Eve's body.

Hugo van der Goes' Eve was not beautiful either. Her legs are thin, her hands and feet too big. Nevertheless there is a sensual affection in the painting of the hairs on the body and the sweet curve of the breasts. But this artist was fascinating only to Italians. The agent for the Medici house at Bruges, Tommaso Portinari, had the birth of Christ painted by van der Goes who included his family as well as his religious patron. The figures of the Virgin and Mary Magdalene, dressed like princesses in grey dresses embroidered with gold and shimmering white damask and wearing tall, gold-embroidered headdresses, are unbelievably beautiful. An indefinable charm emanates from their nonchalant stance and their silent, aristocratically pale little faces; their lips are delicate and the graceful curves of their fine eyebrows set off their dark-rimmed eyes. It is precisely this Gothic line, this reserve of movement, and these slender column-like bodies that charm.

Although the painter Hans Memling cannot really be compared with Jan van Eyck, he has the unwieldy psychological strength of his master, Rogier van der Weyden. The saints in his "Last Judgment" are absorbed in their meditation, pale, dreamy, and exhausted. The same enervated, reflective tenderness was extended to them all. Memling's Eve is quite different from that of van Eyck. He did not give her a large face with sleepy eyes, straight hair in wisps, and big hands, but instead showed her as a delicate little woman with a sweet face, budding breasts, and slender fingers.

In the Dutch Low Countries the spirit of the age that we call the Renaissance asserted itself in economic, social, and artistic life in the 16th but even more so in the 17th century. In painting, a change in taste appeared that can be seen in a picture by Mabuse (Jan Gossaert) in which there is a temple in purest Renaissance style decorated with angels and with a statue of Apollo of Antiquity. The life-size nudes that Mabuse created toward the end of his life show how deep was the feeling this painter from the North had for the forms of the Renaissance. The passage from one style to another can be identified in his painting of Adam and Eve. The background consists of an extremely detailed landscape wherein can be distinguished bodies painted wholly in the style of the Cinquecento. Eve gently takes hold of a branch of the tree; her hips and breasts are smoothly rounded and her hair ripples down about her shoulders. The transition from straight to curved lines has been made, and in the painting with the figures of Neptune and Amphytryon it attained fully the desired effect. The figures stand out from the pillars of a Greek temple with the vigour of a marble group of Antiquity. Not only is the architecture of this scene of Classic simplicity but the figures have lost all Gothic complexity in the dignity of their movements. Even if these nudes could be said to be a little lifeless, almost academic, it should not be forgotten that nudes of such plastic forms had never before been painted in the Low Countries.

The revolutionary temperament of the German 16th century is strikingly confirmed in the Grünewald crucifixion. This panel of the big Isenheim Altar triptych at Colmar, Mathias Grünewald's main work, no longer showed the elegant, almost aristocratic, crucifixion of Gothic art, but a crucifixion of a strength wholly of the people. The violence of expression was also revolutionary

in its pitiless, undisguised, intentional realism that descends to brutality. The weight of the crucified body drags it downward, the fingers are clenched, the legs swollen. A crown, bristling with thorns, is driven into Christ's head which rests heavily on His chest. The feet are twisted and the body covered with bleeding scratches. The yellow-greenish tones of the body are so realistic that one seems to smell the odour of decomposition. By comparison all the Italian crucifixions were mere theatrical backdrops.

Hans Baldung Grien displayed a joyful sensuousness in his figures by allying a certain Germanic coarseness to a Roman sense of sinuous beauty. He painted nude sorceresses or Graces—strange pictures in which, in allegorical form, appear opulent women with mirrors, snakes, musical instruments, and cats.

High, rounded breasts and extremely long legs gave Lucas Cranach the Elder's female nudes a special charm and great elegance; their large feet and ears may seem odd to us, but diminutiveness of these structures was probably not yet a mark of beauty. Cranach's bourgeois refinement led him to create an over-affected style of female nude: slim, unambiguous, intriguingly sensual, and charmingly perverse. He retained something of the appealing awkwardness of the Gothic style with nevertheless an appetizing foretaste of sin.

But, in general, German art was little interested in the nude, partly for lack of opportunity since nudes could only be painted in the martyrdoms of saints, and partly because models were difficult to find—moral prudery in the North thus had a restraining influence on art.

A journey to Italy, however, gave Albrecht Dürer the chance of observing the beauty of the Southerners and, typical of the man, immediately after his return he painted the two life-size nudes of Adam and Eve. They are both thoroughly German but he could never have painted them without his visit to Italy. The enjoyment he took in painting the nude and the rhythm he attempted to introduce into these two figures were very Italian. It suffices, if we want to understand their significance for the North, to think of van Eyck's two figures on the altar at Ghent.

Dürer brought liberty and movement. Before his time, German art had coloured the body in flat areas, but, like Verrocchio, he attempted to show the plasticity of the human frame and to introduce effects of contrast and harmonious interplay of lines into the movement. The motif of the standing figure was the starting point. The concave line was emphasized by Adam's broad shoulders and the extension of his left leg, while the convex was underlined by the broad hips of Eve and the curve of her leg. The unwieldiness of van Eyck had given way to a sensitive movement of the arms. Dürer also revealed the influence of Leonardo in his introduction of something quite new in the facial expression. Van Eyck's Eve is a model holding an apple who understands nothing. In Dürer's painting a fleeting smile plays on her lips. She, the beautiful temptress, is contemplating an Adam who while still hesitating is already desirous. His half-open lips are greedy and impatient. But it was in the sinewy line of the drawings of Urs Graf (a Swiss) that this innovation was pursued to the limits of the Baroque.

Tintoretto, a product of Titian's studio, was the first to go beyond this limit. In his early paintings he appears as a master of the Renaissance. He painted the dazzling nudity of the young female body and, like Titian, used light to model the plasticity of the fine forms. Later he played with the figures as one might with a rope—bending them, throwing them into the air, turning them about, and painting with enjoyment as they plunge down head-first. Tintoretto was also the first to treat the subject of Susanna bathing that was to replace, for the Baroque period, the Zeus and Antiope of the Renaissance. Susanna is seated, her limbs complicatedly twisted. Her left foot is still in the pool, her right leg raised toward the bank. Her tall, opulent body flooded with a pale light, stands out distinctly from the darkened landscape.

From the time when he settled in Toledo, El Greco broke all ties with Italy where his work took shape. Only rarely did he paint a female figure; mostly it is princes of the church, priests, and monks who are to be seen. El Greco's inheritance from Greece—he was born in Crete—is apparent in his "Martyrdom of St. Maurice". The bodies in this painting are as plastic as those in an Antique relief. Their beauty is the innate nobility of Antiquity, a beauty from before the Fall of Man. The figures of the Theban Legion, a multitude destined to die, stride naked. The bigoted King Philip II did not know what to make of this pagan joy in nudity and, according to the historian Siguenza, he was displeased with the painting.

In the "Laocoön" the male figure acquired such a vital intensity that, as Vasari wrote, it "does not appear to be painted, it seems to be alive". Nudity was even more powerfully represented in the figures of the martyrs in the "Vision of St. John the Divine" with its apocalyptic motif and its passionate, tragic earnestness. The martyrs, having heard the wild call that makes the world tremble, cry out "How long, O Lord?" The violent gestures of the arms stretched heavenwards write their tragic message against a flaming sky.

Jusepe Ribera, who was born near Valencia and came from the school of Ribalta, settled in Italy. He is known particularly as a painter of torture, and the dismal inquisitorial spirit of the Spanish hierarchy was expressed with great violence in his paintings. He also painted the crucifixion in brutal detail—a soldier is about to carry off

the body while one of Christ's hands is still tied with rope to the cross. It was paintings of this nature that offended tastes moulded in the Renaissance school.

Since the forms of the nude were in no way beautified, Jacob Christoph Burckhardt, the 19th-century art historian, was able to write that it was a coarse galley slave who was attached to the cross. And yet what strength has gone into the drawing of this naked body. If Ribera's style can be called "realistic" the secret of the effect produced by his painting lies above all in its sobriety—although one must give credit to a certain realism. He immortalized the monks of his country in paintings as Classic as those in which Tintoretto immortalized the doges and procurators of Venice.

Diego Velázquez continued in the "naturalistic", popular tradition of Ribera. He was the favourite painter of the royal court. He painted maimed figures and dwarfs. One of the first, if not the first, Baroque painter, he also depicted the simplest tasks, such as water-carrying and spinning. His portraits of princesses were masterpieces of painting pure and simple, but he did not paint these little ladies of the royal line with the warmth of a human heart. He did not look benignly upon their small figures—so touching in the unchildlike rigidity of their courtly stance. He was only a painter—and a somewhat impassive fanatic of the craft at that. The uncharitable Velázquez sacrificed, so to speak, these little princesses to his passion. Human existences were transformed into pictorial beauty so that there remained nothing of the living beyond the fine painting.

Flanders in the 17th century was a Spanish province and was considered a stronghold of the Jesuits in the North. An art similar to that in Spain could therefore reasonably be expected there. Yet it is quite the contrary that we find—not a mortification of the flesh but an upsurge of health very much of this world. This seems almost incredible after the puritanical prudery that accompanied the beginnings of the Counter-Reformation. Painters of that period were forbidden to depict the nude. Even the completely sculptural nudity of Michelangelo's "Last Judgment" seemed so shocking that Daniele da Volterra was instructed to cover the figures with draperies. But in the 17th century crowds of naked human bodies, warm animal blood pulsing through their veins, filled the canvases. The Flemish painters were almost more preoccupied with the gods and goddesses of Olympus than with the saints of the Church, and used Antiquity, along with Christianity, to exult in the flesh. A consequence of the new Catholicism's sterile exaltation of the soul was a nostalgia for the body.

There is a painting in Vienna by Peter Paul Rubens—the man who fused the two worlds of the Renaissance and the Counter-Reformation that had till then been distinct—called "The Hermit and Angelica Sleeping". It shows a hermit, prompted by sudden desire, gazing upon the opulent body of a woman stretched out on a white couch, and gives an excellent idea of the spirit of the age. Rubens, whose imposing strength and bombastic vitality were well able to glorify the sensual aspect of nature was born into this atmosphere. His "Kermesse" can be taken as an introduction to his work. In this painting, men and women are gathering for a wild orgy, not indoors, not even on the threshold of an inn, but in the open air. In the frenzy of the dance one of the men has put his arm round a woman's waist; another is joyfully tossing his partner into the air; a third has taken hold of his girl, pressing upon her with arms, legs, torso, and lips; while a fourth has flung his partner to the ground and is about to throw himself upon her, like a wild beast. Rubens has transformed the clumsy peasants into satyrs.

The same plump heroines with their straw-yellow hair, blue eyes, and powerful thighs were always present. Correggio, Titian, Domenichino, Albani, and Guercino had all attempted to show Diana as a slender Amazon—not so for a moment did Rubens. He painted her at the chase, spear in hand, as plump and unmuscled as his Venus, as if she were more used to reclining in deep cushions than to hunting. Bacchus is a bloated drunkard. Even Ganymede, carried off by the eagle, has the plump haunches of a woman. Oceans of gigantic women roll over Rubens' canvases. Greedy, avid children suck at the breasts of their intoxicated mothers. Fauns, with unbridled appetites, and wildly sensual embraces press nude, white nymphs to their bloated bodies.

When he painted the massacre of the innocents of Bethlehem, he placed the action in front of a sumptuous palace. Wild ruffians, half-naked under their goat-skins, throw themselves, like maddened satyrs, on women who are fighting with Amazon-like strength. Many of the women have uncovered breasts, others are practically naked; thus the scene becomes also a hymn to the full-breasted body and the plump arm.

Rubens' followers were also true Flemish painters, at once sensual and lusty. Jacob Jordaens used the subject of Holocaustes and Pomona to make a tantalizing still life out of horses, grapes, and the naked breasts of women. Only Anthony van Dyck, the youngest of the school of Rubens, was to tread a different path. He chose the scene from the Old Testament of Susanna bathing. In Tintoretto's painting of the same theme the setting is the chilly, ceremonious atmosphere of the court. One of the two elders leans toward the bather with the dignified "grandezza" of a Venetian doge. In the Rubens version, only fighting and savage violence is seen as one elder tears

Susanna's clothes from her while the other, his mouth watering, pinches her. But van Dyck, in place of the plump blonde Fleming, paints a slender, brunette Italian and the two elders are most restrained.

Holland in the 16th century was bourgeois, middle-class, and Protestant, and its 17th-century Baroque was merely a confirmation of this, lacking, as it did, the aristocratic dash of a Tintoretto or a Rubens—there were no writhing bodies thrown into the air or through the clouds. The bourgeois way of life was level-headed, weighty, and solidly, comfortably dull. Was it Frans Hals' Flemish origins (he was born in Antwerp) that encouraged him to rebel against all this? He found his models in circles remote from the bourgeoisie, and chose girls from the harbour, strolling musicians, gypsies, and vagrants.

Rembrandt differed from all previous painters; in the words of Burckhardt "the actual form of things is of little import to Rembrandt, their appearance alone concerns him". Referring to this indifference to the actual shape, Burckhardt considered that no painter ever depicted the human form in such ungainly fashion. Rembrandt shrouded the body in clothes of the worst possible choice and the more he festooned his subjects with jewels the more violent was the contrast between the clothing and the features. The clumsiness in the ordering of the canvas and the disproportions are striking when contrasted with the awe-inspiring beauty of the painting. Burckhardt has drawn attention to the serious faults in perspective and in construction of the human body, but ugliness of form was often added to these inaccuracies. The small, pale-yellow lieutenant in the foreground of the "Nightwatch" standing beside the burly captain is, even in outline, one of the most pathetic figures Rembrandt ever painted. Burckhardt was convinced that Rembrandt was aware of his incapacity to draw a human body correctly, and gave, as an example, one of Rembrandt's numerous unfinished engravings, "The Drawer of Models". In this the naked model is shown barely sketched, perhaps because the master was overcome with doubt at the thought of the deformed being that was taking shape. Among Rembrandt's engravings on Biblical themes is one sheet on which these doubts have been overcome—the one of Adam and Eve. They have dreadful bodies and the heads of apes.

The opinion of Burckhardt that denies Rembrandt any feeling for human plasticity is understandable when we realize that this historian was influenced by the Greeks and the Italian Renaissance (of which he wrote a history). It is probable that Rembrandt was the painter, in Europe, whose conception of the human body was furthest from that of Antiquity. To appreciate his work, the spectator must therefore approach it in a radically different manner. As someone once said, Rembrandt must be considered "a painter's painter". He marked the turning-point in the pictorial genius of the Baroque and in painting in general. There is nothing that essentially links him with Italian painting. Admittedly he began by painting, in the spirit of Caravaggio, the contrast between a directed light and the confusion of darkness, but in time the crude Southern lighting became softer, filtering through fine curtains. It bathed the room with its immaterial presence toning down a colour here or, in contrast, slightly accentuating one there.

This trend can be followed in the painting in which he shows the body of his first wife, Saskia, just touched by the light. True, the attractive woman who stretches like Danaë on a nuptial couch has nothing of the rhythm of form to which the heroic women of the masters of the Italian Renaissance have accustomed us. However, despite Titian, the warm breath of life and the sensual charm of the skin has probably never been painted so well. Consider also the painting in which Saskia, as Susanna, is climbing down into the pool; the figures of Italian contemporaries, such as Guercino and de Dolci, look like models in coloured wax beside this astonishing nude.

The nudes painted in 1654 represent a perfection in painting that even Titian never reached. Rembrandt rendered the material aspect of things, gave an illusion of bodies gilded by light, and makes us feel the breath and the very throb of life; but he also knew how to give the magic of a spiritual atmosphere. "A Woman Bathing in a Stream" shows the total simplicity and the breadth of the brush stroke that models the forms so delicately and firmly. The legs and arms are painted like a lightly gilded surface surrounded by dark, vibrant contours.

Hendrickje Stoffels, his mistress after Saskia's death, posed for Bathsheba who, bathing, has just received the letter from King David and, completely wrapped in her thoughts, allows an old servant to busy herself with her toilette. The nude is shown as a flat surface and not even the crossed legs give an impression of depth, but the interplay of the areas of light and shadow situate the model in space.

Jan Vermeer was Rembrandt's opposite—the Dutchman who was for, not against, Holland. If Rembrandt was more revolutionary than any politician, Vermeer, who spent his whole life in Delft, was the law-abiding Dutchman. He represented the sublimation of Holland in Classicism just as Rembrandt showed a Baroque, romantic, and metaphysical Holland pushed to its limits. In the enlightened Holland of the 17th century the Madonna had gone but Vermeer replaced her by everyday life. The sacred was nevertheless retained, man and matter being bathed in indescribable happiness. An inner space was created in which, on the same plane, the soul and the body

dwelt in harmonious intimacy. Vermeer reminds us, in the world of Dutch Baroque, of a Greek marble from the Classical period; peaceful, dreamily sensual, light, gentle, and exceedingly pure.

Dutch painting left the 17th century having achieved respectability; it then turned toward France. Gerard de Lairassé laughed at Frans Hals who "seeks beauty in fish and apple-sellers". He demanded that the artist acquaint himself with what "the world calls good taste". This good taste was, at that time, the style of the French court, and it amounted to an ennobling of all Dutch art and the creation of the grand style in the manner of Antiquity and the Cinquecento.

Adriaen van der Werff fulfilled this need. In his "The Repudiation of Hagar" Abraham is wearing the requisite Renaissance toga and Hagar is so aristocratic that we could imagine she had just stepped out of a painting by Raphael. In his paintings of the Madonna, the Infant Jesus had the elegant pose and Mary's breast the eye-catching neckline that are found in the works of the Milanese school of Leonardo.

The splendour of the Baroque was continued in the Rococo. Does any other period lend itself as well to the description "magic mirror of its time" as 18th-century Rococo? He who contemplates the paintings, drawings, and engravings of Fragonard, Boucher, or Watteau, or stops before an engraving by Oudry or Gillot sees merely the smile of a charmed past. The innumerable portraits make history live and breathe. Be it in Nattier, Pater, Chardin, or Roslin we witness the resurrection of 18th-century man.

At the beginning of the century, woman still had the unapproachable aspect and inaccessible grandeur of the Great Century. The serene majesty of her features was fascinating and, although not particularly attractive, she commanded a certain respect. During the 18th century this austerity and grandeur, this strength and will-power, was replaced by charm and grace. The healthiness that put colour into the cheeks during Louis XIV's reign disappeared, and in its place came the pallor of Dresden china. The nose was smaller and the mouth finer, while the neck lengthened as if it were intended to have an allegorical significance. In fact, beauty became less physical; it was not to be found in the facial features but in the spirit that animated them. The look was enhanced by the smile and by a thoughtful air, and the eye became eloquent. The corners of the mouth, the parted lips, owed their curves to a suspicion of irony. The intellect transformed the face and confered on it the thousand and one nuances of sudden fancy.

The spirit of the age modelled woman along the lines of the comedy-masks of Marivaux. She was changeable, whimsical, and dainty; she had good taste, charm, and followed the instincts of her capricious heart.

Toward the end of the century, fashion changed. Piquant charm was replaced by touching charm. Emotions got the better of intellect in Louis XVI's reign. Under the influence of poets and painters, women dreamt of new ideals of beauty. The smile ceased to be contrived and became spontaneous. As a result, the female countenance softened, became more tender and more langorous, and gives us the "lingering drawn out look" that Mirabeau admired so much in his mistress. Madame d'Esparbes even once had herself bled to attain the requisite pallor. Fashion became, as the Goncourts defined it, "virginal and village-like", completely in keeping with the beginnings of Romanticism. Innocent pleasures appeared on the scene.

We can no longer employ the phrase used by the Goncourts to open their work on the 18th century: "a century very close to us". It is not the passage of years that estranges us from that century, but what was still valid for the Belle Epoque, when the Goncourts wrote and lived, is so no longer. The traditions of the 18th century are no longer alive, its aspirations no longer touch us, we no longer understand the genius of the period. We have learnt to decry the charm and frivolity of the Rococo—a mask beneath which much was hidden. But the style of the Rococo was in keeping with its ideal—love. Almost all the painters took womanly activities as the subject for their canvases and, in this sense, it was François Boucher who corresponded best to the taste of the century. He was not only the painter of the century but also an exemplary witness thereof. Boucher kept to the rules of the Rococo; what he sought in the female nude was the essence of pleasure, a refinement of elegance—what the French refer to as "le joli". Prettiness was the soul of his period and he did all that art could to give life charm and brilliance. Despite the wide range of his subjects, his main theme was the mythological nude. To extol the human nude, his life-long dream, he set all Olympus in motion. Phoebus, Thetis, nymphs, and naiads rock on the waves and in the air with gentle, voluptuous movements.

All the same, we can see in his work how the sensitivity of the Rococo differed from that of the Cinquecento. Correggio's goddesses, while possessing nothing of the majesty of Titian's women, were nevertheless women and not young girls. Boucher preferred young girls. At first his wife, a 17-year-old Parisienne, was his model; then, as a result of his connection with the Opera, he found the means to prevent his art from ever ageing. The corps de ballet was very young at the time and only slim, exceedingly slender bodies were appreciated. Boucher was highly successful in portraying the charm of this juvenile beauty with its delicate, wiry legs, dainty waists, and budding breasts not yet full-grown. The details that reflect the

everyday life of these young beings (the hairstyle, beauty spot, pearls, silk slipper) were used by him to highlight their nakedness. While Leonardo considered the feminine nude to be beautiful only when the thighs were tight together, the Rococo took special pleasure in painting movement, including the opening of the thighs. Both legs were raised, or one was crossed on the knee of the other, or one foot was on the ground and the other resting on a cushion. If the Renaissance showed that woman's body harboured many a fine movement, the Rococo made a host of more stimulating discoveries.

The trend continued and the history of the Rococo became that of the wholly corrupt eroticism of the century. Antoine Watteau painted young girls and gallants reclining in meadows, disappearing into the bushes, chatting the while. Disguised as Columbine and Pierrot they weaved many an intrigue in the gentle summer nights. Nicolas Lancret painted the young woman and her cicisbeo caressing each other as they look through some attractive engravings. It was the "Embarkation for Cythera" and when Boucher appeared the end of the pilgrimage had been reached. The saturnalia of ancient Rome re-appeared and with it their "count as nothing all time not spent in pleasure". If licentious activity decreased little by little during the century, the exuberance, nonchalance, and all the grace of the Rococo were still to be found in Jean Honoré Fragonard. The "surprises of love" became an inexhaustible theme—paintings that make of the spectator the secret observer of a titillating scene. He painted the modiste whose tiny foot delights the elderly stroller, or pretty peasant girls unaware of the elegant passer-by who watches them in their erotic nakedness. He gave, too, the impression of looking through the key-hole as when he painted one young girl getting ready to climb into her bath, while another admiringly considers her own nakedness in the mirror.

Fragonard had considerable finesse of colour and knew how to avoid the trivially realistic. His work also sometimes bore the mark of a strange melancholy that could already be felt in Watteau's paintings—a melancholy not to be found at the beginning of the Rococo period. There is a feeling of the joyful turmoil of a carnival drawing to its close.

In the 18th century, Venice also became a city that celebrated the Rococo in intoxicating festivals full of song and flirtations. Giambattista Piazzeta was the first to show the way. Most of his paintings were of young girls at the appealing age, at once innocent and filled with foreboding, when they first move in society. In Giambattista Tiepolo's paintings, too, a different type of woman appears. Only a very old culture, too advanced in years and aware of approaching death, could give birth to such beings in which a royal dignity and sophisticated fatigue, refined sensuality, and Oriental day-dreaming, a wearied look and bubbling exuberance all unite in an irresistible, fascinating charm.

Chapter IX. The Break in Tradition
Neoclassicism and Romanticism, Realism and Impressionism

▶ Francisco Goya's work marked the end of the Rococo and the beginning of the 19th century. His first canvases depicted the themes that were familiar in the French works of the period, but with the painting of the two Majas he made a unique contribution to the art of his country and, indeed, to art in general for the naked Maja was the first modern nude. She was painted moreover in a country where studies of the nude were forbidden, in a Spain that had only one nude—Velázquez' "The Rokeby Venus".

Antonina Vallentin, the Polish-French biographer, described the Maja as a woman with a small, almost square, face: a small, straight, fine-cut nose; long almond-shaped eyes; a pink mouth with an upper lip that makes a perfect Cupid's bow. The Maja is stretched out on a cloth thrown carelessly over a sofa. Her arms are crossed behind her head, which rests on a green cushion. The yellow velvet bolero, with sleeves trimmed with black net, falls back over a chemisette of white lawn, drawn tight, clinging close to her breasts. Her slender waist is bound by a satin sash, the folds of which make reflections of silver on a background of faded rose. White undergarments hardly veil the curve of her hips, the firm young thighs, the flat little stomach.

"The brown hair, with its copper lights, of the Maja dressed, falls in disorder about the almost square little face. A tide of blood is flowing under the clear skin, flooding the smooth full cheeks with a blush. The delicate nostrils are quivering. The rosy mouth is an invitation, melting in sweetness. The brown iris of the long, almond-shaped eyes is drowned in the delight of the senses. There are dark circles under those dewy eyes. The Maja dressed lies motionless, hands crossed behind her head, her body offering itself under its veil of white lawn, the points of her firm breasts showing through her chemisette; her small face is transported with desire.

"A lithe body, its skin the colour of a sea-rose, lies extended on some cushions and a white cloth. The curve of the hips widens out and then draws in, like the edges of a champagne glass, toward the smooth arches of the knees. Mauve shadows gather over the roundness of the thighs, all the light shines on the gleaming satin of the knees. Shadows that are warm creep up under the armpits and through the round breast into relief. The delicate waist of the Maja naked still bears the impress of a corset; her toes seem a little crushed by slippers that were too small.

The Maja is lying stretched out in precisely the same position as the Maja dressed, hands crossed behind her head. But the brown hair with its copper reflections has been recently combed and frames her forehead and her cheeks in well-arranged waves. Her knees are drawn up, the thighs modestly held close together. One would think her all at once embarrassed by her nakedness. Her long eyes are quiet, and tired. A brown shadow has spread over her eyelids. The small mouth is drawn together, apprehensively. A blush sweeps across her cheekbones. The small square face has a closed look; its glance is questioning, either in embarrassment or doubt.

"Between the Maja dressed and the Maja naked there is somewhere, around this green sofa, clothing that has been torn off in haste and scattered in disorder. The Maja dressed is all provocation. She is the shamelessness of desire. The Maja naked is satisfied quietness; in spite of her nakedness, and the abandonment of her pose, modesty and diffidence have again taken possession of her. Here is a piece of audacity without precedent—and it has remained without sequel: a picture before and after the act of love."

It was only after the strangest of detours that 19th-century painting followed the path to which Goya had pointed. At the end of the 18th century an aristocratic culture and style had been buried. The bourgeois civilization that approached had neither; it appeared shabby, ugly, and prosaic when compared with the dash that had previously been cut. It is therefore understandable that few new artists were, or desired to be, interpreters of their times; the majority turned to the beauty of past civilizations. The climate of opinion convinced the artist that he could only create something of beauty if he relied upon existing beauty and imitated it.

Imitation characterized Jean-Dominique Ingres' work. He spoke the language of the Classicists and was reproached for the lack of reality in his paintings. He might just as well have lived at the time of Raphael or of Poussin. In his nudes—for instance, the celebrated Odalisque—is revealed an incomparable savoir-faire. The extreme sobriety of manner with which he modelled the plasticity of the bodies is almost unique in the history of art. He was 78 years old when he painted the "Turkish Bath", but look at the vigour in the subtlety of his eroticism. The bodies are lengthened unwieldily and given over entirely

to pleasure; an atmosphere of infinite passivity and endless awaiting prevails. The enervating intoxication of pleasure weighs heavily over these caressing bodies. How well Ingres depicted the look of divine lasciviousness. His dream was space filled with elongated women all professing the same religion of which they were the high-priestesses, their bodies the altar.

But it was in no way the dream of an old man, for in 1808 when he was 28 he had painted the nude with the charming back and in 1814 had created the elongated body of the Odalisque. He dreamt only of heavy limbs, of gentle rounded forms, and of a carnal robustness. It was this dream and this nostalgia that saved him from Classicism. David's "Romans" are unbearable but Ingres' gods are theatrical figures. Yet, in truth, there is hardly anything to link him with Antiquity except perhaps the joyousness of the bodies. When Classicism is bathed in this joy, it is suddenly animated by a breath of life. "Jupiter and Thetis" are of course ridiculous; but the way in which Thetis' little foot touches Jupiter's toes is magnificent. This touch saves the painting.

Ingres saw only nudes, even in the portraits of women sumptuously dressed. A garment existed for him only as an allusion to what lay beneath and to delineate that if possible. "The Viscountess of Sessonnes" — this magnificent painting represents what? An aristocrat of the period but not, for the moment, imprisoned within her clothes, jewels, and setting? Ingres frees her and restores her to the Classic eternal by rendering her her nudity. How he does it is extraordinary and one wonders at the refined sensuality of a man capable of succeeding in an undertaking of this sort. Most probably, he was not himself conscious of the eroticism of his art.

Yet it is precisely this most traditional and bourgeois of painters, this reactionary who had no fresh contribution to offer, or desire to make one, who appears to us, one hundred years after his death, as a revolutionary. His compositions are considered as bold as those of Juan Gris; they have the latter's iciness under which is hidden the embers of a magnificent eroticism.

How Ingres misled us by saying "one is always in the presence of beauty, when one is with truth". He lengthened woman's body to the impossible because, as he said, "the neck of a beautiful woman is never too long". These are the words of a great lover yet they reflect a modern attitude. Without realizing it, he agrees with Cézanne. Perhaps only the unintended revolutions are real in art.

Gustave Courbet was the first to quit the ways of the idealized plastic and supreme beauty. The movements in his canvases were the most natural of the period. To escape the aristocratic stereotypes he chose themes that, from the outset, excluded the poses of models. He painted young women sleeping—that is, in a position in which the body assumes no pose whatsoever. He painted women stretching in bed, bathing in springs, or being rocked by the waves of the sea. He was capable of considerable mastery in showing off, by means of a background against which the body was outlined, the plasticity of the forms, the charm of a breast, the elegance of a leg, the rounding of a hip, or the richness of a complexion. His nudes suggest the throb of life in a most unusual manner.

Edouard Manet's first paintings were still in the Courbet tradition. In his "Déjeuner Sur l'Herbe" can still be seen a dark-green landscape and a shaded pool. In the foreground, two men and a naked woman are seated. Another woman, wearing a shift, is paddling in the water. The indignation that this painting aroused is difficult to understand today; the public then was incapable of grasping that, for a painter, a white shift and the naked body of a woman could be seen as colour values. Thus they viewed two unclothed women picnicking with two fully-dressed men as an offensive joke (notwithstanding their admiration for Giorgione's similar "Le Concert Champêtre"). The "Olympia Naked" also shocked because Manet, without a thought for the elegant line of the Cinquecento, had set the young girl down naturally, almost awkwardly, as a Cranach might have done.

The admirable quality of Manet's work was that he managed to marry two trends that appeared mutually exclusive. He reconciled Ingres and Courbet—the aristocracy of line with the sensuality of colour. Ingres might almost have painted the Olympia, with her slim, graceful, ethereal beauty. This success of Manet's demanded an unusual, intuitive intelligence, a good deal of understanding, and a breadth of outlook.

Edgar Degas considered Ingres to be incontestably the master in his tradition, and referred to himself as a pupil of Ingres. He had the same predilection for drawing and wished to give bodies in movement their foreshortened and plastic values despite the unaccustomed and irritating perspective. For some time he was on intimate terms with Renoir whose interest in the plasticity of the body he shared but from whom he differed in temperament. While Renoir never tired of praising woman in the simple innocence of her shape and colours, in her natural joie de vivre, Degas often cast on her a critical eye tinged with cynicism as for example in the painting "The Rape" that shows a Zola-like scene, and later on in "The Washerwoman" where the woman is yawning so pitiably. Degas also observed, with the chill of an impassive onlooker, feminine intimacy in the displeasing disarray of a bath. Woman had never been shown before as in the "Pedicure" of 1877; the later scenes of bathing and boudoirs are totally lacking in chivalry. When he wanted to praise

womankind Degas chose examples the furthest removed from nature and the most disciplined—ballerinas in the artificial glare of the footlights or in the chill lighting of an empty practice room.

Pierre Auguste Renoir might have said that his overriding desire was always to paint the human figure as a piece of fruit. He depicted the nude in Hellenistic fashion but without the Classical or mythological overtones; he gave it that quality of the Greek idiom that is born anew into the world with each child. His nymphs were neither mythological nor theatrical in origin; they were Parisiennes—not the types found at the manicurist's or the beautician's, but little salesgirls, maids, and waitresses. Renoir's bathers had pink flesh, radiant in the light, firm breasts and silky hair, blue eyes, and little snub noses; they were shy, astonished, simple, openhearted beings, who appeared to live in a perpetual spring. Renoir's paintings show us life and make us taste, smell, and drink it. Blood flows in the veins, scent is in the flowers, and juice in the fruit. His art was a feast to fertility in which Eros was ubiquitous.

The essence of France, Eugène Delacroix, the 18th century, the Baroque, and the shades of Antiquity were concentrated in the manner typical of the days at the end of his life. Grandeur and purity were linked with the pleasing to a greater extent even than in Boucher's Rococo. In his later years, Renoir took to sculpture; the finest example is a large bronze Venus. For this he drew a sketch, and then had a young sculptor execute the work under his direction. This Venus resembles the protectress-goddess of his entire work and is the most perfect of his output.

Henri de Toulouse-Lautrec also cast a cynical eye on reality. He was attracted by the world of the cabaret, the circus, and the theatre, and felt most at ease in the places on the edge of society. The mocker became enthusiastic in the cabarets of Montmartre. Toulouse-Lautrec's contribution to the history of the human figure was rather special as he was one of the inventors of the star. His posters succeeded in capturing the essential of an individual with such vigour that they turned out to be a very persuasive form of publicity. He exaggerated the contours to the point of caricature, and although his models, adored by their public, were not at first very happy with this treatment, they nevertheless felt that they were being granted a more than momentary fame. When Yvette Guilbert, for example, after a long absence, decided to resume her career as a monologist, she appeared before the public exactly as Toulouse-Lautrec had portrayed her some 20 years earlier. In this way, Europe and America retained memories of the stars of the frivolous, satirical genre (Aristide Bruant, Jane Avril, Marcelle Lender, Loie Fuller, and the famous La Goulue). They resemble venerable characters from Proust and if one were to meet them, they would be like old friends. Their bohemian faces were typical in the eyes of an apparently still stable bourgeois society, on the edge of which these shadowy beings lived, courted but always disdained.

The rationalizing art of Classicism, based on ideas, made way in the 19th century for Impressionism, which was pure sensualism based entirely on the sensations received by the eye. No matter what was under consideration, the appearance always had to be translated independently of intellectual control or experience, as an object that was perceived uniquely by the eye. Among the sculptors, it was Auguste Rodin who came into closest contact with the Impressionist painters; he was a close friend of Claude Monet. He began as an avowed realist, his "Age of Bronze" having even been the subject of a lawsuit as it was believed to have been cast from life. Later on, Rodin followed in the steps of the Impressionists. The way in which they attacked the problem of light led the sculptor to model all the details on a surface, and the perfection with which he managed to animate a surface can be appreciated in his powerful statue of Honoré de Balzac. In it the surfaces were enlarged and the whole became monumental; in it were realized all the objectives of his generation.

This Balzac is without doubt the most impressive figure created within the Impressionist movement, and even beyond it. The poet is shown in the creation of writing, drawn up to his full height, his head thrown back, lost in a fiery vision. His eyes, deep in their sockets, seem to be fixed on the distance. A shock of hair falls forward over his massive, uneven forehead. A broad, fleshy nose overhangs the sensual mouth, while a timeless coat, somewhat unreal with its lack of folds and precision of shape, envelops the burly figure. Neither legs nor arms are visible, and are but barely indicated. The elaborate head rises above this inarticulate pedestal like a spirit issuing suddenly forth from shapeless matter. The whole statue gives an impression of being a disembodied vision, a work born of the light and the mists, the very spirit of Balzac.

Chapter X. The Human Figure Expelled
20th-Century Art

▶ If Maillol were to be in any way related to Impressionism, it would be through Renoir. They shared the same love for the fullness and fleshiness of nature. Aristide Maillol sculpted powerful women, ample as fertile arable land, proud as goddesses of Antiquity, images of a life in full bloom. Their pure, vigorous, naked bodies are the very expression of motherhood. Even the names of some of these women—Floran, Pomona, Wuelle—are evocative.

Maillol's secret was that he never had to fight to get what he owned. He was utterly sincere and lacking aggression and complexes. He existed in total simplicity, free of doubt and torment, under a blue Homeric sky. His animal nature gave itself up freely to sensual rejoicing without shame or remorse.

Paul Gauguin retreated from Impressionism, yet he overcame it by replacing the dissolving of forms with a new decorative ordering that, as a result of the experiments he made in Tahiti, resulted in the attainment of an unsuspected quality. Some paintings of the Tahiti period could be fragments of frescoes in the spareness of the semi-naked figures, their hands full of fruits or flowers, and in the mouth-watering sensuality of their forms. Gauguin contrasted the type of woman that he had discovered in his Eden with the ideal woman of Western civilization. "In our civilization, Eve makes misogynists of us all... Only the Eve which I paint can undress under our eyes. In this condition, yours would always seem immodest and, if she were beautiful, a source of pain and even more..."

When Paul Cézanne painted his own wife while she was still young, about 1870, he gave her a set expression in an oval face—there are Gothic Madonnas who receive the news of the Annunciation in an equally inexpressive pose. All Cézanne's women have an unapproachable aspect, for he was frightened of women and his secret resistance led him to change them into symbols. In the last period of his work he created compositions of men and women bathing under the trees; Arcadian-like scenes in which he expressed his need for scale. "We have forgotten how to compose", he complained, and recalled, as something marvellous, the naturalness of the composition and of the subjects in the Venetians' paintings. He wanted, in his attempts at composition, to become "a classic, like nature". This essay led him to discover the hidden science that enabled him to ensure exactness in his tones and thus to become a "cubist", as Bach had done in his fugues—a being who succeeded in expressing himself in dice as clear as crystal.

Vincent van Gogh's work was dedicated more to humanity itself than to the human figure. His paintings, the beauty of which has such a strong attraction for us, were always intimately bound up with the essential humanity that expressed itself through them. It is something of a miracle that an art that was art to such an extent could leave so much room for the human, and that the human could take up so much room without displacing beauty. Van Gogh confirmed Gauguin's view: "Colour in itself expresses something". Many things became visible through the simple force of colour in his work—the "dreadful human passions" that can otherwise be expressed only in gesture and mimicry. Through colour, van Gogh reached the land where objects have significant value for the passions. The "classic tragedy" of van Gogh's life (to use Paul Klee's phrase) has been a secret source of energy for modern painters.

The other artist who had a particular influence on the generation of young artists at the beginning of the 20th century was Edvard Munch. His contribution to the human figure in painting was something special; he transformed nature—the world of appearances—into a universe of symbols. Instead of painting a young girl naked, he painted "Puberty", because his psyche, extending beyond visual perception, transformed the model. He did not paint a landscape, but "The Cry"—the answer of his subconscious to the dionysiac aspect of creation. Thus Munch's and van Gogh's contributions to the realm of human expression were the greatest that the so-called Germanic element could furnish. They translated the world of the dionysiac and the psychical into painting.

Oskar Kokoschka, too, began from the incorporeal, the evanescent, which he expressed as directly as he could with brush on canvas, often only suggesting material forms and leaving the spectator to identify them and to draw on his own experiences for their elaboration and definition. Kokoschka's conception of the human figure greatly shocked the visitors to his first exhibition. In a room hung with his early paintings they found themselves surrounded by ghost-like figures emerging from coloured mists, insubstantial and yet possessed of a mysterious life of their own. Distorted, yet intensely expressive, these sad, forlorn people with large eyes and gesticulating hands had

a peculiar fascination: like the very prototypes of modern man emerging from chaos. Later on, Kokoschka's portraits became more sensuous; his shapes gained in roundness and lost, in their sensitiveness, the inquisitive, emotional frenzy of his early work.

In German Expressionist painting the attempts to convey man assumed a passionate aspect. The originators of this painting put aside all individual character and exaggerated the typical features to the point of the grotesque, so as to convey the inner life. As in the portrait, the forerunners sought new paths to express the human figure. First they painted subject pictures; Ferdinand Hodler painted the shoemakers, van Gogh the weavers, Gauguin the Bretons on the beach. Later, they went beyond naturalism; simplified, as in a portrait, the setting, which became fragmentary; and accentuated the significance of the figures. Human beings became portenders of fate. Some of the brilliant subjects of the Impressionists—the theatre and society—in no way interested these pioneers.

The Impressionists were fanatics of the theatre, spectators in love with the life shown on the stage, the singers and the dancers. They painted scenes from the theatre—Renoir's "La Loge" is one of the most famous examples. Munch, in contrast, painted backcloths for "Ghosts", one of Ibsen's plays, that lacked any sparkle. In a vast, comfortably furnished room, the three actors—the mother, her son, and her daughter—confronted each other peacefully, without pathos, struck by fate.

The Expressionists tried to paint as directly as possible, on the basis of first impressions, using elementary techniques. In their desire to withhold nothing, there was no veil of tenderness to attenuate sexual desire. Ernst Ludwig Kirchner pictured men and women in the sexual act. He painted audacious scenes—the pavement meetings of made-up cocottes with eager clients, titillating girls dancing in bars. He painted the revels of the young nude girls in his studio at the wash-basin; and the vermilion bodies of young girls and youths, naked human figures in nature. Kokoschka was the only member of the German school, excepting Max Beckmann, and perhaps the Austrian Herbert Boeckl, to be a painter of quality in the representation of the human figure. In general, the portrait gave way to the depiction of the full-length human figure. The violence of the erotic painting of the Expressionists is striking. Their French contemporaries, the Fauves, in contrast, showed a beautiful woman as they would a vase, calm, free, with no sentimental or literary allusions.

Kees van Dongen's wordly women are captivating documents of a decadent society. Yet the women he painted before 1914 remain proof of the savage delight he took in painting, as well as the dash that was characteristic of the young Fauves. Van Dongen's taste for the Eastern appeared early —it had been introduced into French art by Ingres and Delacroix. Its passivity had little attraction for the Impressionists but it aroused the Fauves to compositions of the most incredible colours. What Henri Matisse liked in the Odalisque was a subject that corresponded more than any other to his own art—woman, still life, and decor all at once.

Georges Rouault, a major Fauvist, conceived the human figure quite differently. His paintings of prostitutes were painted from models of naked women, just perceivable as being in a brothel. In intention these paintings are more reminiscent of Nordic Expressionism than the Fauvism of a Matisse or a Dufy.

Otto Mueller, in Germany, was another who made a very special contribution to the representation of the human figure in 20th-century art. His figures, with their angular forms that merge into nature, are the silhouettes of young girls. Rarely, and never in his nude female figures, did he paint full-blown bodies. Beckmann (perhaps the greatest of the Expressionists), on the other hand, allowed lyricism to show through only in his first works; later his art became tormented. He took as his subjects, scenes from the non-bourgeois world—the carnival, the circus, variety shows, and fairs. His conception was of a Passion, a grotesque caricature derived from the Human Comedy. When he painted, at the end of the 1920s, his "Large Woman Reclining"—a female nude—he spread large shapes in chill colours with decisive, spacious strokes over the canvas, almost brutally.

However, it is Pablo Picasso who has shown the human figure with the most variety in the 20th century. At the outset, in the rose and blue periods, he painted grief-stricken figures, variations on those of Toulouse-Lautrec and Théophile-Alexandre Steinlen, in which he simplified the drawing and deepened the sentimental expression. In about 1906 he painted the completely revolutionary "Two Young Girls Naked". He did away with tradition, rejected the existing formulae, and constructed by pictorial means alone. This synthesis of forms has an echo of African sculpture; not surprisingly, for Picasso had recently seen examples of this primitive art and, as a result, had freed himself from false forms and returned to elementary ones.

In the "Harlequin with Guitar" of 1918, the onlooker can just make out, in the audacious tangle of surfaces that interlock, a face with a mask and a cocked hat, a piece of the costume, and fragments of the guitar. Yet in the "Seated Pierrot" of 1923 terrestrial beauty was once again faithfully restored; the clasped hands, the vertical lines running through the arms and the chair, and the pose of the head have the calm ordering of a Classic work. The chill arrangement of the colours, the intimate union of

drawing and painting, the surface and the plastic form are also Classical elements. Then the "Woman Reclining" of 1939 brought a new variation of the human figure. In it a creature, both human and inhuman, was taken apart and changed into a deformed being with a savage expression. The violent and dreadfully dissonant colours seem as cruel as the fragmentation and distortion of the forms.

The brilliant conception of space that had taken root in these pictures was quite different from that of the Renaissance with its linear perspective. The human figure had been dissected and from the pieces arose a Minotaur-like creature. Is it true that Picasso unwillingly put his creative powers to the service of destruction? Is he, in the field of the intellect, one of the unwittingly guilty who had an unfortunate influence on Europe's destiny? But what was personal—that is, most human—had already been denied for, in the course of the 20th century, many artists have considered the intervention of the human in art to be taboo. They fled from the human figure and little by little painting gave up rivalling reality.

Expressionism, Cubism, and other schools represented attempts in this direction. The representation of man and woman had given way to that of idea. The artist closed his eyes to the external world and turned his regard to the subjective landscapes of the soul.

José Ortega y Gasset, the Spanish philosopher and humanist, has asked why the contemporary artist fears the ample curves of a living body. Why does he replace them by geometrical shapes? He reminds us that similar outbursts of painted and sculpted geometry are not unknown in the history of art. He interprets iconoclasm as a religious phenomenon that appears in times dominated by anxiety in the face of the cosmos. To this can be added the fact that artists turn spontaneously from existing theories of art. A new style arises from the conscious rejection of all tradition.

If we are to understand contemporary art, we must take this negative, provocative, and mocking attitude into account. A good deal of art rests on a denial of that which has gone before, and it is easy to understand that this must be so. After many centuries of almost continuous evolution, undisturbed by major historical catastrophe, the weight of tradition becomes too heavy for the artist to bear. Either tradition stifles the potential creator—as happened in ancient Egypt, the Byzantine Empire, and throughout the East—or else a new period must arise in which art frees itself from the stranglehold of the past.

Much of what could be called this dehumanizing of art and distaste for the living form comes from this rejection of the traditional interpretation of reality. But even if non-figurative representation reaches a climax in the final eclipse of the human form from painting and sculpture,

there were still artists during the first half of the 20th century for whom the human being was their principal inspiration. It is this very century that produced a painter who, more than any other, extolled the human form in his work. The poetry of Amedeo Modigliani remained a poetry of the visible. Nudes and portraits were his only subjects and his finest paintings were those of his girl-friends with their long, slender, fragile necks and the melancholic curve of their drooping shoulders.

Marc Chagall attempted to preserve the human person by making visible the human themes that animated his work; these originated in the distant spirituality of the Eastern European Jews and in Chassidic religiosity. Pierre Bonnard, even though he ventured deeply into trans-figuration, never completely escaped the earth, but re-mained close to us in a world that was open, inhabited, and generous; a world in which women, flowers, and fruit offered themselves in abundance. Like Renoir, he chose to show only happiness.

The human form was also the main subject of the sculptural work of the century. Admittedly the meditative presence in Maillol's uncomplicated statues rapidly disappeared; this natural life was no longer desired—it was transcendence that was sought. Thus Wilhelm Lehm-bruck's subjects (for example the "Standing Woman" of 1910) still had the same rounded contours as well as the solidly composed volumes of Maillol, but this fullness of the body was to be very short lived. Structure replaced volume. Bodies became the fragile vase of the spirit and of the sensitive soul rather than a sensual, pulsating whole.

Toward the 1920s, in Jacques Lipchitz' work, matter became the interplay of three dimensions. There was neither inside nor outside. The fugue-like crossing of con-trasting elements led to a figuration that was transparent on all sides. In the mid-1930s, a certain Baroque element could be seen in his work but he was also influenced by the vital dynamics of Rodin. Important human themes were changed into forms that were still close to nature yet without abandoning the experience of previous periods.

Henri Laurens, who, like Lipchitz, began with Cubist sculpture, gradually arrived at metamorphosed figures that were plastically and organically conceived and con-structed in such a way as not to appear too far removed from reality.

Alexander Archipenko was working with negative forms when in 1912 he sculpted the "Woman Walking". The counterpoint of substance and vacuum, form recalled and form liberated, resulted in a lifelike vitality. This rhythmical interchange of convex and concave surfaces gave his numerous feminine torsos, often very smooth, an austere elegance. Alberto Giacometti removed sufficient substance from sculpture to attain refined, elongated,

sketchy, metal totems, like corroded stems that are just sufficiently plastic to suggest a substance in space. What interested him in these figures were the features because they retained an aura of a human being.

Fritz Wotruba also sought to translate the human body, not by breaking it up but by making a monument of it. He constructed the human body like a Stone Age monument and captured in his shapes a prehistoric human species — Cyclopean and powerful.

From 1945 onwards, Henry Moore had tended toward a more human and more figurative conception. His figures, powerful and rocky, arouse memories of a prehistoric human state. They have the rhythm of the landscape within them, the slope of the hills and the valleys, the fossil traces of the epoch. His more recent figures are no longer integrated into the landscape; he uses a time-worn figure without harmonizing it into nature. A sombre, tragic breath passes over works like "King and Queen".

Marino Marini has said of himself: "As a Mediterranean, I can only freely express myself through the human." Into the theme of the horse and rider, he compressed his conception of man. His women are heavy with broad hips and short legs and their nudity is imposing in its naturalness.

In the United States, Elie Nadelman and Gaston Lachaise adopted the European tradition of the human figure. Lachaise turned away entirely from the Impressionistically-treated surface and sought the monumental aspect in his majestic women; this constituted the main theme of his work. He extolled the physical majesty of woman with the help of harmonious interplay of replete forms. Vigorous, almost "barbaric", conceptions of the eternal feminine were thus born.

There remains practically nothing of this sensual magnificence in the work of someone like Leonard Baskin. He depicts suffering, humiliated beings whose existence takes place in the shadow of death while they cling with tragic grandeur to a last hope. Baskin's sculptures are characterized by heavy shapes that recall his admiration for Ernst Barlach.

Basaldella César sought his truth with care among materials like scrap-iron that lend themselves admirably to constructions and collages. With mere trifles, trash, things thrown out and disdained, he re-created an organic world that is true and thrilling. After creating his famous "compressions", the tradition of Antiquity took hold of him once more and the "Victoire de Villetaneuse" represented his return thereto. Much more than a woman, than a mother-goddess, the Victory, set on her iron columns like some superb mare, parades her enormous belly, at once taut, replete, dynamic, tender, and quivering in the morning dew. With her terrific presence, she has no age and is

of all time. A tradition both venerable and alive has been embodied in present-day reality.

The human being in Francis Bacon's work is usually recalled by a naked creature, half-man, half-beast. Man is reduced, so to speak, to signs and characteristics that suffice to direct, if somewhat vaguely, the onlooker but do not permit him to recognize a precise human figure.

Raoul d'Haese's horseman in "The Song of Evil" has lost all the proud self-consciousness that was formerly the preserve of the statue. The rider's stomach has been torn open; his head inspires pity—the large, inexpressionless eyes are wide open. The figure makes a defensive gesture with his hands.

Only with great reserve can we consider these artists as "preservers of the human being". In their work, the ciphers that characterize the human are interchangeable. Although their sculptures are of human beings, they are human beings who are part of a varied, fanciful world that permits the survival only of a human cast-off, a trembling Godot.

In Horst Antes' work any mark of individuality has completely disappeared. What is supposed to be a human being is an anonymous heap of dismembered bodies, lacking any organic ordering. The problem of figuration versus abstraction loses all significance when confronted with such paintings. The shapes preserve only a very distant relationship with the organic whole from which they have been borrowed. This is true also for Willem de Kooning's women. The shape and matter are violated to such an extent that any illusion of the human figure would seem to be accidental. All we can say is that the arrangement of space is organic. We can no longer speak of any sort of realism. What is shown as a painting is much more a projection of a subconscious inner world than the reflection of an external reality.

When Karel Appel attempts to create an anthropomorphic painting he in no way detracts from the abstract character of the picture. What the painter wants to express is not the possible presence of a human being but matter; nevertheless, the human form does appear from time to time in Appel's pictures, and the portraits display a most surprising synthesis of pure iridescence and psychological reality.

Discussing the appearance of anthropomorphic forms in his own paintings, Jean Dubuffet had this to say: "Those who have referred to a psychological venture when speaking of my portraits have understood nothing at all. These portraits were anti-psychological, anti-individualistic and nurtured in the idea that he who wishes to paint something of import does not have to take into account, even in a portrait, the futilely accidental which differentiates one person from another—a fuller face, or a shorter

nose, or a temperament which is more or less embittered or playful. It seemed to me that by depersonalizing my models, by transposing them onto a very general plane of elementary human figures, I helped to release, for the user of the painting, certain mechanisms of imagination and evocation which considerably increased the power of the effigy." In this way, Dubuffet realized portraits that were freed from any relation with the visual, were not caricatures, and from which the slightest hint of moral reprobation was excluded.

"At the end of the 1950s in both London and New York there was the sort of atmosphere which encouraged certain painters to attempt to delimit the unique attributes of our time, that is the special aspect of our world as it is. These painters attempted to create a new type of art which was to give the documentation necessary for understanding the human condition in its ceaseless change."

This description of the scene comes from the English painter, Richard Hamilton, who was himself a member of the group he mentioned and explains approximately what is meant by "Pop art". "Pop" has also been defined as raw materials and documents of the technological culture on which the artist builds, and which he uses to their limits, thus creating his own world of images. The collages of the "Pop" artist contain examples from all the mass media of today—photographs of pin-ups, Coca-Cola bottles, comic-strips. Re-assembled or re-created in a picture, these objects produce a reaction through the simple fact of their existence, not by virtue of their "transposition". The human figure in Robert Rauschenberg's collages is composed of a collection of photographs, pieces of material, strips of posters, and paint.

Jasper Johns' works contain plaster casts of parts of the human anatomy; a white fragment of a face, a hand with four fingers painted red, a piece of pink breast, a yellow heel, and a green penis. But the human body is not the real subject. Triviality becomes the subject of art. Art itself puts reality on the stage—for example in the case of Claes Oldenburg.

Thus the story of the human figure in art ends at the present day with the image of trivial man. It began with the representation of divine man and revealed successively down the ages mythical, princely, heroic, and tragic man. Then came the aristocrat, the religious figure, the elegant man, the bourgeois, everyday man, and finally a man humiliated to the point of triviality...

List of illustrations

Chapter I
Ritual and Magic

Prehistoric Man

1 Venus of Lespugue. Palaeolithic,
c. 20,000 B.C. Ivory. Height, 15.2 cm.
Lespugue (Haute-Garonne).
Museum de l'Homme, Paris.

Despite the stylistic difference between the
Lespugue and the Willendorf Venuses, the
same stress on sexual forms, the same
suppression of facial features, the same
positioning of the arms, distinguish both
and demonstrate their iconographic kinship.

2 Venus of Willendorf. Palaeolithic,
c. 21,000 B.C. Limestone. Height, 11.4 cm.
Lower Austria; Aurignacian school.
Natural History Museum, Vienna.

This statuette with its full female body,
abbreviated limbs, and featureless head
was supposed to promote human fertility.

2

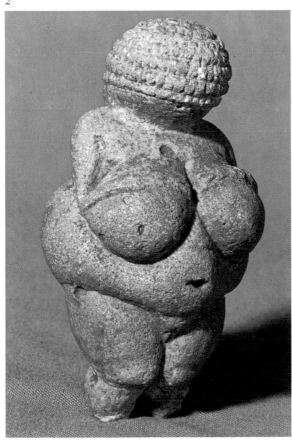

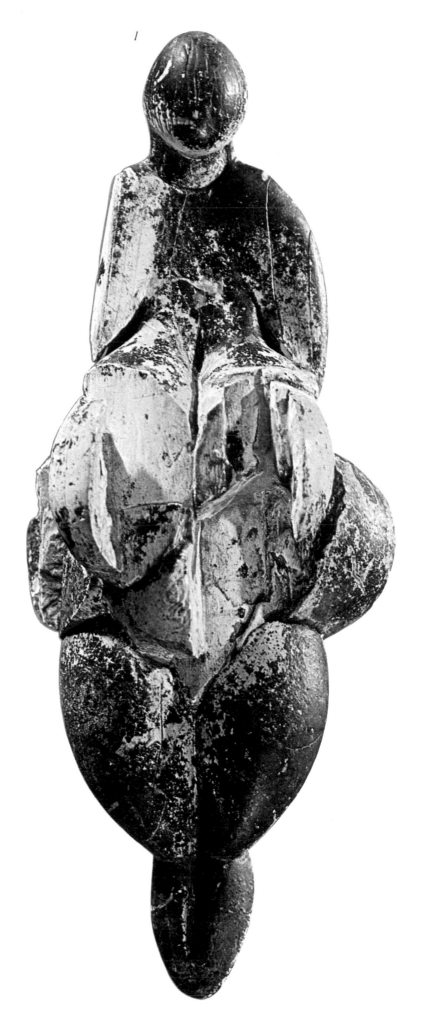

1

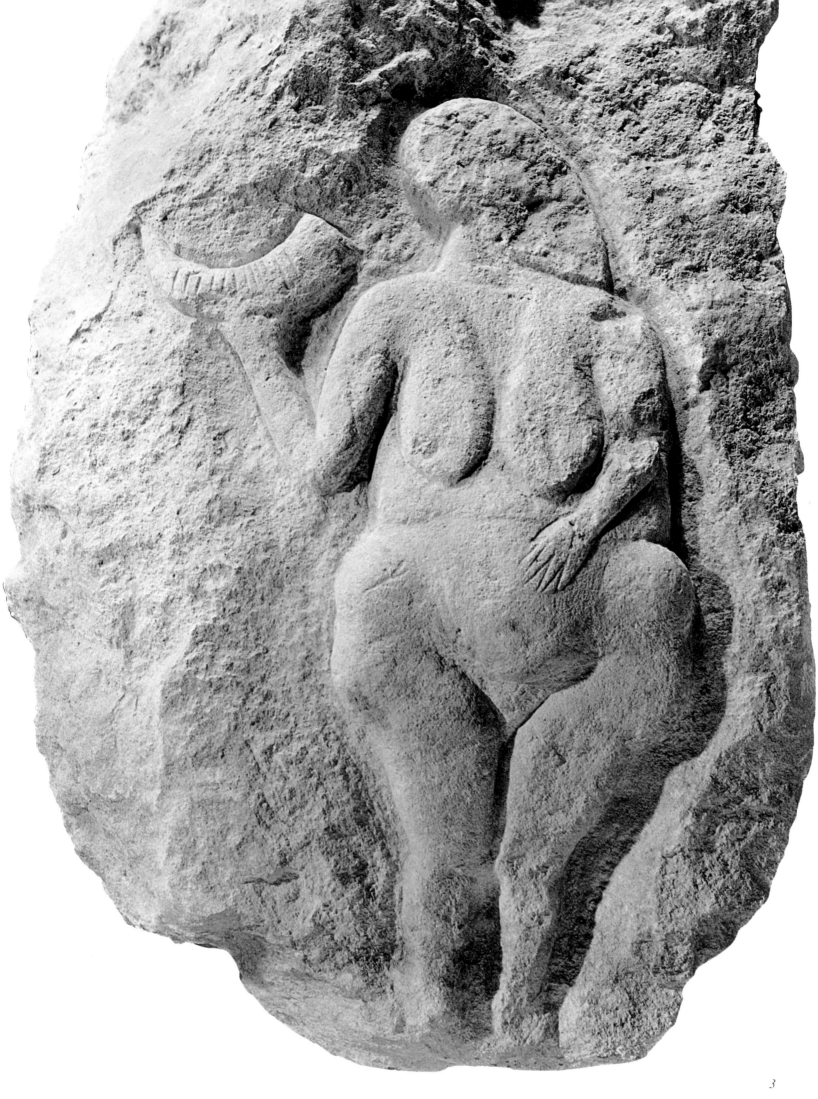

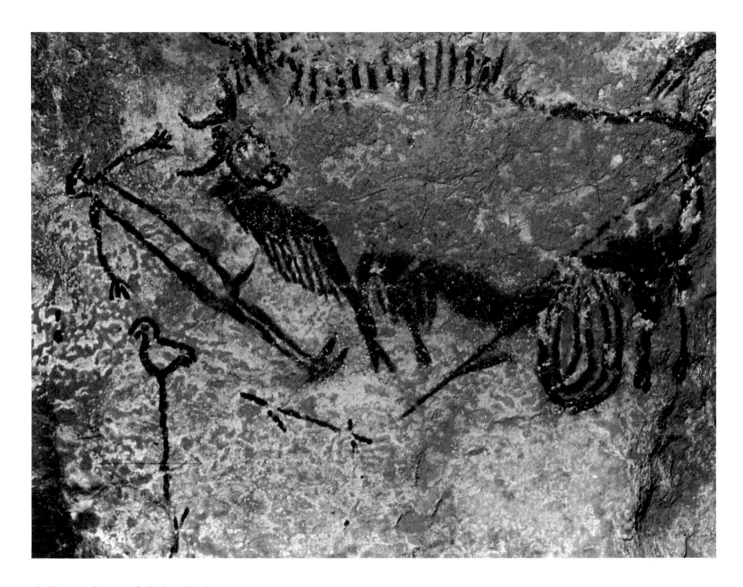

3 *Venus of Laussel*. Palaeolithic,
c. 21,000 B.C. Relief on rock.
Height, about 37.5 cm.
Laussel-Dordogne, France.
Archaeological Museum, Bordeaux.

At Laussel, a whole open-air sanctuary has
been found. The main sculpture is this
female figure, represented full face, holding
a bison's horn perhaps as an offering.

4 *Wounded man and rhinoceros*. Earliest
Upper Palaeolithic, 10,000 B.C.
Detail of Franco-Cantabrian cave painting.
Lascaux, Dordogne, France.

Outlined in red in front of the bison lies
an ithyphallic man with a bird-like head, his
arms and hands (four fingered) stretched
out. The Lascaux paintings are of uncertain
age but they cannot date from too far back
in the long span covered by Franco-
Cantabrian cave paintings, which ranges
from 40,000 to 9000 B.C.

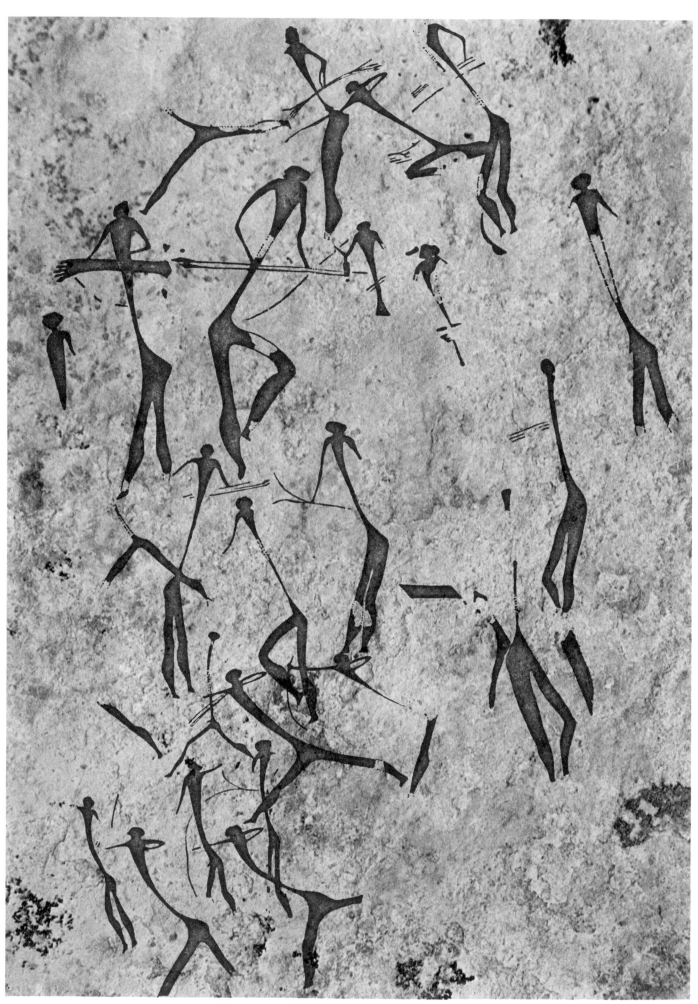

5 *Hunters*. Mesolithic. Wall-painting. Valltorta canyon, Castellón, Spain.

The wall-paintings, discovered in Spain and described for the first time by Abbé Breuil in 1909, are in many ways comparable to those in South and North Africa. They were not executed in caves, but on free walls, overhung by rocks. In front of these niches, seats were placed where people could worship. The situation of the paintings differs from those in caves; but more important is the fact that they differ in representation. Man enters the scene. The destiny of human beings is illustrated: they are hunting, they are making war in groups; they march out to plunder. All these human figures are in motion, running, shooting, or jumping. Even so they are not natural. The artist stylizes the figures, without aiming at volume and perspective. They remain flat and two-dimensional. Astonishing though is the artistic perfection of the composition. Although the arrangement of the figures is probably fortuitous the result is surprising.

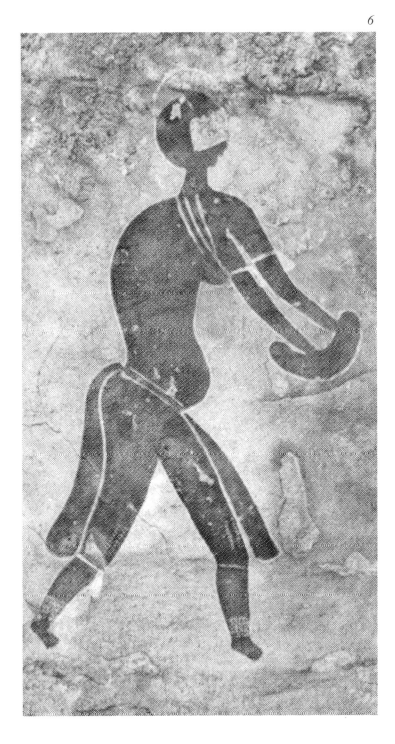

6

6 *Masked negroid woman*. "Period of the Roundheaded Men" (later than the Neolithic period). Rock painting in copy. Height, about 69 cm. Sefar, Eastern Tassili massif, central Sahara desert, Algeria.

The woman wears ornaments below her knees and around her ankles and arms, and her only garment is a sash hanging from the waist to the knees. The object she holds with both hands may be some sort of vessel.

Chapter II
In the Margin of History

Primitive Man, Africa, Oceania, Mexico, Peru

8 Mbulu Ngulu. 19th century.
Ba-Kota. Gabon. Private collection. Paris.

It is generally assumed that these grave
images, called Mbulu Ngulu or "image of
the spirit of the dead man", were placed on,
or partly in baskets, in which the bones of
an ancestor were kept. Emphasis is laid on
the head; the rest of the body is only
indicated by an almost abstract figuration.
The head was considered to be the place
where the powers of the spirit resided.

7 Mother goddess. Neolithic,
c. 7000-6000 B.C. Haçilar, Anatolia.
Collection of H. E. Smeets,
The Netherlands.

Although scholars cannot definitely interpret
this figure, presumably it represents a
goddess of earth and fertility. The reduction
of the body to those essentials that are
strictly linked with fertility underlines this
function.

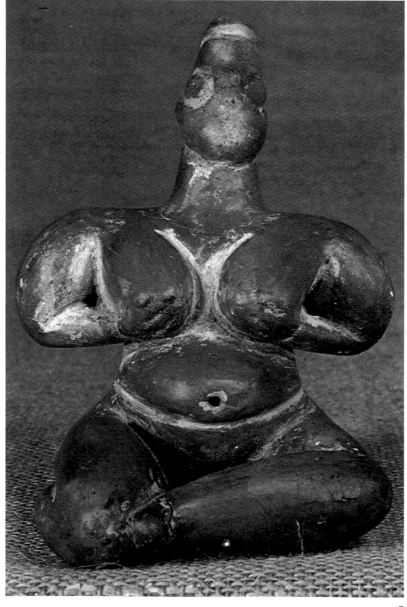

7

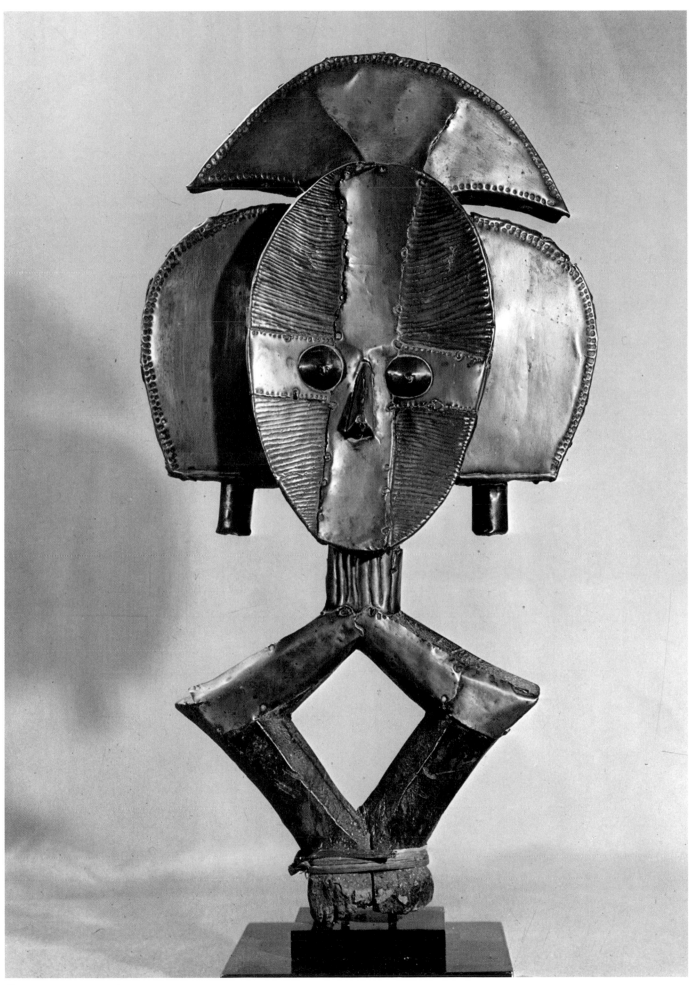

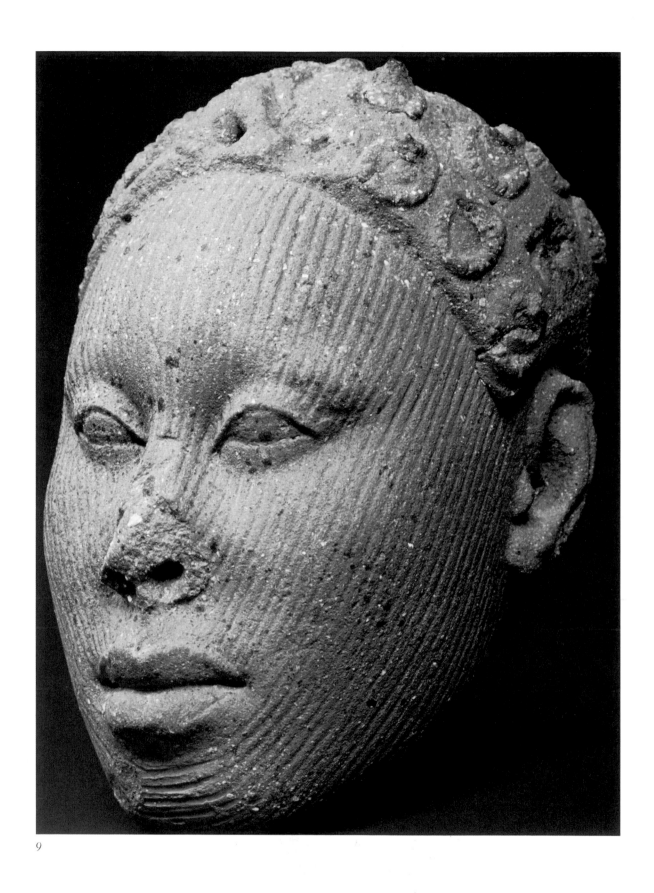

9

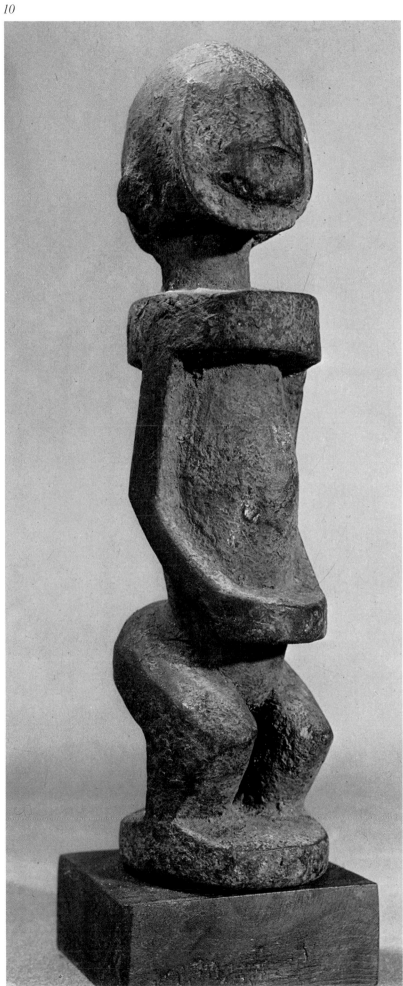

9 Head of a woman. Ancient Nigerian culture, 11th-15th centuries. Terracotta. Height, 16.5 cm. Völkerkunde Museum, Berlin.

The sober and delicate modelling of this small commemorative head with its network of grooves, undoubtedly meant as tattoo marks, permits us to glimpse, over and beyond its obvious naturalism, the serenity and dignity that characterized the aristocracy of this Nigerian people.

10 Standing figure. 19th century. Dogon, Mali. Private collection, France.

The formal dynamism of Dogon sculpture results from a rhythmic conception of volumes that confers on it an architectonic quality.

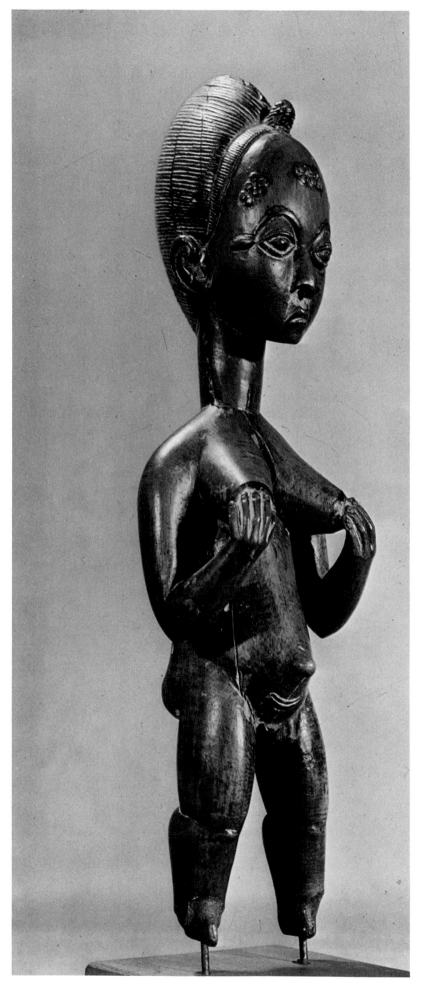

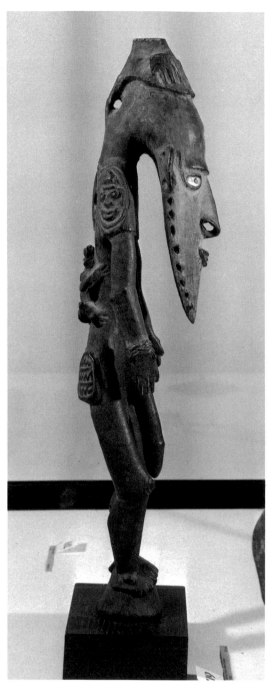

12

11 Female ancestor of the Baule.
Probably 20th century. Ivory Coast.
Private collection, France.

The remarkable elegance of this small
statuette and the rhythm of its rounded
forms do not exclude a pure and even
monumental treatment of the volumes. This
beautiful example of Baule art is strikingly
subtle and delicate in its modelling.

11

12 Melanesian statue. Probably 20th century. Height, 57 cm. Sepik, Valley of the Yuat, Mundugumor, New Guinea. Brignoni Collection.

The region of the Sepik river produced one of the most remarkable, if not the most important, art-styles of New Guinea. The Sepik region is not far from the coast; in consequence, cultural influences from overseas could enter the region by means of the river traffic. This stimulated the birth of a magnificent art, and it is significant that the further one retreats into the hinterland, the less interesting the art becomes. All figurative sculptures represent ancestors or heroes.

13 Standing figure. Micronesian. Probably 19th century. Wood. Height, 33 cm. Nukuoro, Caroline Islands. Museum de l'Homme, Paris.

Micronesian art is characterized by extreme simplicity. Though small, this statue gives the impression of being much larger, owing to the purity and severity of its forms and to the broad, yet delicate, treatment in the modelling. The head, a simple egg-shaped volume, its pointed end forming the chin, the straight, hanging arms, the position of the legs, and even the shoulders, all show a subtle use of asymmetry.

13

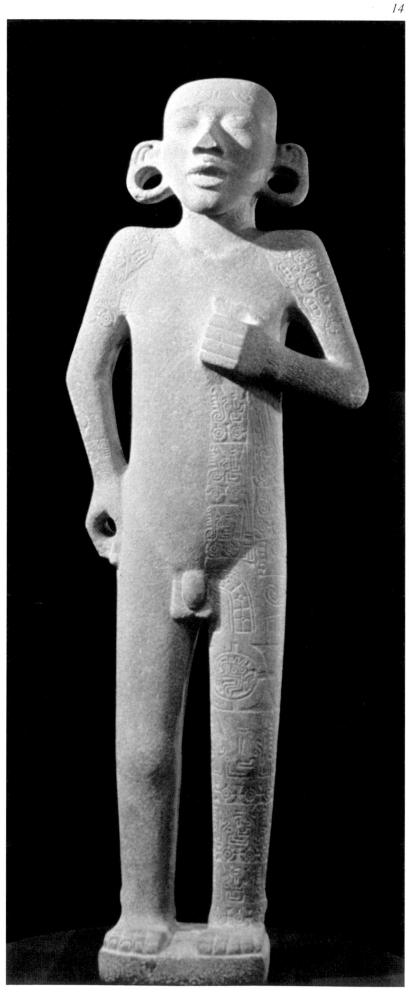

14 The Adolescent of Tamuin. Huasiac culture, classic period, seventh-10th centuries A.D. Height, about 112.5 cm. Tamuin, San Luis Potosi.

The "Adolescent" of Tamuin is one of the masterpieces of Huasiac culture in its classical period. The beautifully proportioned body is decorated with delicately incised symbolic and mythological reliefs. It is thought to represent the young god Quetzalcóatl. On his back he carries the sun as an indication of the newborn day. Huasiac figures are almost always anthropomorphic, have rigorously geometric stylized forms, and are powerfully simple.

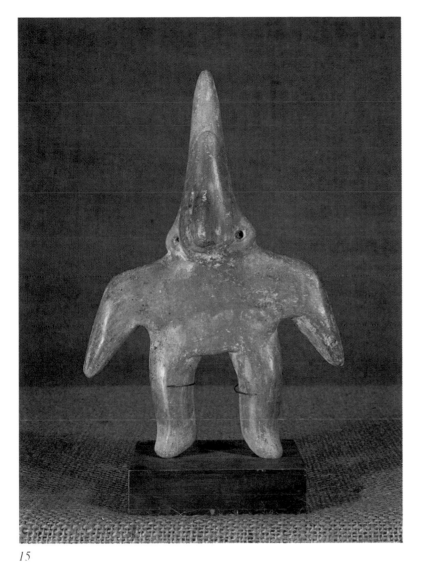

15

16

15 Figurine. Pre-Columbian. Terracotta. Colima, Western Mexico. Collection of H. E. Smeets, The Netherlands.

It is hardly possible to recognize in this strange creature the features of a human being. Maybe the mixture of animal and human form has something to do with the god Quetzalcóatl, who passed as an eagle across the sky, sank into the underworld as an ocelot, and represented, as a bird, the heavens, or the heavenly characteristics of man. In this statuette an association with a bird is apparent.

16 Figurine. Michoacan, late first millennium B.C. Terracotta. Mexico. Collection of H. E. Smeets, The Netherlands.

The dead were buried with their arms, tools, and these figures.

61

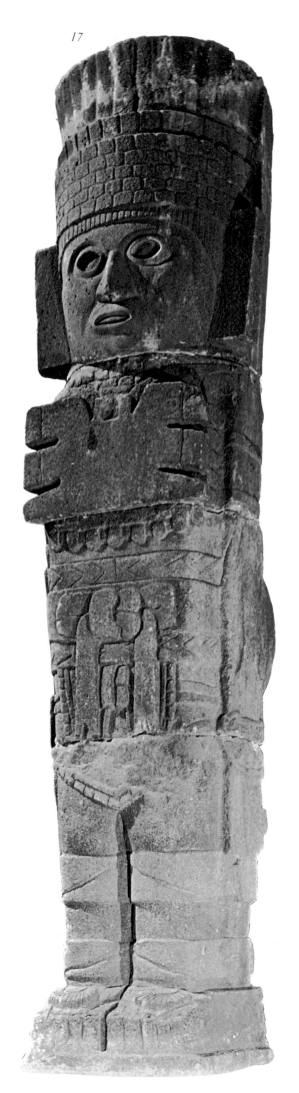

17

62

17 *Atlante*. Toltec, 10th-12th centuries A.D. Tula, Mexico.

Four such Atlantes, supports for the wooden architrave bearing the roof, stood at the entrance to the sanctuary on top of the pyramid at Tula, the religious city of the Toltec people. All four colossal statues, identical in attitude and expression, were executed with great care and precision as to their ornamental details and attributes. A feeling of power emanates from this figure, which symbolizes the sun-warrior armed with shafts of light.

18

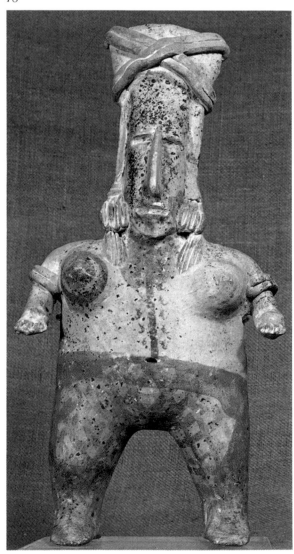

Chapter III
In the Face of Eternity

The Near and Middle East

19 Female statue. Susa, Mesopotamia,
end of third millennium, B.C. Terracotta.
Louvre Museum, Paris.

This type of terracotta figure has been
found not only in Mesopotamia, but
throughout the Aegean-Anatolian region,
where they were produced up to the Late
Bronze Age. The head with the big nose
and the strange decorations surrounding it
is Asiatic in type. The subject is probably a
fertility goddess.

◀

*18 Standing female figure with elongated
head.* Mexican, classical period,
Eighth-10th centuries A.D.
Terracotta, polychrome. Height, 36 cm.
Collection of H. E. Smeets,
The Netherlands.

Excavations in Mexico have brought to
light female and male figures, young and
old, thin and obese, sitting and standing,
naked and clothed. The female figures are
neither goddesses nor portraits, but may be
intended to possess magic properties,
designed to awaken or increase human or
agricultural fertility.
This statuette demonstrates that naturalism,
as it appeared in Olmec art, still resisted the
tendency towards stylization. Although the
head is elongated in an anaturalistic way,
the rest of the figure still surprises by
the freedom of its conception: sculptured
in the round, with limbs moving in three-
dimensional space. Modelled in soft clay by
hand and fired once only, these figures can
ignore the limitations of stone carving.

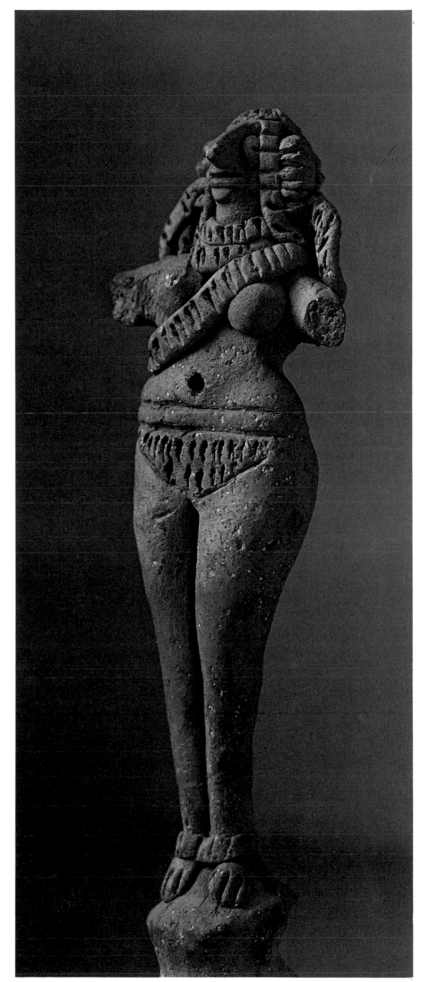

19

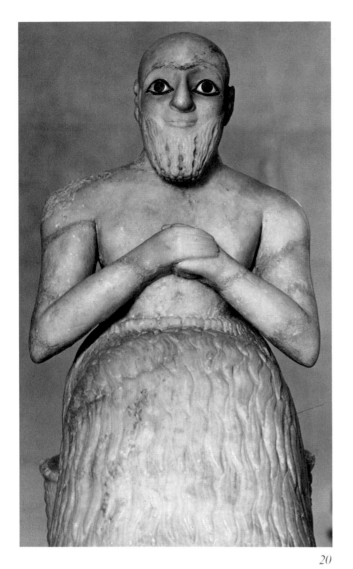

20 *The Intendant Ebih-Il.* North
Mesopotamia, third millennium B.C.
Alabaster. Height, 52 cm.
Louvre Museum, Paris.

The intendant Ebih-Il was a minister in the
Kingdom of Mari; his statue was found
near to the king's in the temple of the
goddess Ishtar, at Mari.
The technical skill of the execution as well
as the intensity of expression of this
sculpture prove that it was the work of an
outstanding artist.

21 *The god Abu.* Al'Ubaid period,
3000-2500 B.C. "Mosulmarble". From the
temple of Abu at Asmar, Mesopotamia.
Iraq Museum, Baghdad.

These two large statues were in the group
found in a pit in the square temple at Tell
Asmar. The extremely schematized features
of the god Abu, the abstractly patterned
mouth, nose, and eyebrows, and especially
the enormous eyes that seem to consume
the face, give rise to a concentration of all
expression in the rapt, intense gaze. Some
scholars believe these inhumanly staring
eyes would be appropriate to a worshipper
gazing into the divine light.

20

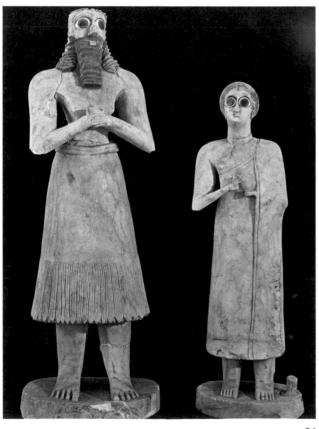

22 *Astarte.* Phoenician, 1400-1200 B.C.
Bronze. Louvre Museum, Paris.

Dressed in a long robe and adorned with
jewels, the Great Goddess sits on a throne.
She lifts her right hand in a gesture of
peace; her left hand probably once held a
sceptre. With its eyes deeply cut, maybe
to hold some now lost inlay, the head has
a strange, fascinating expression. The
goddess is Astarte, one of the great figures
in the Phoenician pantheon, and one of the
many names given to the Great Mother,
goddess of motherhood, of fertility, whose
cult spread through the whole of western
Asia, and who reappears in Greece with the
names of Aphrodite and Cybele, among
others.

21

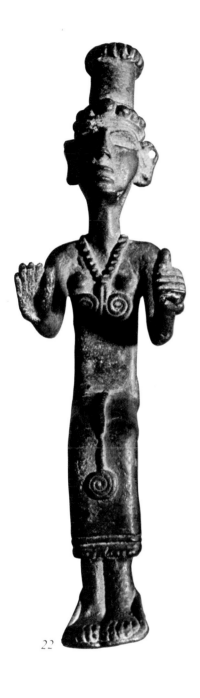

22

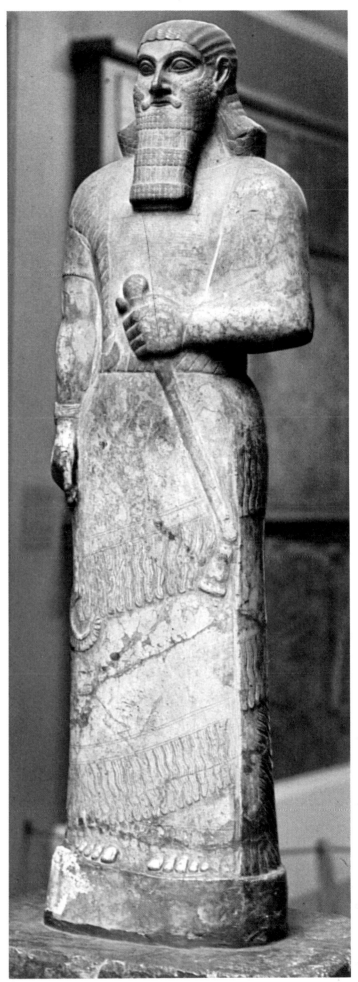

23 *King Assurnasirpal II*. Assyrian,
ninth century, B.C. Alabaster.
British Museum, London.

The Assyrian era was characterized by a
prolific artistic production intended mainly
as political propaganda. The Assyrian kings,
absolute monarchs, wanted to immortalize
their deeds in writings and in images.
Representations of the king as an all-
powerful being multiplied; but once the
type had been codified it became fixed, and
the man himself disappeared behind the
symbol of his power. Without the inscrip-
tion, there would be no way of recognizing
in this impersonal, majestic statue, a
portrait of Assurnasirpal II.

23

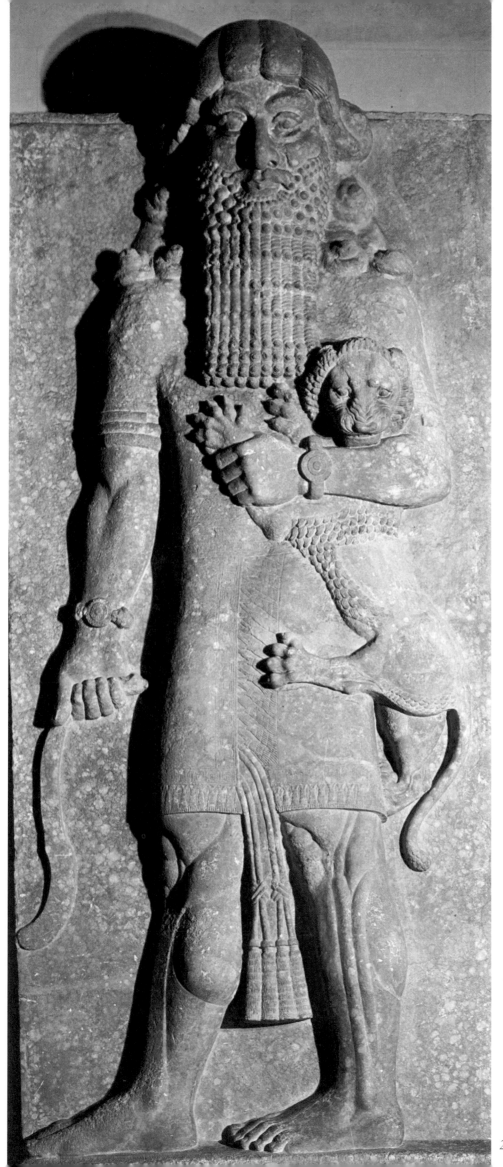

24

24 The hero Gilgamesh. Assyrian, eighth century B.C. Alabaster. From the palace at Dur Sharrukin, Khorsabad. Louvre Museum, Paris.

Bearded and long-haired, and dressed in an Assyrian-style fringed tunic, Gilgamesh is taming a lion. The artist uses the convention, well-known in Egypt and common also in Assyrian reliefs, of the human figure seen frontally, the feet in profile. Gilgamesh is one of the figures that Mesopotamian art loved to depict. But, although his epic could have provided artists with a great variety of subjects, the hero's iconography tends to be limited to the same few themes, endlessly repeated. Pre-eminent among these is the scene of his combat with wild beasts.

25 Female figurine. Predynastic Egyptian. Ivory. British Museum, London.

This feminine figure of pure and simplified shape has big eyes in a bluish surround. The elegant and refined Egyptian women accentuated their eyes when making up their faces.

25

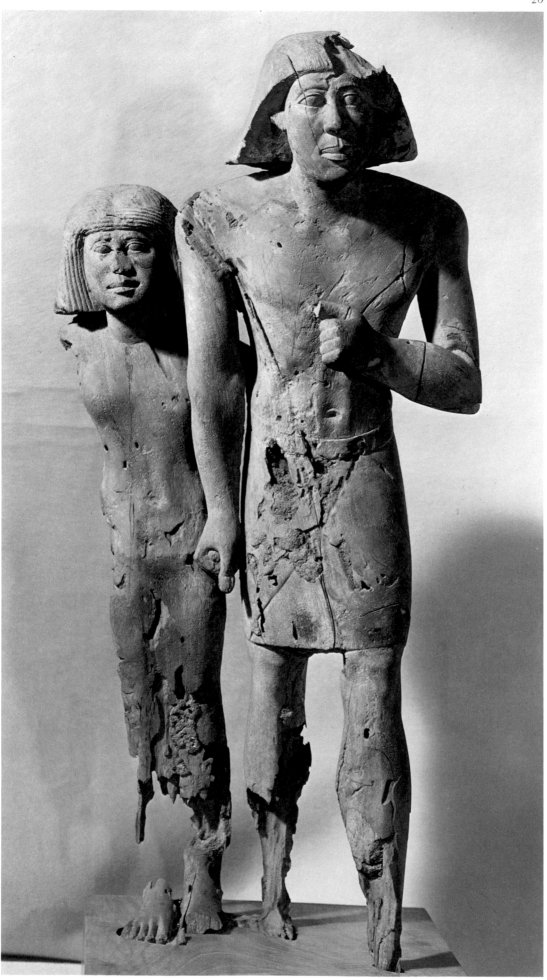

26 Functionary and his wife. Egyptian, IVth Dynasty. Wood. Height, 44 cm. Memphis.

Compared to the statues of Rahotep, of the same period, this pair of less important dignitaries shows a freer attitude and their features are more individual. The frontal law is still severely respected.

27 Young woman smelling a lotus flower. Egyptian, Vth Dynasty, 2750-2625 B.C. Limestone block carved in sunken relief. Height, 128 cm. Louvre Museum, Paris.

This young woman is dressed in a long shirt that reveals the elegant forms of her superb body. All the refinement that Egyptian artists were capable of is combined with a strong sense of formal simplification and an intense sense of rhythm in the display of contours.

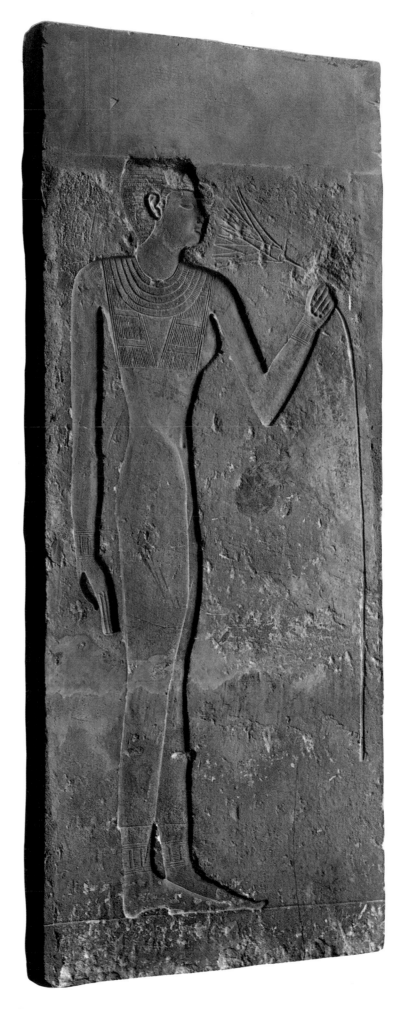

27

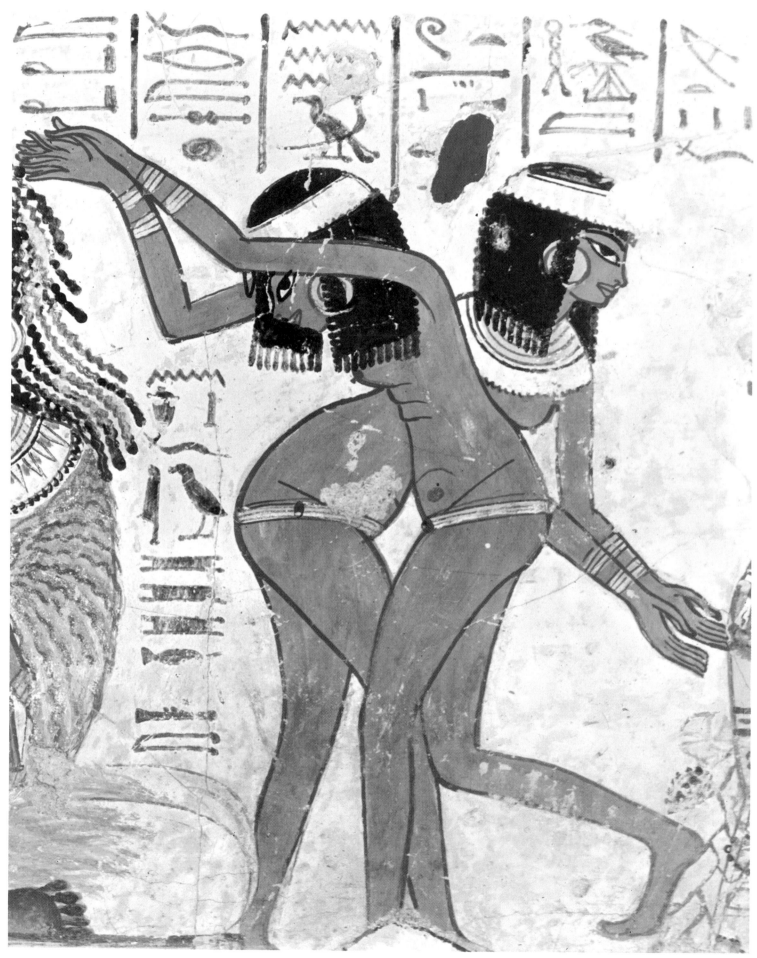

28

28 Egyptian dancers. New Kingdom,
XVIIIth Dynasty, c. 1400 B.C. Detail
of wall-painting. British Museum, London.

Elegantly undressed young women expressed
the new freedom that broke, to a certain
point, the bonds of the archaic style that
had ruled so long in Egypt. The urbane
refinement of the new royal residence and
metropolis of Thebes led—among various
circumstances—to this change in Egyptian
art.

29 Queen Karomana, wife of Theleth II.
Egyptian, XXIInd Dynasty, 950-730 B.C.
Damascened bronze. Height, 59 cm.
Thebes. Louvre Museum, Paris.

Nature, left to her own devices, will
produce a Venus like that of Willendorf;
a goddess of procreation to which all
flesh must submit. In this Egyptian queen
there is no such reminder of carnality.
Her hips are those of a young boy; her
breasts reveal no noticeable swelling. Her
belly is not meant for conception and
child-bearing; the emerald drapes her body
like the skin of a lizard. Her expression has
the innocent earnestness of a child. On her
lips plays the shadow of a smile. No more
than a shadow: a restrained joy, not yet
visible in the rest of the face.
Only decline brings this: the late flowering
of one born for beauty, not at the beginning
of a dynasty, but at the end.
All that royalty has been and will be no
more is summed up in this one unique
figure of an infant-queen, the secret of
whose promise is that it can never be
fulfilled.

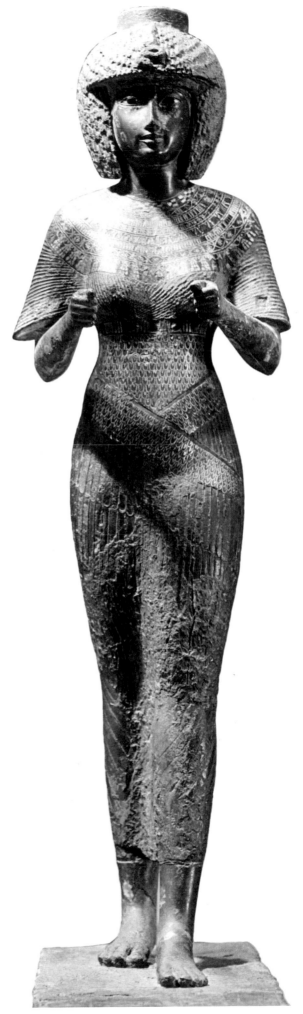

29

71

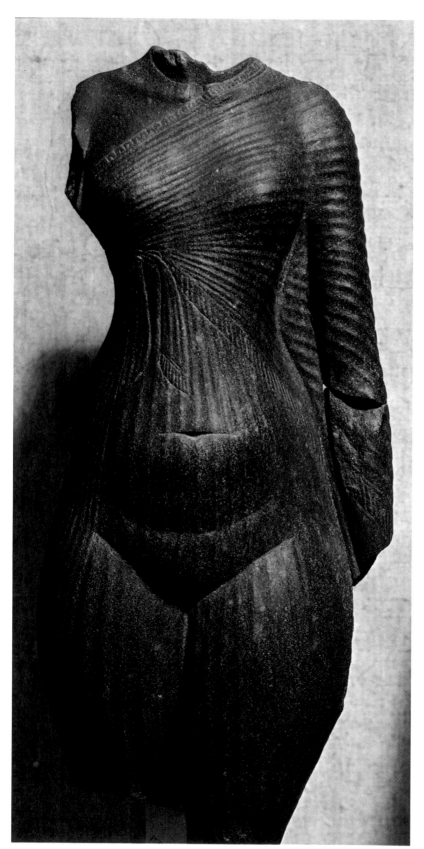

30

30 Torso of an Armana princess. Egyptian,
1375-1350 B.C. Red quartzite. Height,
29 cm. Louvre Museum, Paris.

This torso is one of the highest achieve-
ments of sculpture in the period of
Akhenaten IV. The introduction of drapery
allows the artist to express the subtleties
of the human figure with an accuracy never
before demonstrated. The elegance of the
body and the voluptuous beauty of shape
and silhouette interfere with the aristocratic
attitude without disturbing the joyous and
self-conscious presence.

Chapter IV
Mythos and Idea

Crete and Hellas

31 Schematic idol. Cycladic, 3000-2000 B.C.
National Museum, Athens.

Almost without exception, the Cycladic
idols represent female figures that symbolize
the Great Mother Goddess from whom
stems every form of life, and who is
equally the protector of the dead.
The simplest stylization that occurs in
Cycladic art is the reduction of the female
nude to the forms of a violin: the lower
part of the body reduced to a circular form,
the head to a cylinder.
Even in this elementary representation of
the human figure, the plastic beauty of
awakening Greek art is striking.

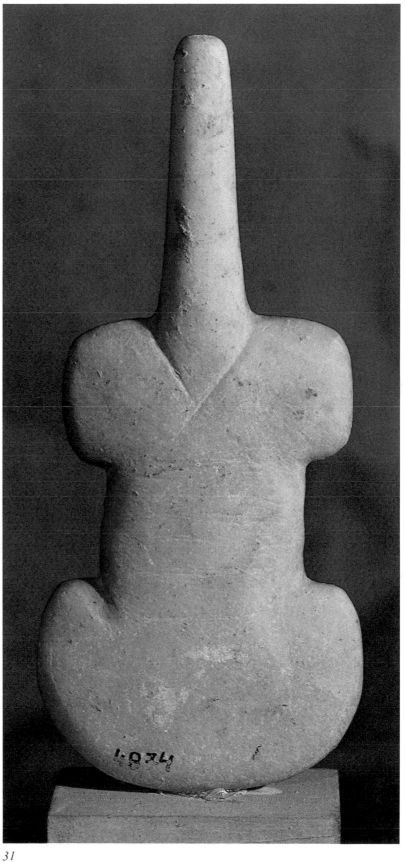

31

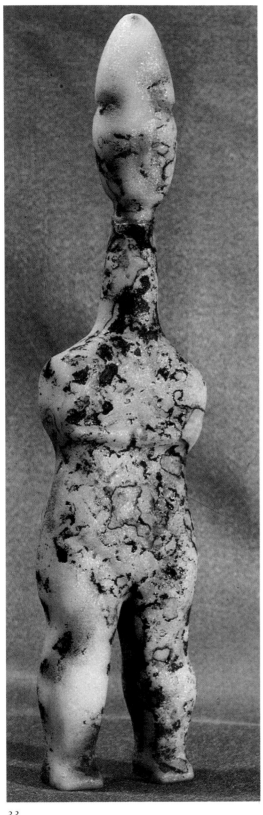

33

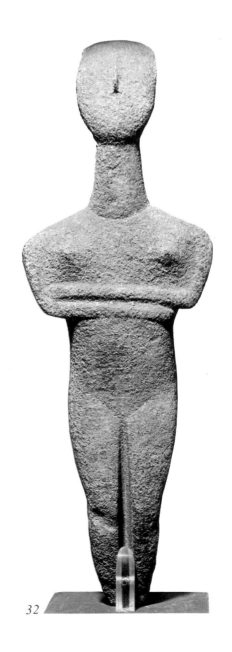

33 Figure. Cycladic, early Bronze Age, c. 2000 B.C. Marble. Found at Naxos. Louvre Museum, Paris.

Idols such as this are unique in that they were usually carved from the local island marble, and were of a competely different type from the Palaeolithic and Neolithic female figurines. The idea of fertility is no longer insisted on by means of obesity, but is merely hinted at. There is a striving toward simple plasticity, as much in the construction of superposed geometric volumes as in the great simplification that eliminates all detail.

32 Figure. Cycladic, c. 2500 B.C. Marble. Collection of H. E. Smeets, The Netherlands.

In Cycladic art the whole human figure is reduced to a geometric pattern. This conception owes nothing to the influence or example of other cultures, although broadly similar conventions have been adopted in different parts of the world at different times.

32

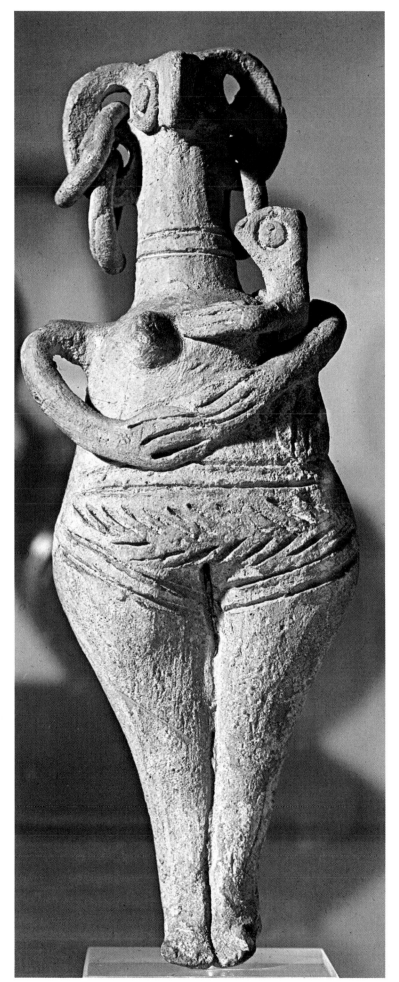

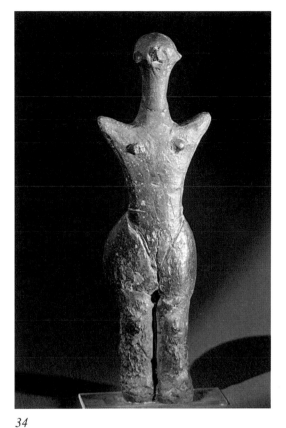

34

34 Strélice idol. Neolithic, 2000-1600 B.C.
Height, 21.7 cm. Moravske Museum,
Brno, C.S.S.R. Prehistoric Department.

Many Neolithic idols have been found in
Moravia; the most important come from
Strélice; closed forms and the intensity of
expression are typical. Most of them show
reduced arms, like the idols found in
Bulgaria. Although the clarity of forms,
that characterized Cycladian idols, was not
attained in this middle-European sculpture,
still a remarkable conception of the human
figure stands for the image of the Alma
Mater.

35 Mother goddess. Late Bronze Age,
14th-13th centuries B.C. Red-varnished
terracotta. Cyprus. Louvre Museum, Paris.

During the last period of the Bronze Age,
the island of Cyprus entered on the era of
its greatest prosperity, having become one
of the chief centres of the Mycenaean
world and the intermediary between Asia
and the Aegean. Cypriot art tended to
become schematic, as can be seen in this
curious statuette, discovered at Alambra.
The head, with its bird's beak and its huge
ears pierced with moveable rings, recalls an
Asiatic type. The subject is probably a fertility
goddess holding a child in her slender arms.

35

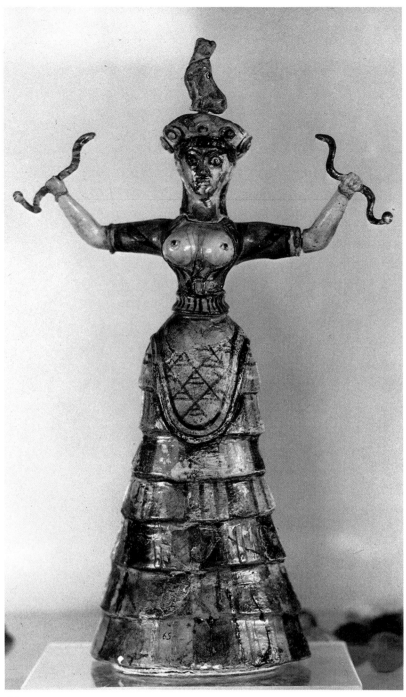

36

36 *Snake goddess*. Minoan. Terracotta, polychrome. Height, 20 cm. From a sanctuary in Knossos. Archaeological Museum, Herakleion.

The principal interest of this figurine lies in the information it gives about Minoan religion and costume at the beginning of the 15th century B.C.
The Cretans frequently paired the snake with their goddess for symbolic reasons, as the snake was associated with fertility, regeneration, and immortality.
The young woman wears a long skirt with tiers of flounces. The very low-cut, close-fitting bodice reveals the breasts and is prolonged, front and back, by a rounded apron.

37 *Bell idol*. Boeotian, eighth century B.C. Terracotta. Height, 39.5 cm.
Louvre Museum, Paris.

This statuette is distinguished by a bell-shaped tunic; details of dress and ornament are picked out in a reddish-brown colour. A necklace carries a pendant that falls between the breasts; the short arms are decorated with a swastika; the tunic is ornamented with geometrical patterns and two birds.

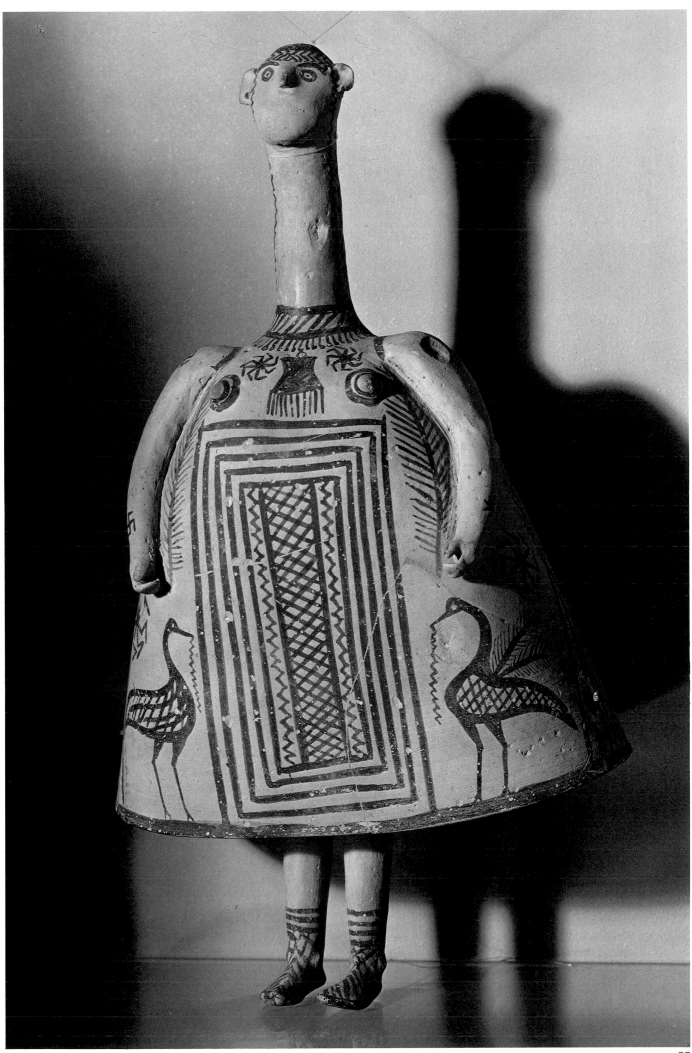

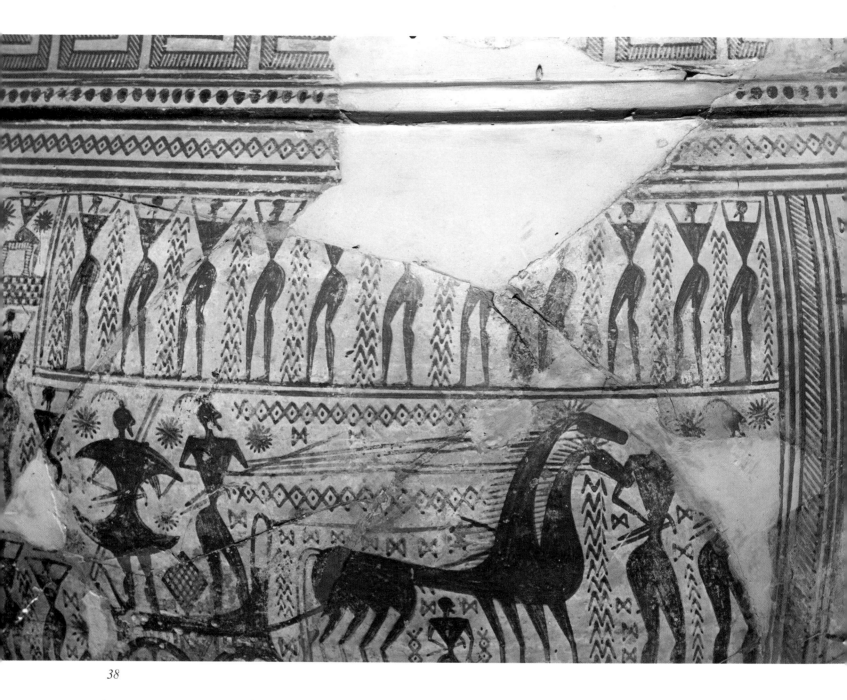

38

38 *Fragment of geometrical vase in the Dipylon style.* Eighth century B.C. Louvre Museum, Paris.

During the "geometric" period, roughly from 900-700 B.C., stylized animals appeared. The shape of the human bodies show how seriously divorced from actual observation the Greek concept of the human figure was at this time.

39 *Statuette of Apollo.* Boeotian, Archaic, seventh century B.C. Bronze. An ex voto of the Theban Apollo. Museum of Fine Arts, Boston.

The god is represented naked, and must have held a bow in his left hand. The forms are close to the geometric style, but already the facial details and the anatomical structure of shoulders and chest are more defined, the waist narrow and the thighs well rounded. The interest in anatomical structure displayed by this figure anticipates later sculptural developments.

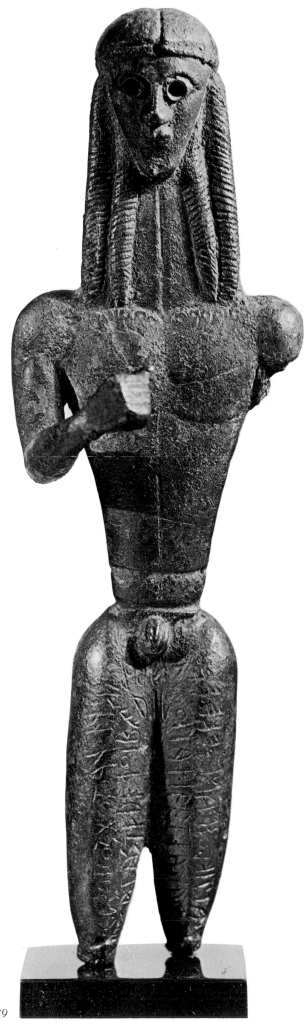

39

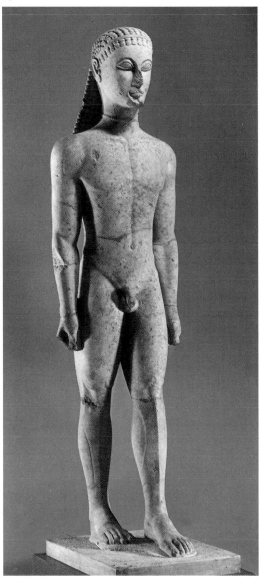

40 *Statue of a youth of the Apollo type.*
Athenean, early Archaic period, 615-600 B.C.
Marble. Height, 190 cm.
Metropolitan Museum, New York.

The anatomical structure of this figure is
less close to the geometrical style. The
representation is still frontal, but movement
is slightly indicated. A development has
begun toward refinement and grace
without weakening the features, expressing
enjoyment of life and aristocratic graveness.

40

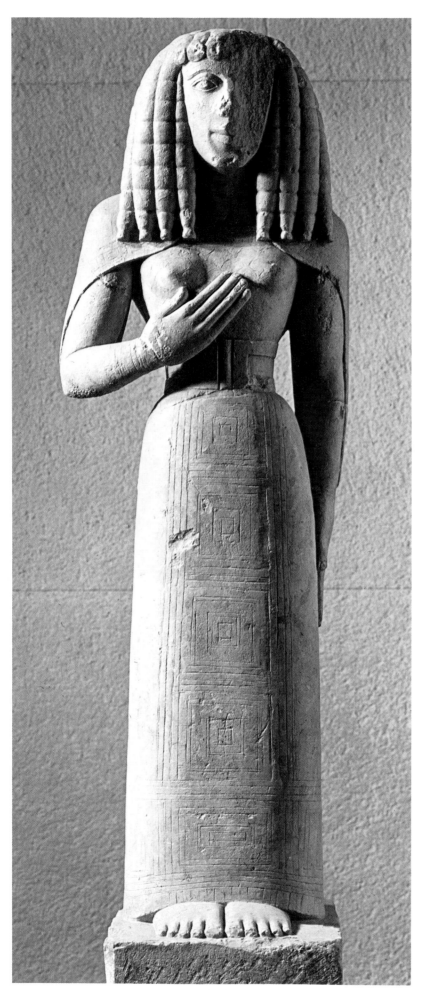

41 Female figure. c. 650-600 B.C.
Limestone. Height, 65 cm. From Auxerre.
Louvre Museum, Paris.

This female statuette illustrates clearly
the first phase in Greek statuary. Standing
rigidly encased in her tunic, squared-off
curls of hair framing her face in the
Egyptian manner, she holds her right hand
pressed against her chest. A wide belt
is drawn tight about her waist, and a cape
covers her shoulders; her costume is
adorned with geometric designs.

41

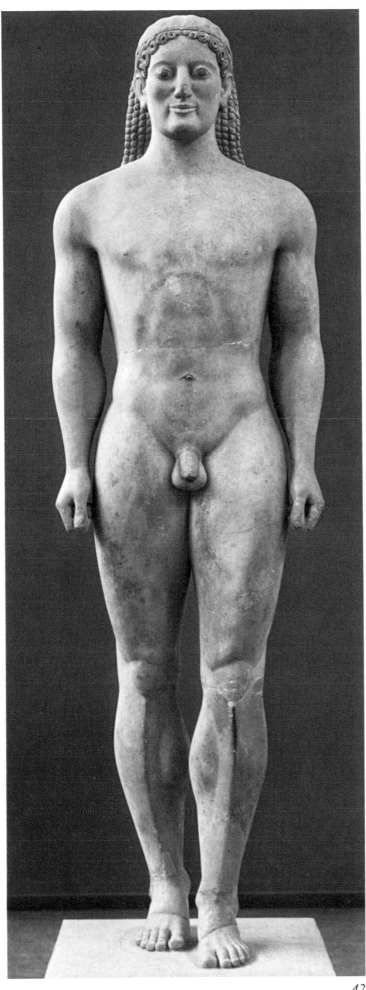

42 Kouros from Anavysos. 540-515 B.C.
Marble. National Museum, Athens.

This youth of Anavysos, taller than life-size,
still shows the long and curled hair of his
predecessors, but some parts of the body
are indicating an awareness of sensuality;
for example the stomach has softer forms
than ever before in Greek Archaic sculpture.

42

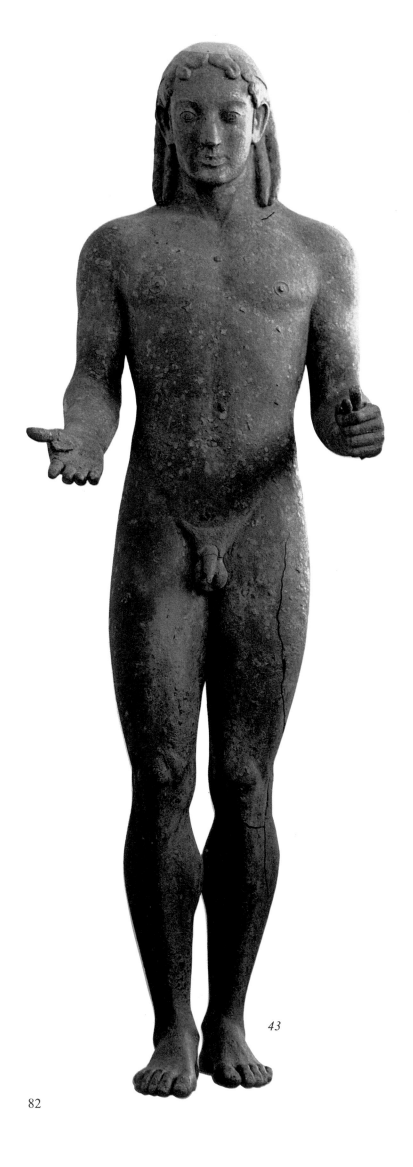

43 Kouros from Piraeus. Greek, Archaic, c. 520 B.C. Bronze. Height, 190 cm. National Museum, Athens.

The youthful figure held a bow in his left hand, and probably a patera in his right. His body is sensitively modelled in firm volumes; the representation of the legs already shows a sound knowledge of surface anatomy. The perfect stateliness of the body finds its complement in the grave awareness of the head, in which the features are sharply delineated, the eyes slightly downcast, the nose straight, and the lips compressed.

44 Cleobis and Biton. Greek, Archaic, 600-590 B.C. Marble. Kouroi signed by (Poly?)medes. Delphi Museum.

The heads of the two figures are flattened, and the strong faces, symmetrically framed by long curls, are expressionless, but the bodies are striking in their athletic strength. The anatomy is represented according to the general conventions of the time, but the artist has modelled his details with an intensity to express vigour and power: necks thick, pectorals massive, legs muscular, arms tensed, and fists clenched ready for action.

43

45 Statue of "Diadoumenos" after Polyclitus. Roman copy of a lost Greek bronze of c. 430 B.C. Marble. Height, 185 cm. National Museum, Athens.

As famous as Polyclitus' "Doryphoros" was his slightly later "Diadoumenos", known also only through replicas, of which this marble from Delos is one of the best. It betrays the influence of the more graceful style that came to dominate Greek art in the last quarter of the fifth century B.C. The pose is quite similar to that of the "Doryphoros", but the raised arms with which the young athlete tied a fillet round his head break the tight spatial framework in which the earlier figure was inscribed, and movement is now more important than stability. The slimmer forms foreshadow the taste for youthful nudes that characterized fourth-century sculpture.

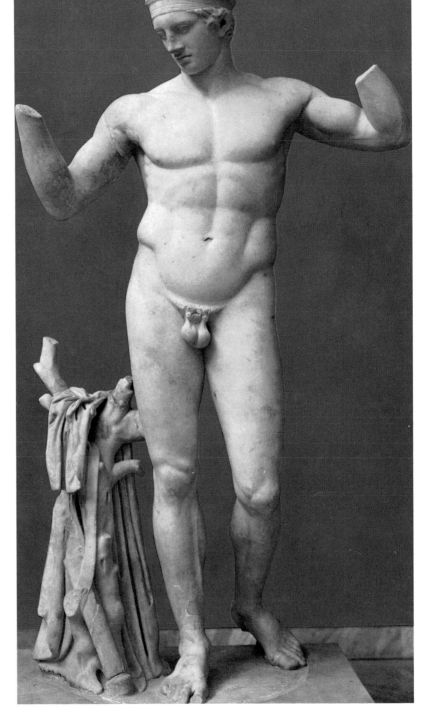

45

44

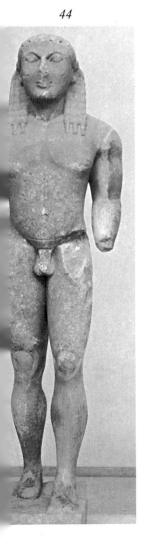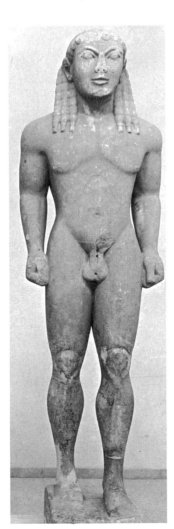

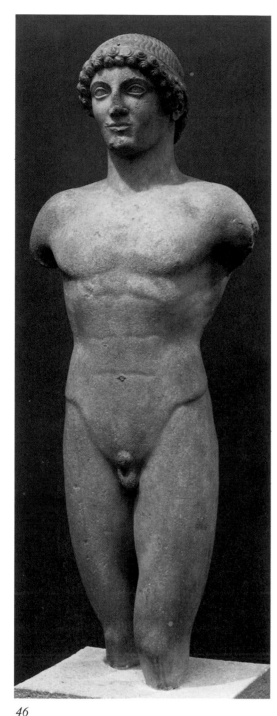

46

46 Statue of a young man. Greek, c. 500 B.C.
Parian marble. Height, 85 cm.
From Lemnos or Anaphine in the Cyclades.
British Museum, London.

This statue represents the severe style
between the Archaic and Classical periods
of Greek sculpture, which means that
certain anatomical details are developed
further than in the Archaic works, and that
there is a freedom—a beginning of
movement—in the frontal position
that foretells realizations attained in the
Classical period.

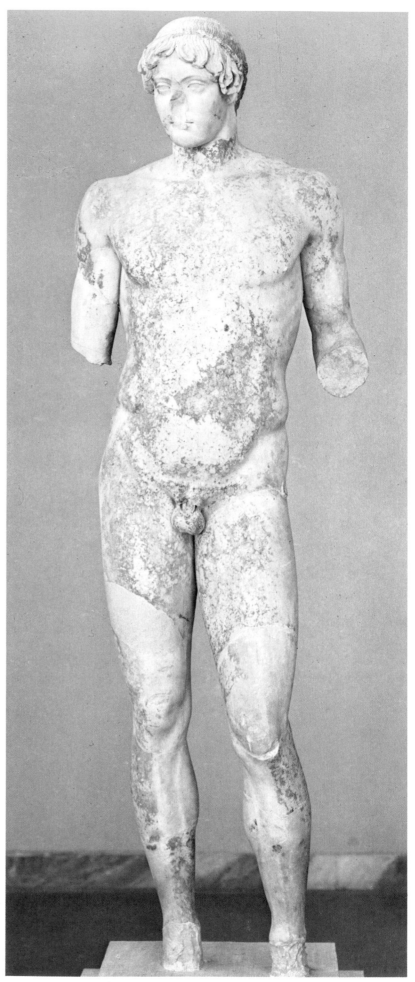

47

84

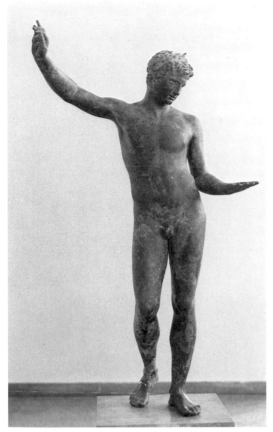

48

48 Statue of a boy. 375-350 B.C. Bronze.
Two-thirds life-size. Retrieved from a
wreck off Marathon. National Museum,
Athens.

In the treatment of the naked body it
seems that all anatomical problems have
been solved and attention can be paid to
the quality and texture of the flesh and
muscle.
This bronze statue of a boy represents the
Praxitelean style. The eyes are inset lime-
stone, with glass pupils, the nipples are
inlaid with copper. The impression of
gentleness is accentuated by the searching
gaze of the deep-set eyes.

47 The "Omphalos Apollo". Roman copy
of a Greek bronze of c. 460 B.C. Marble.
Height, 175 cm. National Museum, Athens.

The Archaic stiffness of the kouros has
newly given way here to a timid attempt
at asymmetry, the left leg is bent, the left
hip and the right shoulder slightly lowered.
The rendering of muscles is a compromise
between the earlier monumental stylization
and a more realistic approach.

49 Torso of Aphrodite of Cnidos. Copy of an
original by Praxiteles of 304-354 B.C.
Louvre Museum, Paris.

The sensuousness of this nude body is a
non-Classical feature; but the realistic
curves are still disciplined by a grave
harmony of undeniable majesty.

49

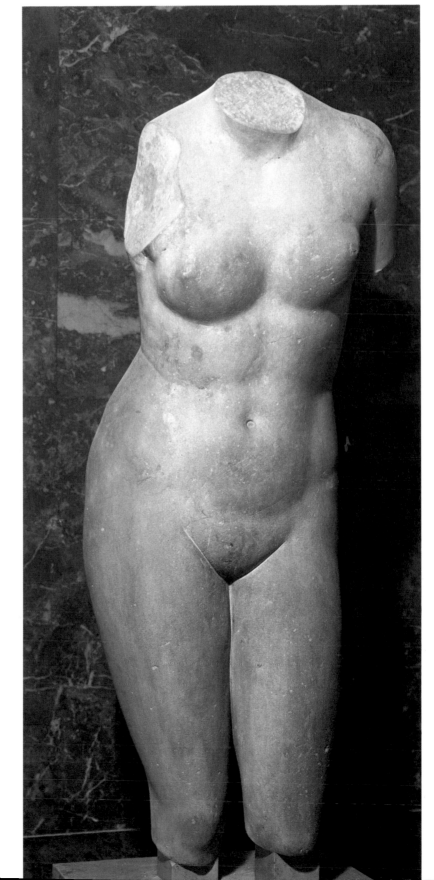

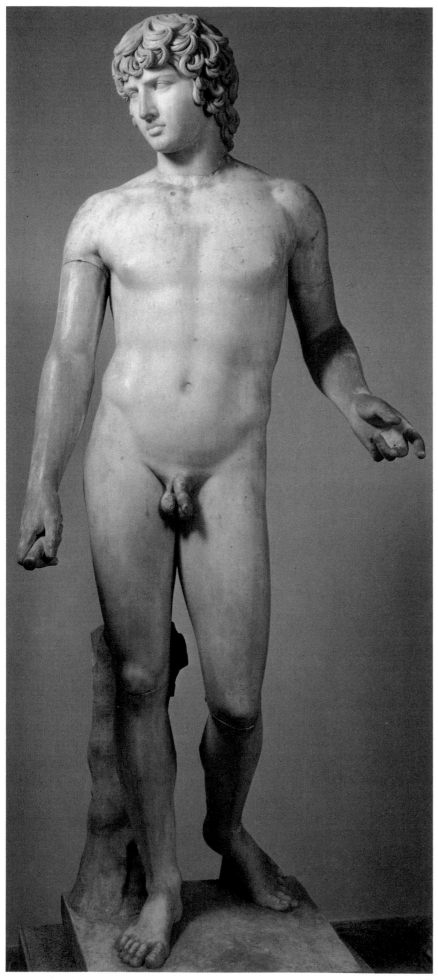

50 Statue of Antinous. First century B.C.
National Museum, Naples.

Antinous was a beautiful youth from
Claudiopolis, and the beloved of the
emperor Hadrian. He accompanied the
emperor during all his travels through
the Mediterranean world, and drowned in
the River Nile in 130 B.C. The emperor
gave him a place among the heroes,
named the city of Antinopolis in Middle
Egypt after him, and built a temple at
Mantineia in Arcadia for him where god-like
worship was offered. In all the statues—as
in this one—Antinous incorporates the
image of ideal youthful beauty.

51 Statue of a man. Third-second
millennium B.C. Terracotta.
Mohenjo-Daro, India. Karachi Museum.

The most complete ruins of a city of the
Indus valley were brought to light at
Mohenjo-Daro. A large number of small
terracotta objects were found. Human
figures as well as animals prove that the
makers of this pottery were well-trained
craftsmen. They did not try to get too far
away from nature, and followed the visual
reality with a certain faithfulness. Still, they
added expressive qualities to their represen-
tation by introducing abstract stylization of
the realistic form.

50

Chapter V
Mysticism and Philosophy

The Far East

52 Female figurine with elaborate hairdo.
Beginning of second millennium B.C.
Terracotta. Harappa, India.

Geographical conditions do not explain
the hybrid character of the earliest art in the
Western regions of central Asia. Historical
and religious circumstances contributed
equally to the phenomenon. Relations
between the Indian peninsula and the world
beyond go back to proto-history. Similar
features are to be found in the Mesopo-
tamian culture of the first half of the
second century B.C. and in that of the
region of the Indus at the same period.
Figurincs found at Harappa prove this
congruity. This figurine probably represents
a mother-goddess.

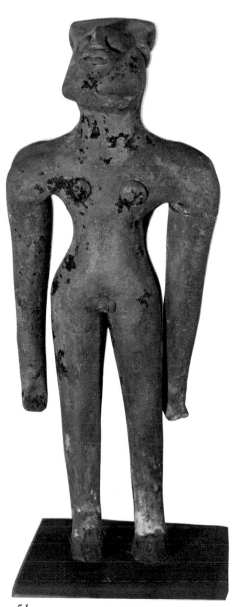

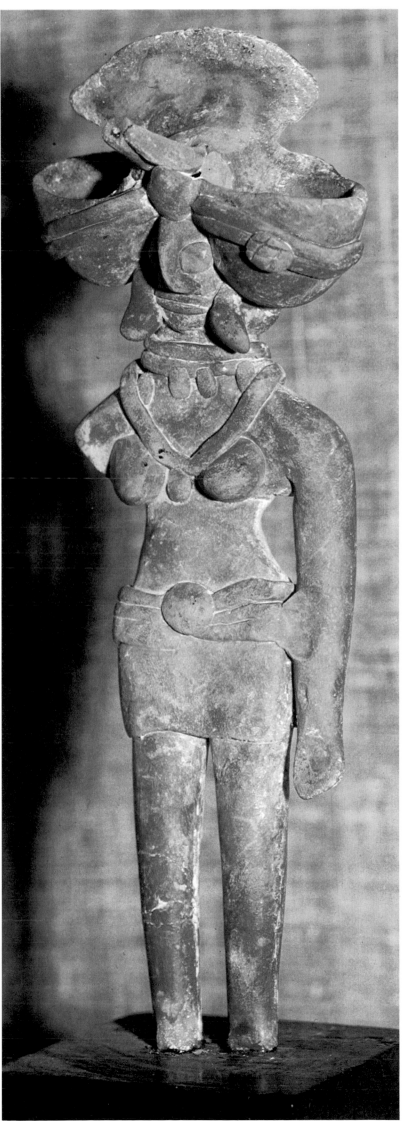

51

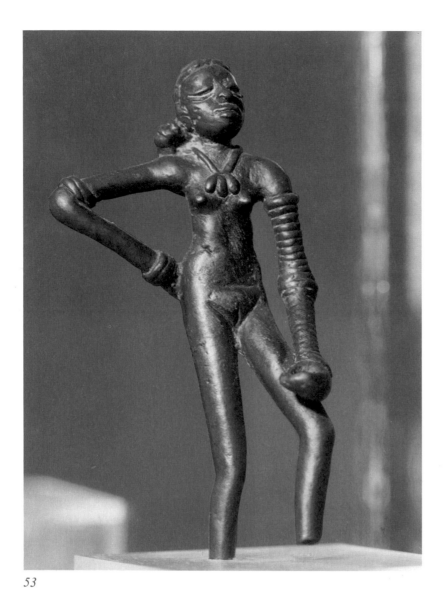

53

53 Statue of a naked dancer in repose.
First half of second millennium B.C.
Copper. Height, 14 cm. Mohenjo-Daro,
India. National Museum, New Delhi.

One of the most remarkable aspects of this
statuette is its powerful realism. It
represents a young female temple-dancer,
decorated with rings around the arms. It
can be considered as a prototype of the
tradition of Indian art. This work of one
of the first artists in the region shows a
highly developed skill, but astonishes
mostly because of the combination of
aggressive nudity and impressive self-
consciousness.

54

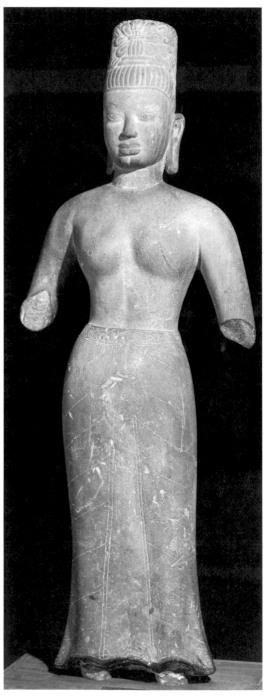

54 Female deity. Khmer, second half of the
seventh century A.D. Cambodia.
Guimet Museum, Paris.

Khmer sculpture evolved in the direction
of an evergrowing concern with perfection
in modelling, based on a profound
knowledge of anatomy; the knowledge is
not obviously asserted but is evident in
the mastery of the body's muscular
equilibrium. Admirable, partly-draped,
female statues were produced, equalling
Classical Greek sculpture in the beauty of
their modelling. For the most part these
figures have reached us in a mutilated
state, with head or arms—as in this piece—
missing.

55 *Banteay Srei*. A detail. Khmer, second
half of the 10th century.
Guimet Museum, Paris.

The bas-relief sculptures in Khmer art appear to have been subjected to all manner of subtle stylistic devices that strive to transform human figures, animals, and plants into moving, patterned arabesques, exploring all possible variations. The sculptors did not aim at rendering realistic spatial effects, but the infinite variations of light give an illusory depth to the compositions, enhanced by surprisingly pictorial effects. Every available space in the relief is filled with foliage or figures.

55

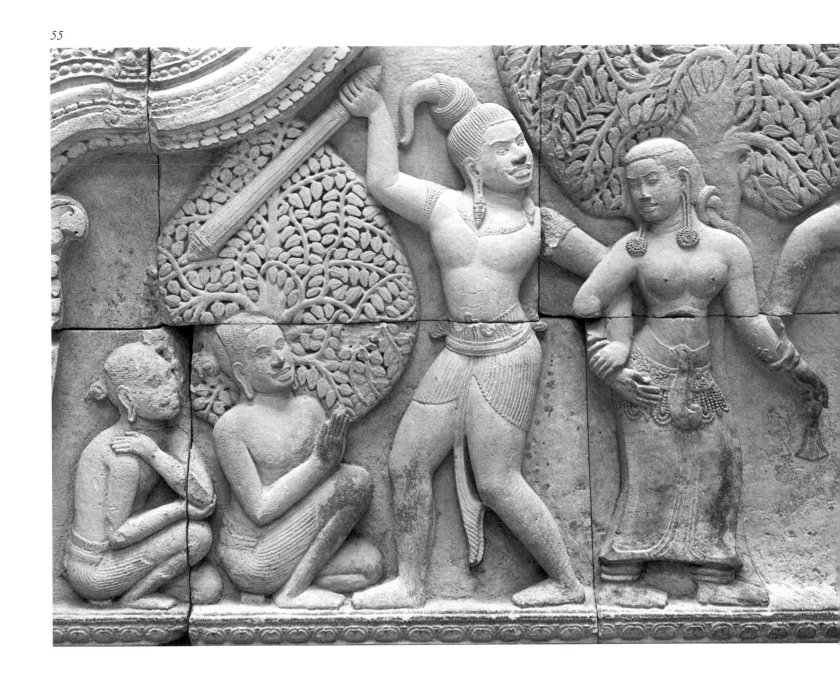

56 *Statuette of a Pârvâti goddess.* Indian, Chola period, 12th-16th centuries. Bronze. National Museum, New Delhi.

The goddess is represented upright—her hands make canonical gestures. The Indian conception of the female body is characterized by the importance given to the breasts. Although in this goddess their size is not exaggerated, their presence completes the ideal of female beauty. Even when they seem to be disproportionate, they are counterbalanced by subtle movements of the body; thus they form a natural unity with the whole. They belong to a harmony that is more of a vegetable than of an animal order.

56

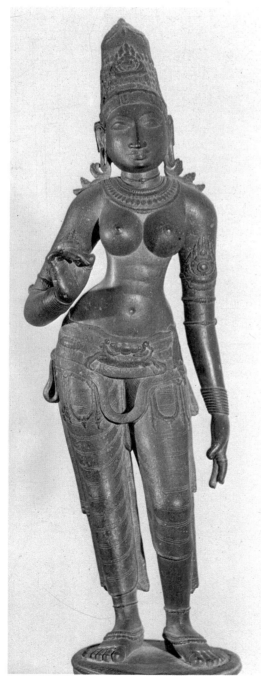

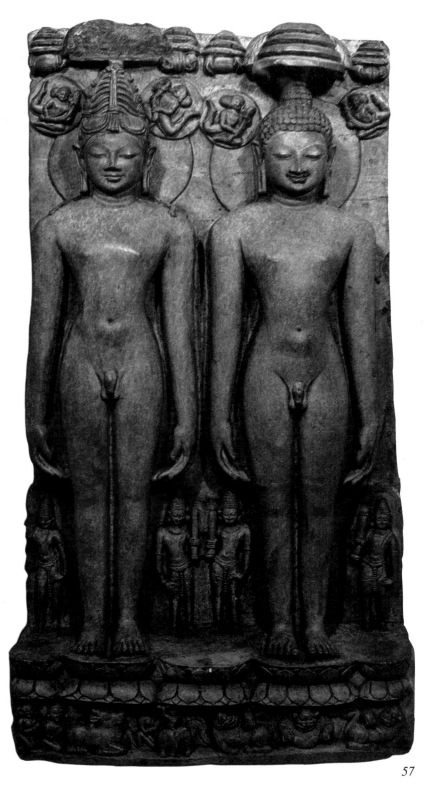

57

57 The Jinas, Rishabhadeva and Mahavira.
12th-13th centuries. Height, 68 cm.
From Jain cave temples at Khandagiri,
near Bhuvanesvar, Orissa, India.
British Museum, London.

Both figures are naked, or "sky-clad",
like many Jainist statues, nakedness having
been a rule of Mahavira and his disciples.
The two Jinas—conquerors—stand in
meditation in the posture of Kayotsarga
or dedication of the body: arms hanging
straight, feet in line. One of them stands
above his symbol, a bull; his eyes are
half-closed in meditation and fixed on the
tip of the nose. The other stands above a
lion—his symbol—and looks downward
with eyes open.

58 Statue of the goddess Tara.
Ceylon, 10th-11th centuries. Gilded bronze.
Height, 142.5 cm. British Museum, London.

The contrast between the message of which
this goddess is the incarnation, and her
proud and self-assured pose, is remarkable.
It is contrast between the doctrine of
abstinence and the renunciation of desires,
of which she is the embodiment, and the
perfection of her stature, somehow arousing
desire. There is a similar contrast between
the Man of Sorrow and his representation
—especially in Italy—as one marked by
beauty and hauteur. Every god worthy
of worship is provided with the attributes
in keeping with this—and the first is
beauty. It is, however, possible to explain
the proud mien of this Tara: she is beyond
suffering and shows her aloofness from the
bonds of all earthly things in the
deprecatory gesture of her hand.

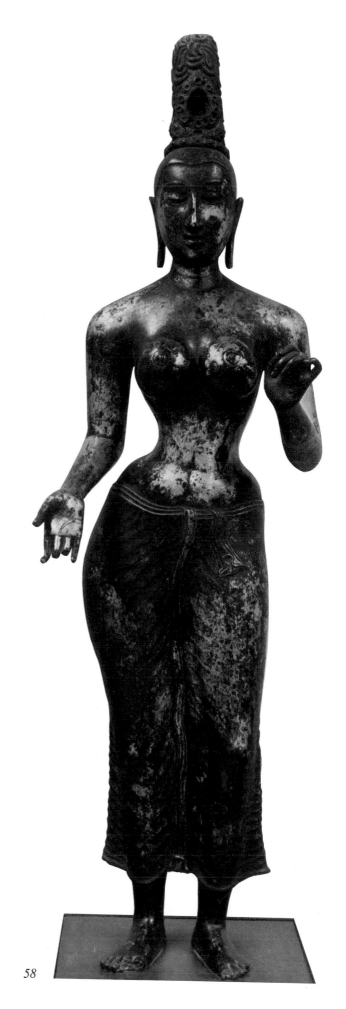

58

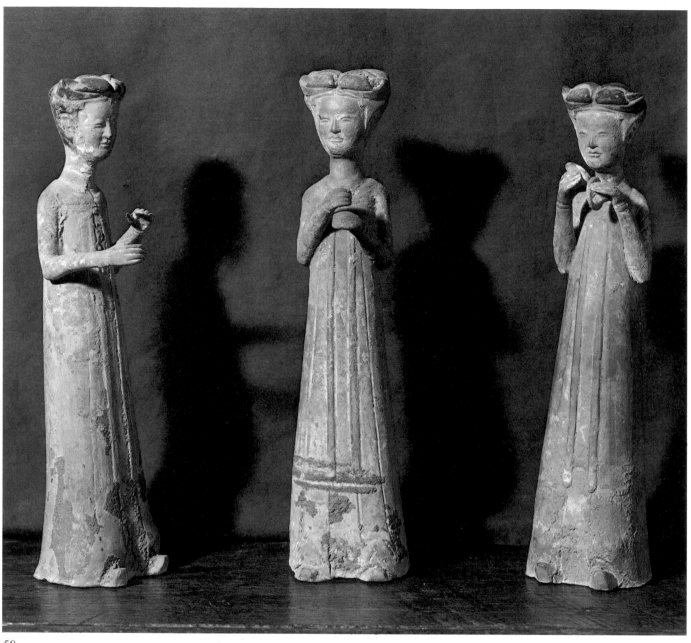

59

59 Three musicians. Chinese, T'ang Dynasty.
Terracotta, polychrome. Height, 25 cm.
Collection of George Renand, Paris.

In T'ang funeral pottery the figures of
human beings, birds, and animals are
modelled in a lively and spirited fashion,
especially those of horses, dancing girls,
and musicians. They are usually of a white
or pinkish-white clay. These exquisite
images of femininity still show a dynamic
stylization, a quality of synthesis tending
toward a simplification of forms.

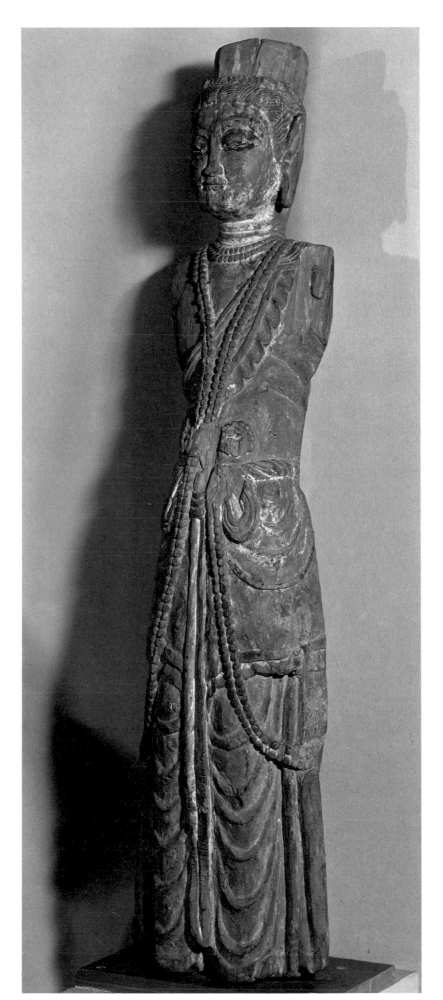

60

60 *Bodhisattva (of Tuang-Huang).*
Chinese Turkestan. Sixth-ninth centuries.
Wood. Height, 1.16 m. Guimet Museum,
Paris.

In Chinese Buddhist sculpture the body
usually played a subordinate role. It expressed
neither natural posture nor the rigidity and
nervous tension of trance. Its organic
relation with the head was not always
evident. Summary treatment of the body
was often linked with an unconvincing
rendering of drapery which neither
followed the natural rhythms of movement,
nor revealed the underlying form.
Nevertheless, these limitations of Chinese
Buddhist sculpture do not detract from the
imaginative appeal it exercises. The
repetitive nature of the work tends to
obliterate personal sensibility. Yet is retains
distinction and even majesty—as in this
Bodhisattva—owing perhaps to its simple
and direct mode of expression, unmarred
by overtones of sentimentality or the
falsely dramatic.

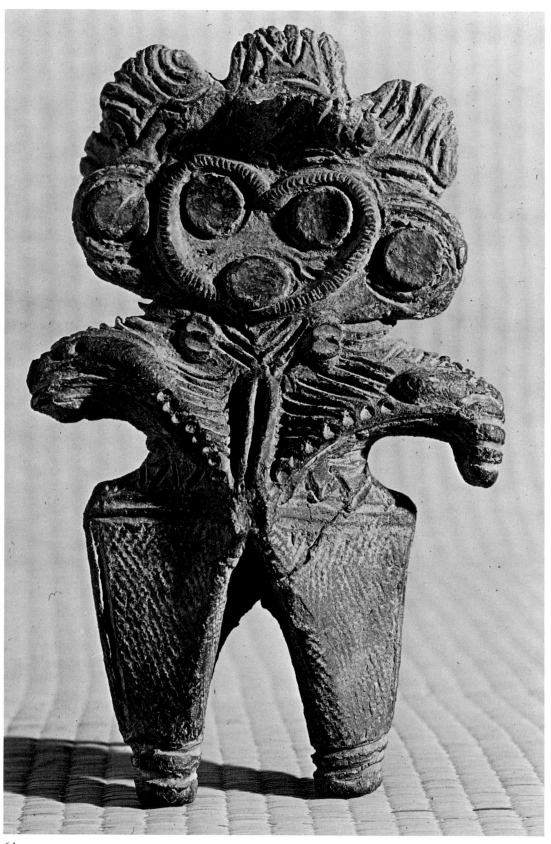

61

61 *Female figurine.* Japanese, Jomon period,
first millennium B.C. Terracotta.
Takeo Nakazawa Collection, Tokyo.

This female figurine is one of many
terracotta idols from the late Neolithic
culture of the Japanese archipelago; it
was found during excavations of a mound

of shells near Iwatsuki. The treatment
of the figure—a woman wearing a three-
lobed headdress—is schematic; her facial
features have been stylized and rendered
by small terracotta pellets. Like all the
terracotta statuettes of the Jomon period
it is interpreted as a symbolic portrait
of a mother-goddess and part of a cult of
abundance and fertility.

62 Haniwa. Japanese, fifth century.
Terracotta. Height, 80 cm.
Guimet Museum, Paris.

The haniwa, which originally were probably
simple terracotta tubes (the name in fact
means a circle of clay), were later sur-
mounted by figures, or heads, or models of
houses, boats, or objects of daily or ritual
use. Though almost certainly influenced by
the tradition of the Chinese Ming-ch'i, they
were intended for a different use: instead
of adorning the inner chambers of the
tombs, they stood close together in rows
following the outline over the top of the
monumental funerary tumuli.

62

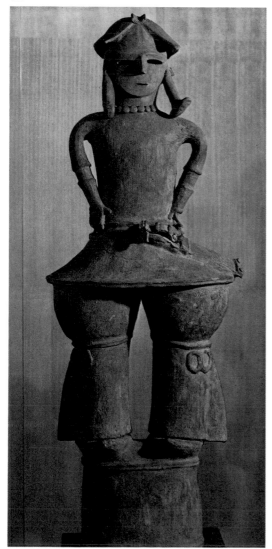

63

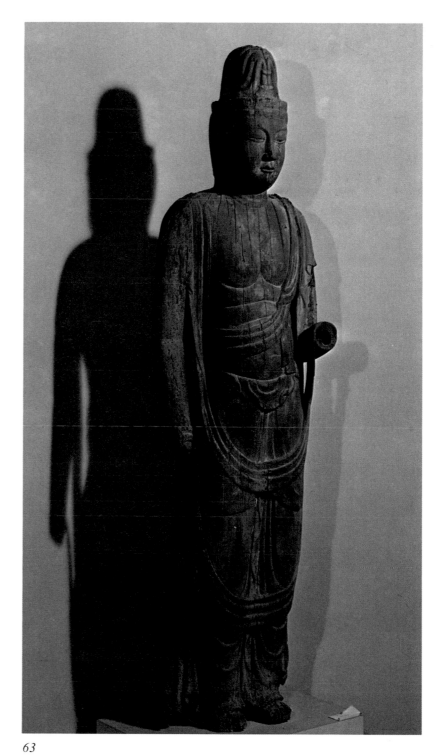

63 Standing Buddha. Japanese, probably
second half of the eighth century. Wood.
Guimet Museum, Paris.

This representation of the Bodhisattva
shows a strong influence of the monumental
art of the T'ang. They have the massive
body, the pliant draperies, and the austere
physiognomies in common. Most of these
statues, except the lotus-shaped base, were
carved in one piece of wood of the hinoki,
a Japanese cypress.

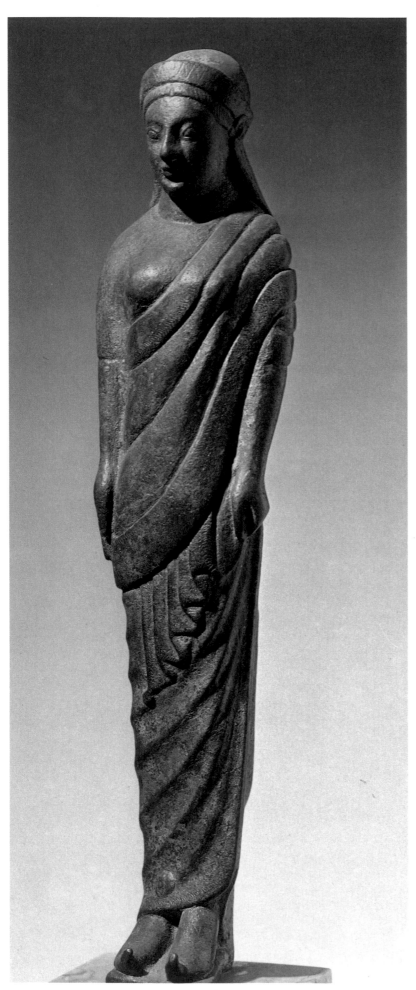

Chapter VI
From East to West

Etruscans and Romans

64 Aphrodite. Etruscan, sixth-fifth centuries B.C. Bronze. Louvre Museum, Paris.

Although Aphrodite was a Greek goddess, and although this statue shows evidence of Greek influence, there is something in its attitude that is unmistakably Etruscan. Between the eighth and the beginning of the seventh centuries, artistic activity in the cities of Etruria developed parallel to that in other Mediterranean countries, including Greece. It participated in one of the last elaborations of an ancient pre-Hellenic Mediterranean artistic experience. From the beginning of the sixth century the influence of Greek Archaism on Etruria manifested itself in the realms of religion, dress, and arts.

65 Naked lancer. Etruscan, fifth century B.C. Bronze.

In many ways this naked lancer reminds us of the bronze figures of early Mediterranean cultures. As a matter of fact, in Etruscan art there is a notable persistence of formal patterns, technique, and traditions belonging to the Mediterranean and orientalizing phase of the Archaic period. At the same time, the strongly individualized and immediate attitude of the lancer reveals an artistic vision that may be considered as unmistakably Etruscan.

65

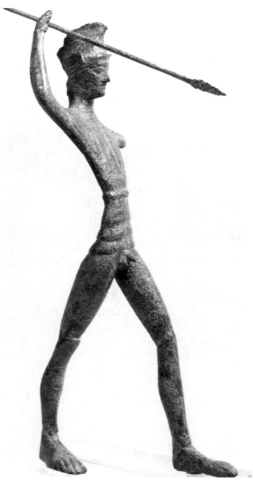

64

The elongated figure of this female goddess owes no fidelity to Classic proportions in sculpture. The ecstatic gesture of the two disproportioned hands adds to its strange impression the undefinable quality of Etruscan, death-enhanced art. The gaze seems to be fixed on a suddenly revealed hereafter. The power of this vision communicates itself irresistibly, thanks to the radiant face of the youthful goddess and the expressive, motionless gesture of the hands.

67 Votive statuettes. Etruscan, third century B.C. Museum of the Villa Giulia, Rome.

Votive statuettes like these were produced in great number. In expression they do not differ much from the Aphrodite (no. 66) that is supposed to be about a century older. This might explain the lack of sculptural individuality, and of magic as well, in these votive statuettes, compared to the Aphrodite. They have become a standardized product, even though the figure, reduced to a vertical, and the limbs, to two gesturing hands, still fascinate.

67

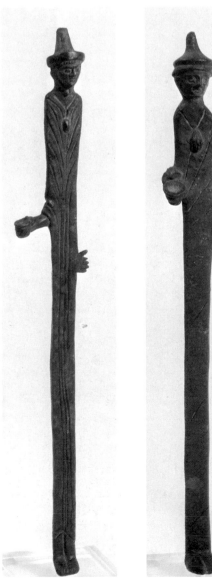

66

66 Aphrodite (?). Etruscan, fourth century B.C. Bronze. Height, 33 cm.
From the region of Ancona.
Louvre Museum, Paris.

69

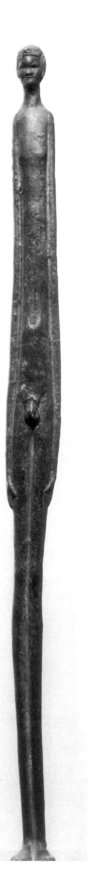

68

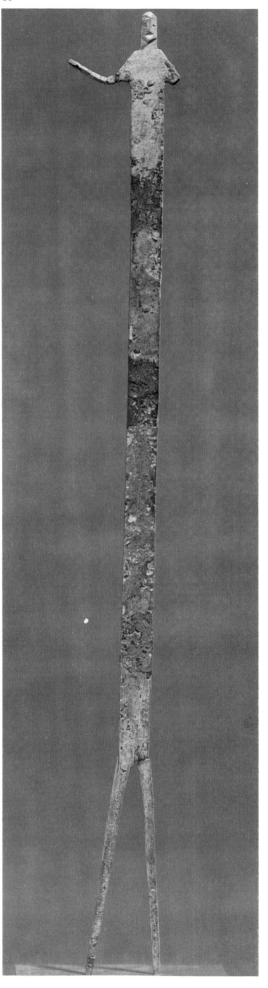

68 *"Ombra"*. Etruscan. Bronze. Etruscan Museum, Volterra.

Rarely did European art show such a distortion of realistic forms and dimensions as this Etruscan figure. Nothing is left of the Classical rules, dividing the human body into well-proportioned parts. Motionless, without any gesture, the man stands, being more of a sign in the silence of eternity than a reminder of earthly existence.

69 *Elongated figurine*. Etruscan, end of fifth century B.C. Bronze. Umbria. Borowski Collection.

In this figure the artist arrived at the maximal reduction of the human body to non-representative abstraction. As in similar works of the modern sculptor Giacometti, the illusion is created of an endless distance between the spectator and the sculpture.
The highly stylized figure seems to belong to another dimension of life, perhaps the one of death. Anyhow, all the sculptor could do to underline the distance that separates nature from art, the physical from the metaphysical, he realized in this bronze.

70 *Girl gymnast*. Roman, fourth-third centuries B.C. Mosaic. National Roman Museum, Rome.

This is from a set of late Roman mosaics, recently excavated at Piazza Armerina in Sicily. The girl is the centre figure of three, usually believed to be gymnasts. The wheel fitted to a stick, which she holds in one hand, was presumably meant to be twirled. Acrobatics was a popular entertainment in the Ancient World and this mosaic shows that the appeal was maintained in the later years of Imperial Rome.
The cloth that covers the breasts served a utilitarian purpose; the effect is remarkably like that of a present day "bikini" swimming costume.

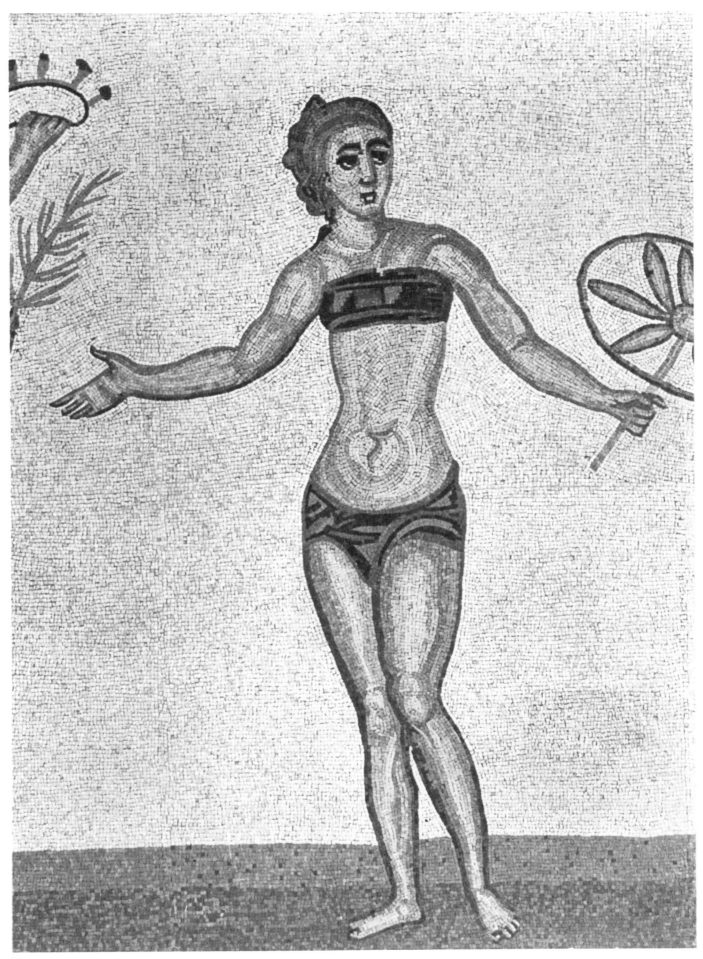

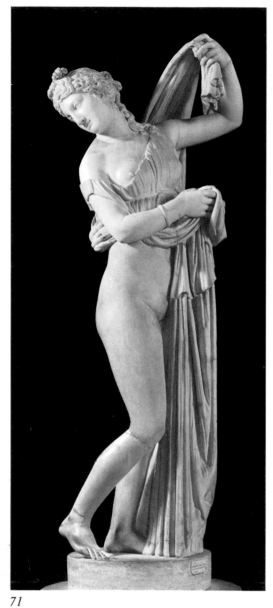

71

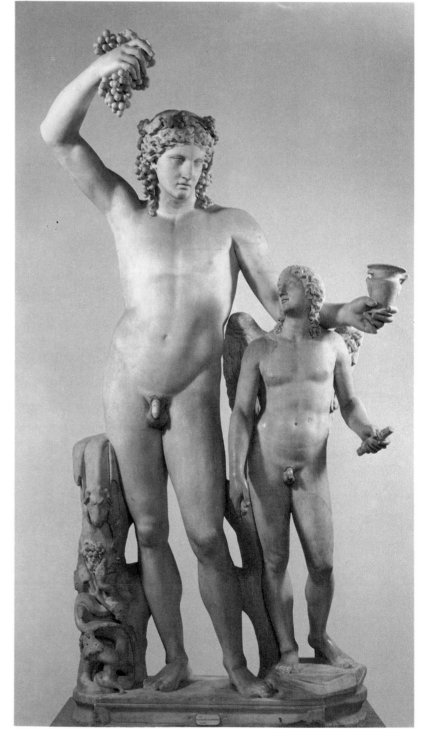

72

71 Statue of Aphrodite Callipygous.
Roman. National Museum, Naples.

In general form, this female figure belongs
to the tradition of Classical Aphrodites.
But the twist of the body on its axis—head
and shoulders turned to her right—the
complex tilting of the different sections
of her torso, the provocative gesture with
the draperies, and the sensuousness of the
nude body are all non-Classical features,
typical of the development of the Greek
style in the Roman period. The softness
and weakness of the face are the result
of a further disintegration of the Praxitelean
tradition.

72 Group of Bacchus and Amor. Roman. National Museum, Naples.

The conquest of Grecia Magna first, then of Asia Minor and of Hellas itself in the mid-second century B.C., increased the flow of Greek art works to Rome. The fascination that Greek art held for the Romans is shown by the innumerable copies that were made of famous Greek sculptures, copies that very often provide us with the only form we know of those pieces. The work of art, having become simply a luxury item, provided an excuse for a skilful manipulation of diverse forms. Characteristic of the resultant eclectic style is this group, that assembles reminiscences of different Greek originals.

73 Statue of Antinous as a god. Roman, c. 140 A.D. National Museum, Naples.

The cult of friendship that flowered in ancient Greece was taken over by the Romans. The emperor Hadrian, whose friend Antinous died by accident in Egypt, installed the cult of god-like Antinous all over the Roman Empire.
In this sculpture the ephebe is represented as a strong and youthful Bacchus, who holds the wine-cup in one hand and the grapes in the other. Vine leaves are twisted in his hair. The expression of his face makes one think of the "David" by Michelangelo, executed 14 centuries later in Renaissance Florence. Both have the convincing combination of power and youth, of strength and beauty.

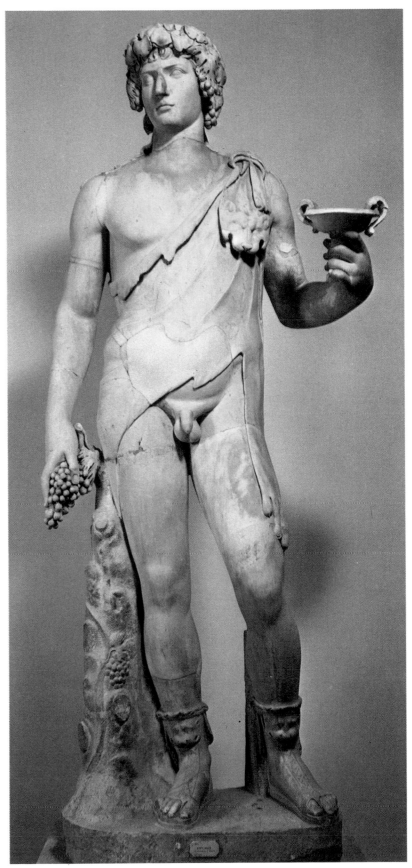

73

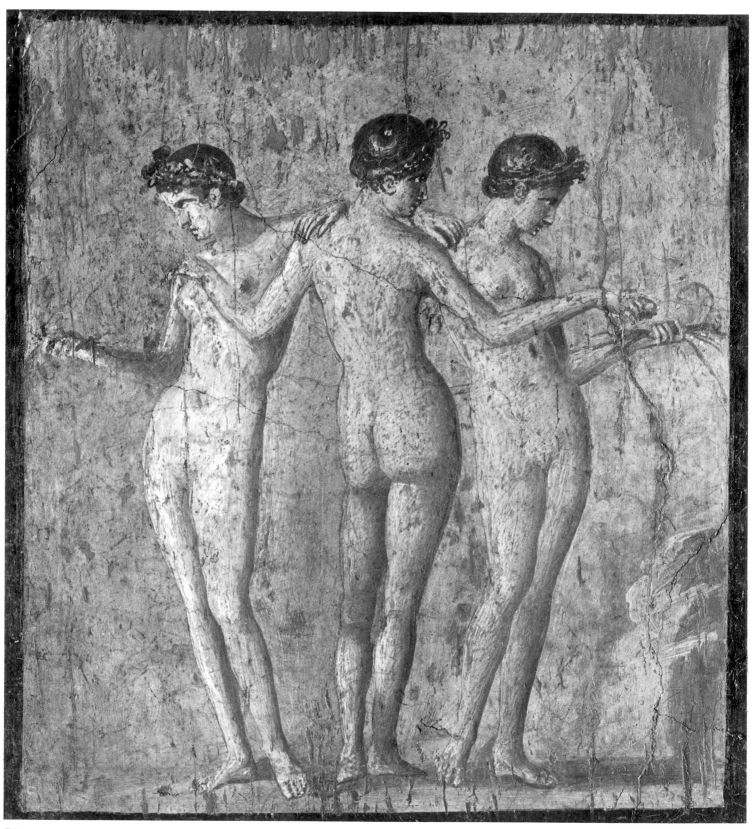

74

74 Group of the three Graces. Roman,
first century A.D. Pompeian fresco.
National Museum, Naples.

The Romans took the theme of these three
goddesses from the Greeks, who called
them "Charites". The naturalism of the
representation of the human figure is not
of great artistic interest, although a certain
grace and elegance distinguish Pompeian
art. But this fresco makes clear the apprecia-
tion of the nude figure, no longer in any
religious context, but for mere aesthetic
—and erotic—pleasure. The composition
follows the Greek example. Paintings of
this kind went well with the hedonistic life of
the inhabitants of Pompeii; they possess
still the virtues of the Classical conception
of beauty: an enjoyment of the nude, an
appreciation of youth and clarity of the
form.

75 Small altar. Gallo-Roman, first-second
centuries. Height, 13.5 cm.
Museum of St. Germain, France.

This small altar, representing three human
figures in the most elementary simplicity,
was found in Burgundy, France. According
to some historians it should be considered
as an altar; others suppose it to have been
a tombstone.
Only the heads bear a detailed and
descriptive indication of forms: the eyes,
the mouth, and the nose. No attention
was paid to the body: a characteristic
phenomenon in all primitive art, where the
spirit of man is believed to reside in the
head.

75

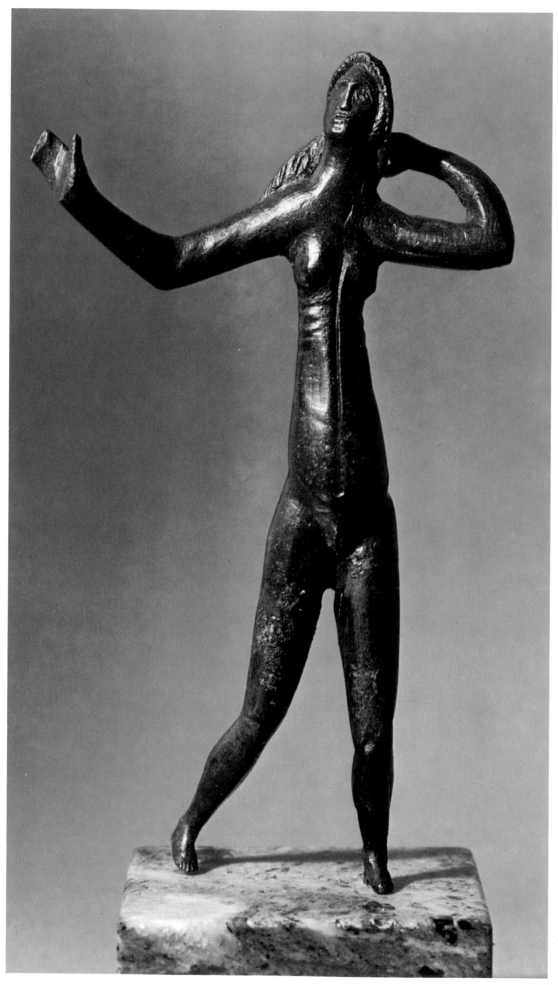

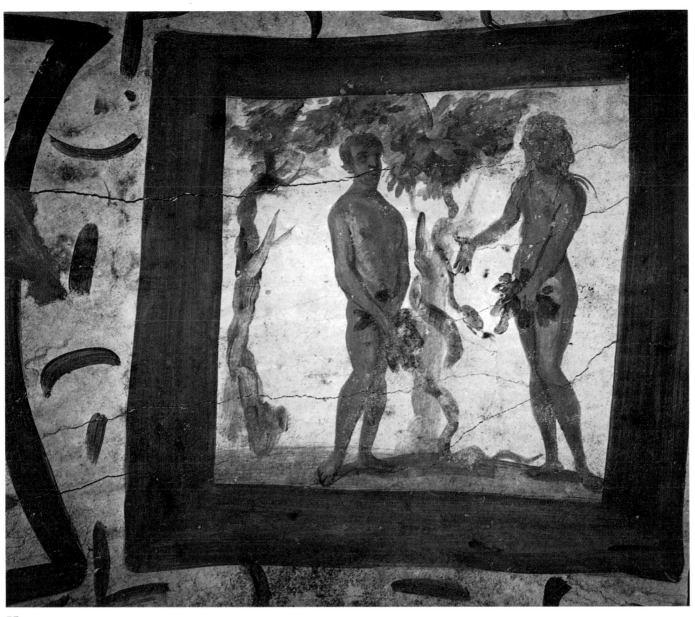

77 *Adam and Eve*. Third century. Fresco. Catacomb of St. Pietro and St. Marcellino, Rome.

Christian painting presented, in its very beginning, not a documentation of the manners, modes of life, and outward actions of the society that brought it into being, but the working-out of a system of communicable signs and symbols. Systematically these signs and motifs were translated into elements filled with meaning. By preference, visual images were utilized that implanted their message in the minds of men. To achieve this end, Christian art did not reject the means of pagan painting. Christian artists maintained the techniques and figurative elements with which the dominant civilization equipped them. The theme of Adam and Eve allowed them to paint the human figure in its nudity; a pagan conception of the body diverted from its non-Christian significance.

76 *Female dancer*. Celtic, Gallo-Roman period. Bronze. History Museum, Orléans.

The little dancer, executed in bronze, is one of the most striking examples of continuity in French tradition. The shape of the body, the reduction of forms to their essential, yet elegant simplicity, foreshadow what Matisse was to do in the 20th century.

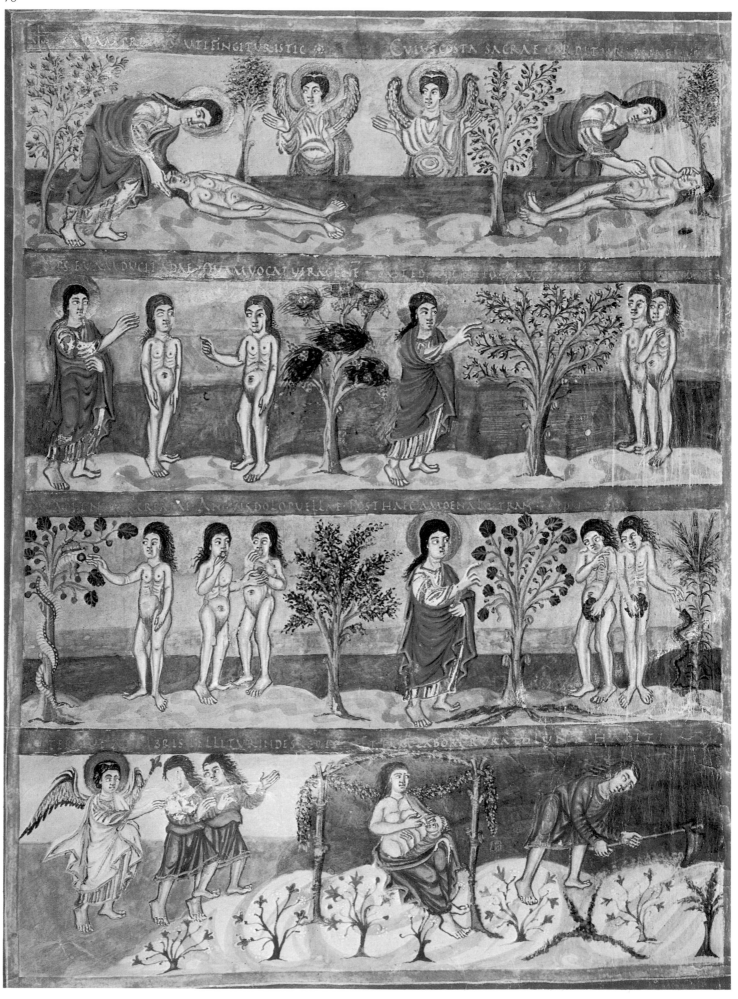

78

106

Chapter VII
Heaven in View

Christianity in Europe

78 The story of Adam and Eve. Bible of Alcuin or de Moutier Grandval. First half of ninth century. British Museum, London.

In this narrative Bible-illustration the story of Adam and Eve is told from man's creation up to the moment he has to work for his daily bread, driven out of paradise. Adam and Eve offered to the artist of the Carolingian period one of the extremely rare opportunities to paint the naked human figure. Both man and woman are rendered here with moving naivety. An early attempt is made to give the biblical story a natural setting. The appearance of angels in the sky goes hand-in-hand with the artist's effort to create a real landscape. Even the psychological expression is introduced; the couple, joyous and almost unself-conscious before Eve did the forbidden thing, turn into beings full of shame, hiding their sex.

79 The Original Sin. Detail of the mural paintings of Santacruce, Segovia, Spain. c. 1125. Prado Museum, Madrid.

Rather than with line, and in spite of the beauty and perfection of certain stylizations, the lasting message of Romanesque painting for us today may well lie in the intensity and play of its contrasting colours, whether these are found in the figures themselves or in the backgrounds inseparably linked with them in a perfectly counterbalanced pattern—for there is little room in this art for perspectives and the false effects of relief, relegated at best to the role of highly decorative fretwork. Quite apart from its plastic value within the framework of European art, attributable mainly to its expressive human qualities, Romanesque painting in the Spanish peninsula had certain historical features. Highly effective stylization was combined with intense whites in contrast to blacks and dark greens.

79

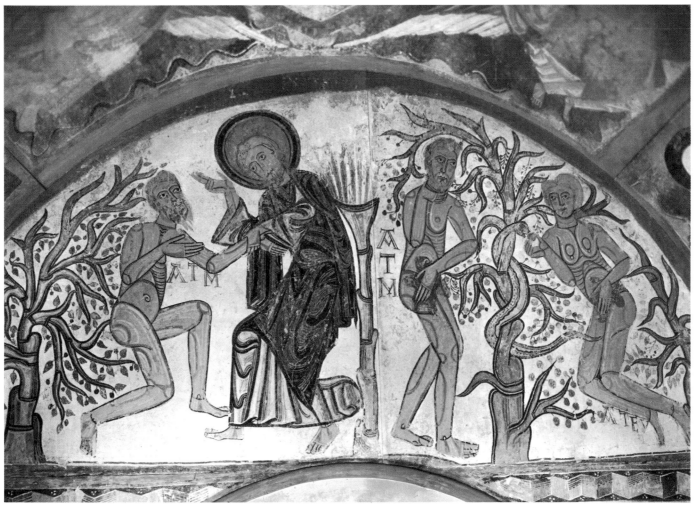

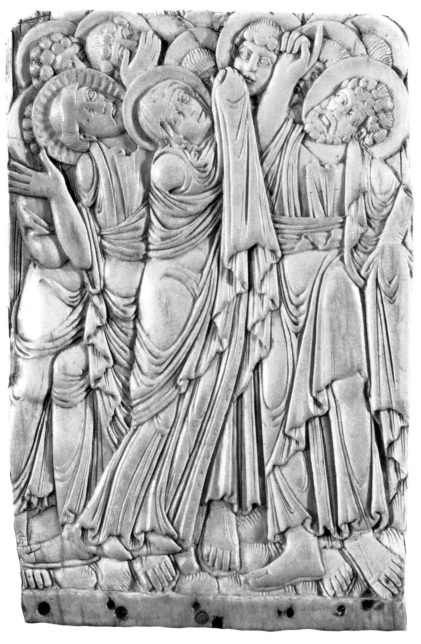

80

80 Ascension. Carolingian fragment of the
Ada group, probably Rhine/Mosel region.
Tenth century. Ivory. Landesmuseum,
Darmstadt.

A more crowded composition can hardly
be imagined. One of the figures in the
foreground indicates in which direction
Christ disappeared; the others look
up toward the Ascension.
As a moment in the history of the human
figure this fragment is of particular interest.
Something of the tradition of Antiquity
still seems to be conserved; but the whole
is fully impregnated by the Christian spirit.
The folds of the mantles hide the bodies;
but at the same time they allow a few
fleeting glimpses. Just enough to translate a
sensuous awareness of the body which was
doomed to decline in coming centuries.

81 Adam gives names to the animals.
Thirteenth century. Mosaic at the dome of
the narthex; St. Mark's, Venice.

The human figure, at the date of this
mosaic, still proved to be something of
which the artist could conceive; its
representation had not been checked by a
study of reality. Anatomical proportions
were neglected, and the artist had no idea
how a body moves at the moment certain
gestures with the hands are made. Never-
theless, a great step forward was made in the
direction of unprejudiced acceptance of
reality. Although the golden background is
still there, it is beginning to be penetrated
by landscape, and in the presentations of
the animals an effort is recognizable to
liberate them from too heraldic postures.
Adam himself is not an idealized figure; he
stands there, a little bit lost in paradise,
wondering what he is doing surrounded by
all these animals he has to baptise.

108

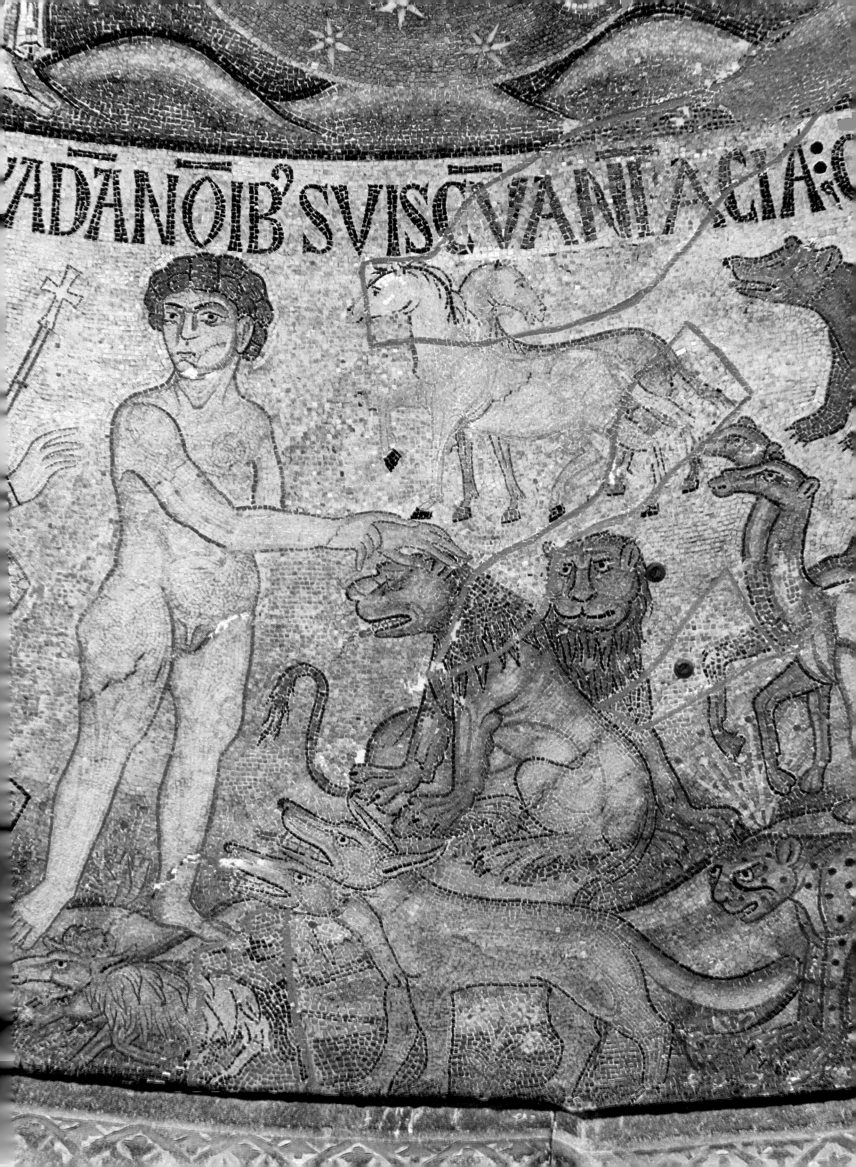

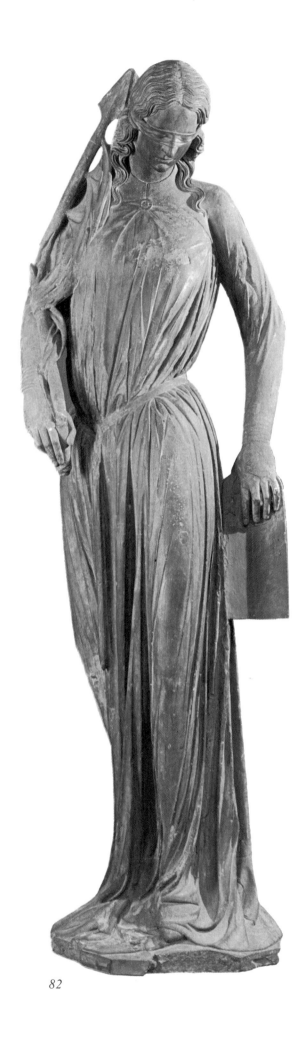

82

82 The Synagogue (c. 1230-1250). From the cathedral of Strasbourg. Museum de l'Œuvre Notre-Dame, Strasbourg.

Master masons and sculptors of Strasbourg worked in the Rheims stoneyards and brought home with them the style of that city. The allegory of the Synagogue is modelled after that of Rheims which was executed in about 1225 and was still impregnated with the style of the classicizing sculptors. But the Strasbourg Synagogue is more ethereal and unreal than its French prototype. Movement is more strongly marked in the gestures of the arms. The art of Rheims had enormous prestige and influence during the Middle Ages, when it was considered the model of all arts by the whole of Europe.

83 Hugo van der Goes (c. 1440-1482): The Sin of Man. 1467/68. 35.5 × 23.2 cm. Kunsthistorisches Museum, Vienna.

Adam and Eve, both tender and vulnerable figures, move in a beautiful and charming landscape. They seem not to take any heed of the strange creature that leans against the tree, but they have surrendered already to its whisperings. Eve, who has the first apple in her right hand, takes the second one to offer it to Adam. Her look is full of innocence; she does not seem to realize that she is committing a forbidden act. Adam looks upon her, stern and honest, and full of—misplaced—confidence.

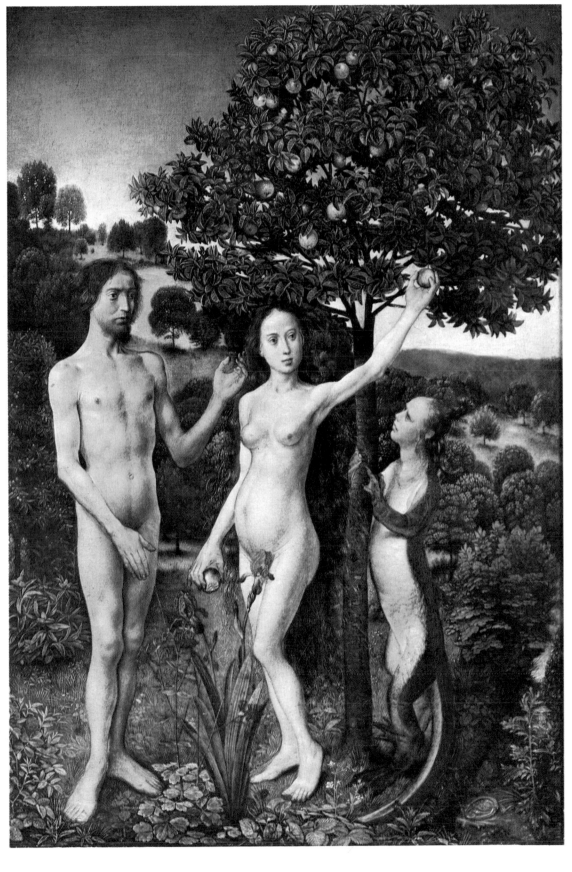

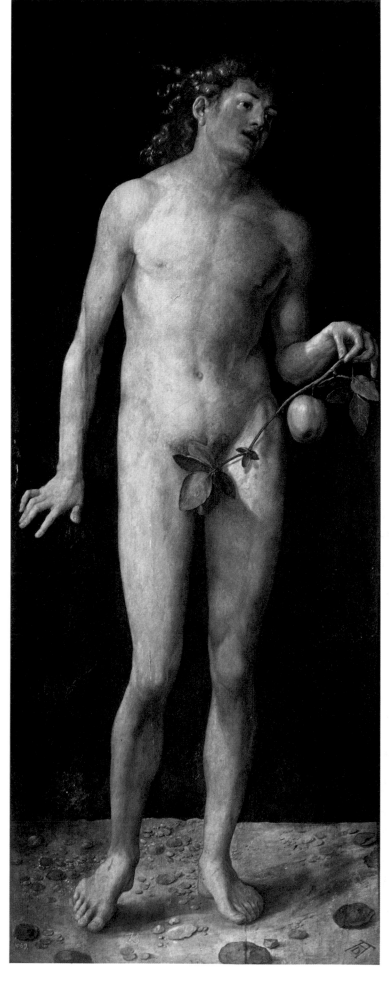

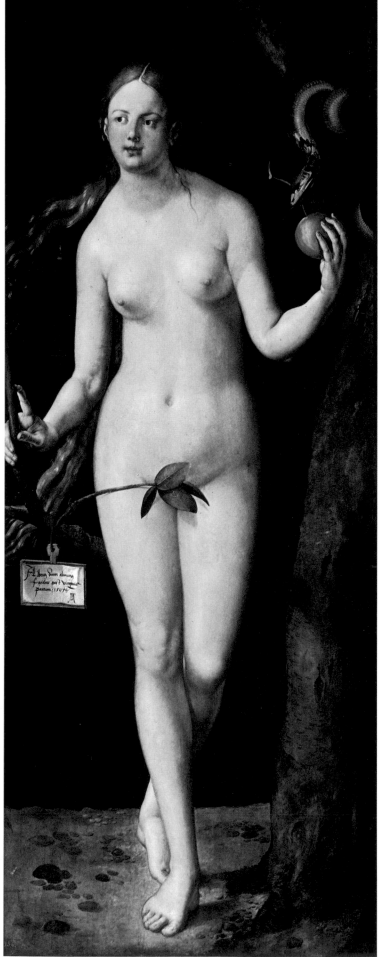

84 Albrecht Dürer (1471-1528): Adam.
Wood. 209 × 81 cm. Prado Museum,
Madrid.

According to humanist theories, the first
couple, created by God after his own
image, should be the perfect model of
humanity. In Venice, Dürer studied the
doctrine of proportions, and he applied
these principles in the two panels of Adam
and Eve. Adam looks like a handsome
Apollo, without muscles, his arms long
and thin. No effort is made toward
naturalistic fidelity; both figures translate
an abstract ideal of beauty. The half-open
mouth of Adam reflects a sensuous impulse.

85 Albrecht Dürer (1471-1528): Eve.
Wood. 209 × 80 cm. Prado Museum,
Madrid.

The Madrid Eve has something of the
Gothic Middle Ages about her—emphasized
by the chance of the leafy branch
concealing her "shame"—and she is full-
faced in a quite Germanic, non-Italian style.
Yet the proportions of her body belong
to elegant Mannerism, and it might even
be held that the precarious placing of the
feet would be more appropriate in a
statuette of a figure posing on a ball.
Dürer was influenced by Leonardo da
Vinci and traces of this influence can be
found in the expression on Eve's face. There
is a kind of a secret smile around her lips.
She looks—tempting him—at Adam,
who still hesitates but already desires her.

*86 Lucas Cranach the Elder (1472-1553):
Adam.* 1528. Panel, 167.5 × 60 cm.
Uffizi Museum, Florence.

At the beginning of Christian art the nude
was considered to be an unworthy subject.
Theology ordered that the first human
couple should be represented sexless; in
Byzantine art Eve has no breasts and only
the length of her hair characterizes her as a
female. In the famous Bamberg sculptures
Eve is an almost neutral figure. It is possible
that this conception of Adam and Eve was
based on the theory that originally—before
the Fall of Man—these beings were sexually
indifferent. In the cathedral at Rheims
Adam and Eve are depicted in clothes.
Up to the beginning of the Renaissance,
the right of being beautiful, well-rounded,
and attractive was not accorded to the
human figure. Only when humanism entered
with the Renaissance, did things change.
A couple like Cranach's Adam and Eve
became possible. Elegant, almost sophis-
ticated nudes, both standing in a relaxed
posture: they feel at ease being nude—a
situation in art that had not occurred since
the decline of Antiquity.

*87 Lucas Cranach the Elder (1472-1553):
Eve.* 1528, Panel, 167.5 × 60 cm.
Uffizi Museum, Florence.

Although the leaves that had to hide
the sex of Eve could not yet be left out,
they are as small and subtle as possible.
They are no longer placed by accident, as it
were; Eve holds the branch in her hand
with obvious coquetry. It looks as if she
realizes perfectly well how charming this
piquant accent will work on her svelte body.
She is, in every sense of the words, a
beautiful and attractive woman, with a
slightly melancholic expression in her eyes
that goes so well with her subtle
sensuality. With conscious elegance she
holds the apple in her hand, showing it to
Adam and, at the same time, tempting him
not with this fruit, but with the presence
of her naked body.
Both faces have an extremely personal
individuality, both in shape and expression.
This panel is part of a diptych; on the
other half is shown the Deploration of
Christ. Obviously, the painter wanted to
emphasize the consequences of Eve's act.
The opposition and confrontation of both
scenes has a strong, immediate, almost
cruel effect.

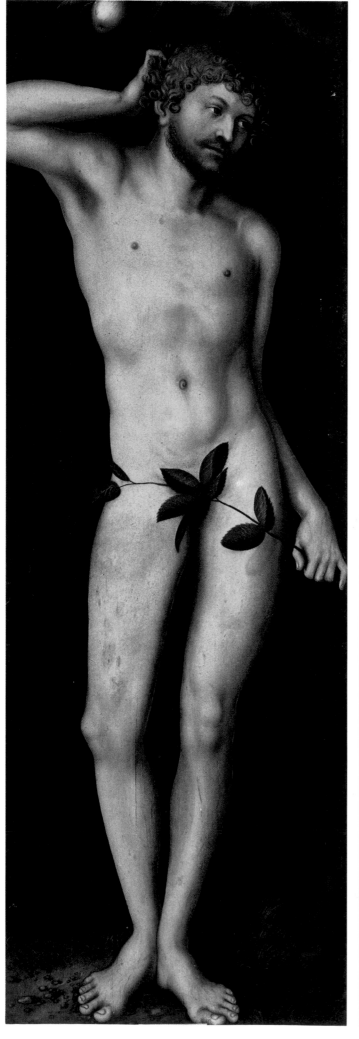
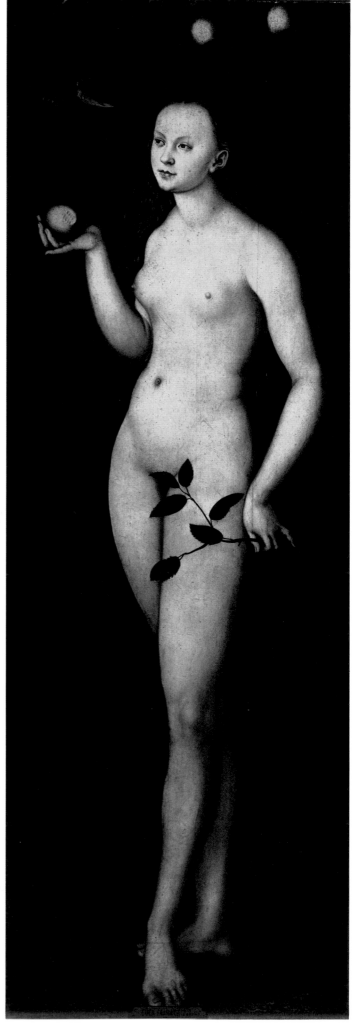

Chapter VIII
The Conquest of Reality

Renaissance, Baroque, Rococo

88 Masaccio (1401-1428):
The Expulsion of Adam and Eve. Fresco,
208 × 88 cm. Carmine, Brancacci Chapel,
Florence.

The great nudes of Masaccio pointed the
way to more vigorous action, and a no
less convincing sense of solid form.
Why is it that the human figure in action
is so expressive? The spectator obviously
does derive a keen sense of pleasure from
a painting of the human figure that
convincingly suggests its weight and
volume, its physical strength, and its
capacity of rhythmical and significant
action.
Masaccio's knowledge of perspective was
not of a pedantic nature. He appears to
have assimilated the principles of the
science with the same native ease with
which he mastered the general construction
and appearance of the human figure.
His figures are living people, not coloured
statues, and in the "Expulsion from
Paradise" Adam and Eve have the heroic
bulk and heavy build of primaeval humanity
created long before canons of ideal beauty
were thought of.

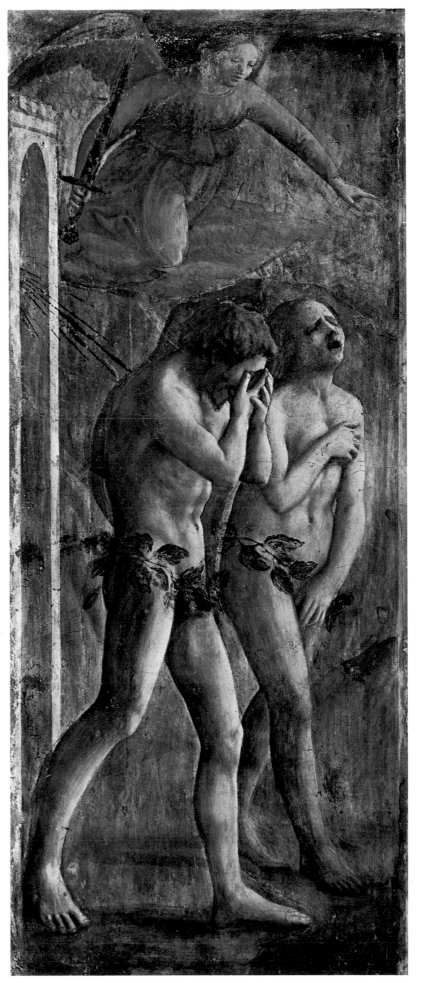

88

89 Piero della Francesca (1416 (?)-1492): The Death of Adam. Detail from the Legend of the Cross. St. Francis' Church, Arezzo, Italy.

Masaccio's Madonna had some of the quality of a monument and this monumental character Piero developed till his personages acquired an impassive calm, superhuman, untouched, like the gods of Lucretius, by affection, sympathy, or passion. Most painters aim at some sort of appeal to the spectator. Piero fascinates by his superb disdain of all such appeals. He presents a very individual outlook upon the world with a knowledge of mathematics unequalled in his day. His superb use of cool, austere colour, his sense of spacious design such as none had possessed before him, and his curiosity

as to effects of light and aerial perspective made him one of the pioneers of landscape. His greatest achievement was the series of frescoes in the church of St. Francis at Arezzo, illustrating the Story of the True Cross.

90 Antonio del Pollaiuolo (1443-1496): Adam. Drawing. Uffizi Museum, Cabinetto Disegni, Florence.

Pollaiuolo devoted himself to the study of artistic anatomy. For the first time the muscles and structure of the human body were minutely examined with a view to their bearing upon aesthetic expression.

89

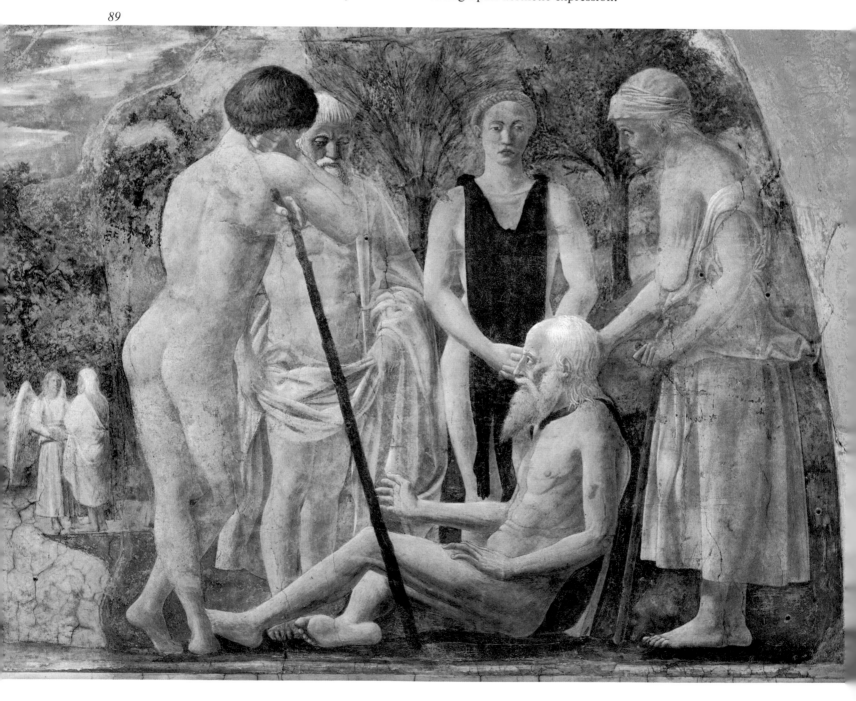

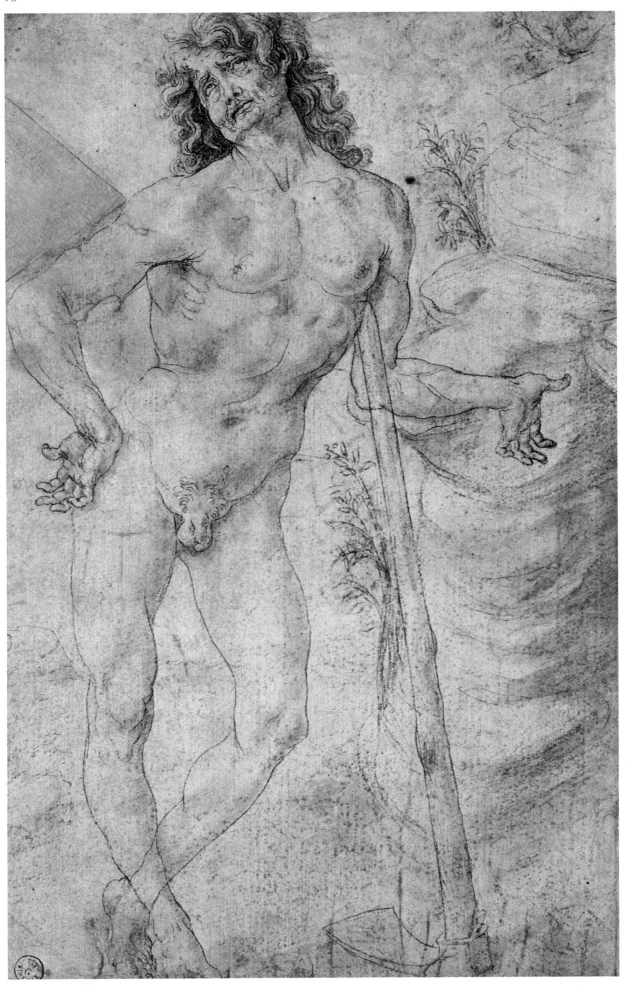

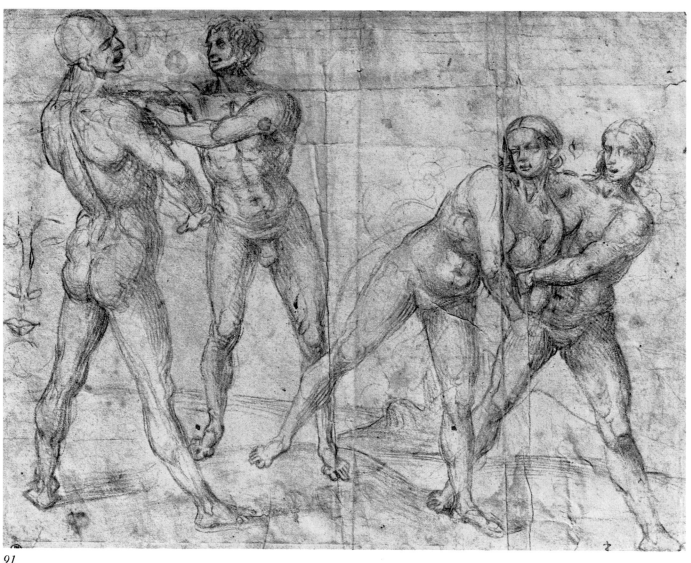

91

91 *Luca Signorelli (c. 1441-1523): The
Four Wrestlers.* Drawing on pink paper,
29 × 37 cm. Louvre Museum, Cabinet des
dessins, Paris.

Signorelli's immense energy found its
chief outlet in the treatment of the nude,
which he handled with a freedom, a
substance, and a command over rapid
and complicated movement that had no
parallel till the days of Michelangelo.
His figures may not show the precise
knowledge of the anatomist so clearly
as do those of Pollaiuolo; nor have they
Leonardo's supple refinement.
Perhaps they owe some of their bigness
and rude power to Signorelli's rustic
ancestry; and of that power there can be
no doubt.

92 Donatello (1377-1446): David
c. 1440/42. Bronze. Bargello National
Museum, Florence.

Donatello's first "David" was a marble,
now also in the Florence Museum; later he
returned to the same theme for the Casa
Matelli "David" (Philadelphia) and for this
bronze "David" executed for the Medici
family. The antique concept of the beauty
of the nude male figure is here revived on a
large scale for the first time in Renaissance
art. This can be seen in the pose and in the
representation of the anatomy, but this
figure is far removed from ancient
prototypes. Standing in a relaxed contra-
posto, the "David" has a subtle, complex
mannerism in its rather sharp and angular
forms that contributes to the ambiguity
of the representation, suggesting a young
Mercury as much as the little shepherd
described in the Bible. History and myth
come together in a mysterious, almost
esoteric climate.

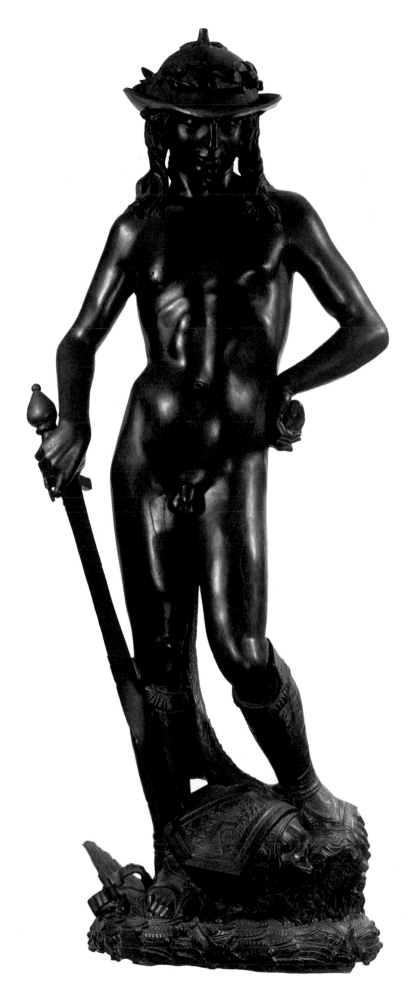

92

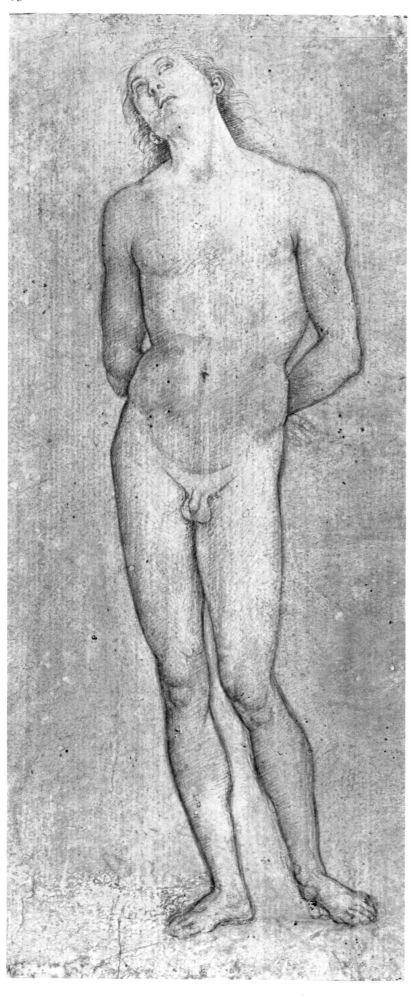

93 *Pietro Perugino (1445/50-1523):*
St. Sebastian. Brush and brown ink over
silverpoint, 25.6 × 14.6 cm. Cleveland
Museum of Art, Dudley P. Allen Fund.

Perugino's figures are often lackadaisical
and flaccid; the gestures, graces, and smiles
are always the same; even his colour is too
uniformly sweet, so that compared with
the real creators of his age he is almost a
weakling. But in common with other
Umbrian fellow-countrymen, Perugino had
an eye for the airy, undulating distances
that stretch away from the Italian hills.
This sense of space redeems nearly all his
work from triviality.

94 *Leonardo da Vinci (1452-1519): Bacchus.*
c. 1506. Canvas, 177 × 115 cm. Louvre
Museum, Paris.

Rubens said of Leonardo: "He gave every
object the fittest and most lifelike aspect,
and exalted majesty to the point where it
becomes divine." The divinity of this
extremely ambiguous figure of Bacchus is a
combination of mystic and erotic qualities.
The blending of forms and colours in the
atmosphere add to the mystery of an
ambivalent and not always benign nature.

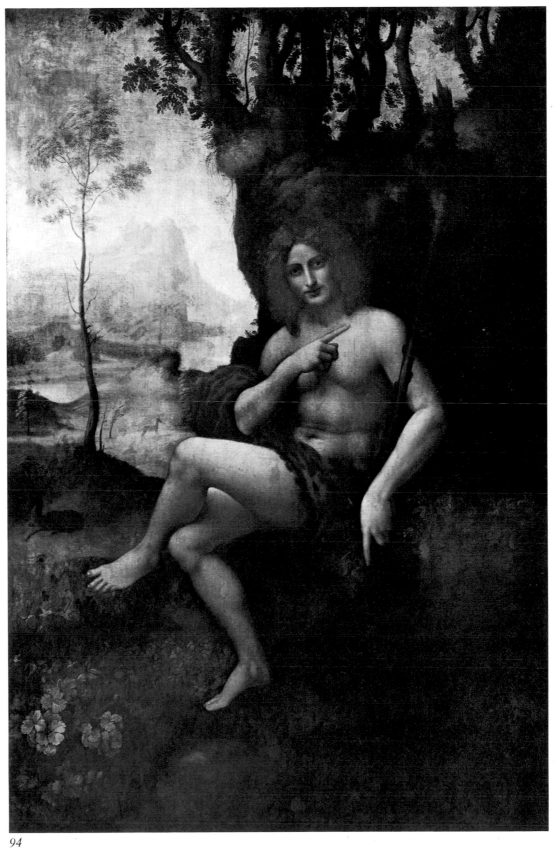

94

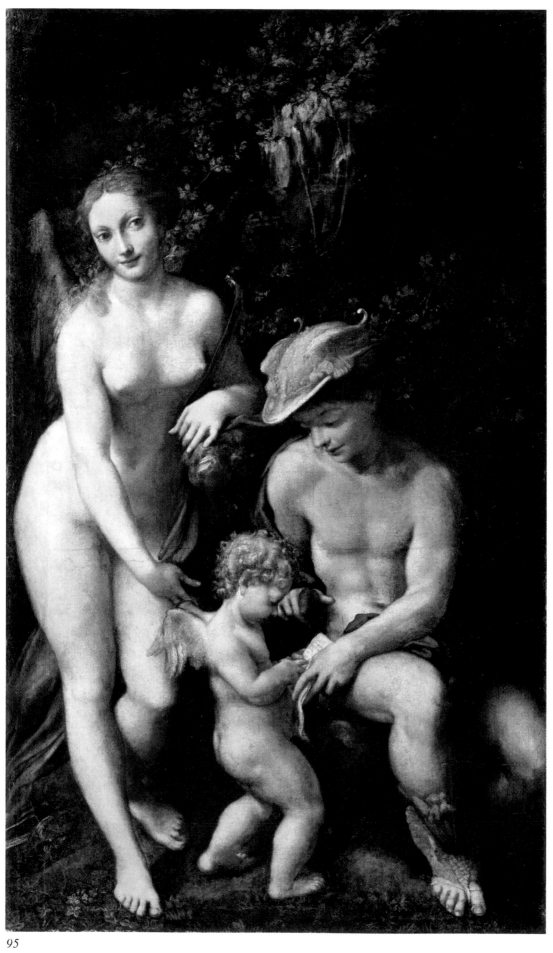

95

95 Correggio (c. 1489-1534): The Education of Cupid. Canvas, 155 × 91 cm. National Gallery, London.

The impact of Leonardo's delicate atmospheric chiaroscuro attenuated the rigid modelling and Classical severity Correggio had learned from Mantegna. Correggio transformed the Renaissance ideal of beauty into one of "grace" and elegance.

96 Raphael (1483-1520): The Three Graces. c. 1500. Panel, 17 × 17 cm. Condé Museum, Chantilly, France.

Raphael rarely exhibited the intense vitality of line that thrills us in the handling of Michelangelo. But he had all the qualities of a serene temper; he had a singular feeling for space and balance of line, and found in the relics of Classical art—of which Rome was the great storehouse—an inspiration wholly congenial to his temperament.

96

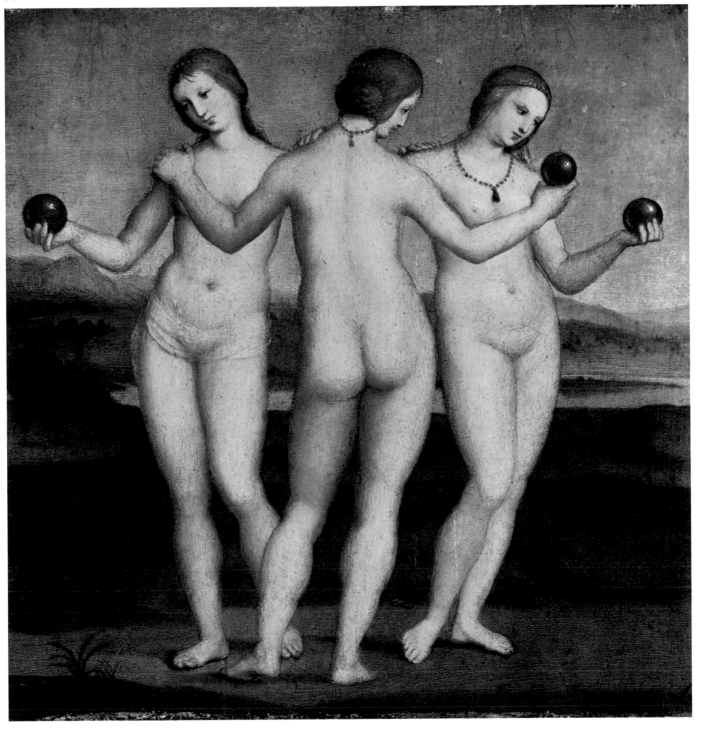

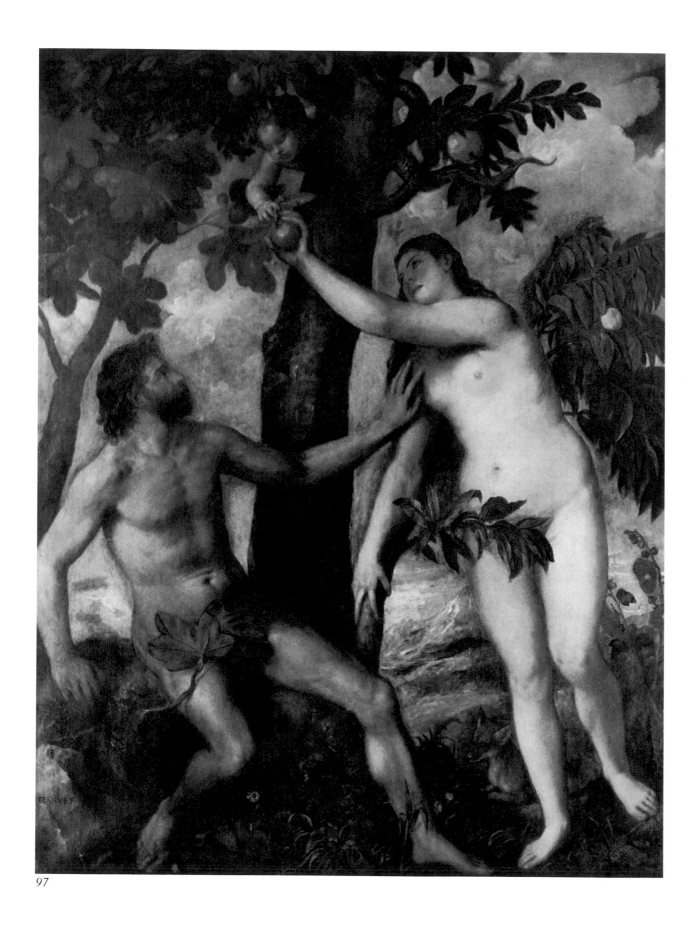

97

97 Titian (c. 1480-1576): The Fall of Man
c. 1570. Canvas, 240 × 186 cm.
Prado Museum, Madrid.

During the last years of Titian's life his
forms were modelled by the light and
dissolved in rapid gleams of colour that give
an astonishingly modern impression. The
great themes of history, religion, and
mythology were enveloped in an atmosphere
of tragic desperation.

98 Michelangelo (1475-1564): Male Nude.
Bistre drawing, 29 × 37 cm.
Louvre Museum, Cabinet des dessins, Paris.

In his presentation of the human figure,
Michelangelo evolved an ideal that had
something of the size of Masaccio, whose
frescoes he had studied, something of
Leonardo's large manner, and he derived
much from his study of Donatello and
Classical art. The nude was his principal
theme; he let the bodies of his figures
twist and turn in an often violent move-
ment; however, their outline always
remained firm, simple, and restful. The
explanation is that Michelangelo always
tried to conceive his figures as lying hidden
in the block of marble on which he was
working. He made his own research into
human anatomy, dissected bodies, and drew
from models, till the human figure held no
further secrets for him. He succeeded in
drawing the human body in any position
and from any angle. They are young
athletes with wonderful muscles, twisting
and turning in every conceivable direction,
but always contriving to remain graceful.

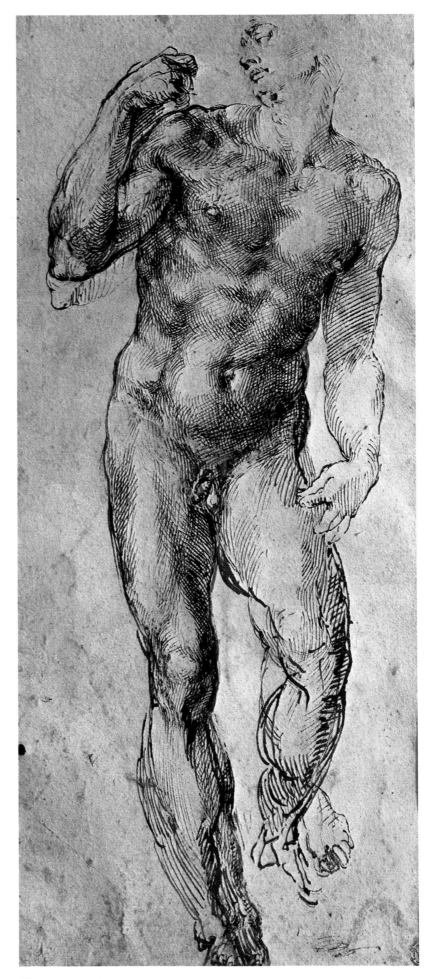

98

99 Michelangelo (1475-1564): Dying Slave
1515/16. Height, 229 cm. Louvre Museum,
Paris.

In 1515 Michelangelo was summoned to
Rome by Julius II, who commissioned from
him a grandiose tomb destined to stand
in the church of St. Peter.
But the artist was forced to gradually
limit its scope; in 1545 the matter was
settled with a much reduced design.
The two Louvre slaves belong to the
second design. They probably symbolize
the human soul imprisoned in the brute
matter of the body, according to the
neo-platonic doctrine.

99

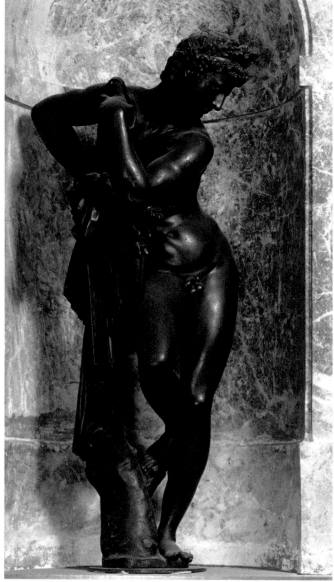

100

*100 Giovanni da Bologna (1529-1608):
Apollo.* 1573/75. Bronze. Height, 88 cm.
Palazzo Vecchio, Florence.

Born in Douai in 1529, Giambologna left
the Low Countries to complete his training
in Rome. On his way back, he stopped in
Florence, where the collector Vecchietti
noticed his wax and clay statues, modelled
after the Antique. In this "Apollo" the
sculptor showed his debt to the refined art
of Benvenuto Cellini, but he went further
in giving an impression of extraordinary
ambiguity to his figure. The Greek god
shows his bodily charms in a pose that
only the very late Hellenistic Greeks would
have allowed their god to take.

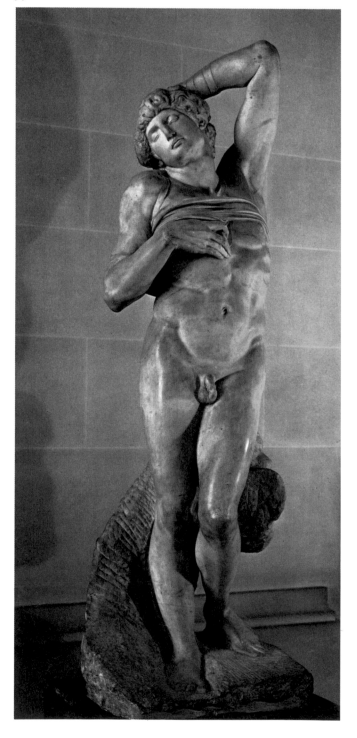

101 School of Fontainebleau (16th century):
Venus and Amor. 103 × 130 cm.
Private collection, France.

Some historians attribute this painting to
the Italian, Bronzino. It is a remarkable
and typical example of the Mannerist
style of the French School of Fontainebleau,
composed of French and Italian artists.
Mannerism was essentially an Italian style,
and wherever it appeared outside Italy
it represented the adoption of Italian
standards. One of the most astonishing
contributions of Mannerism was the freedom
in the distribution of the parts of the
human figure, as if they were abstract and
not figurative material. The figures, often
interlaced one with another, were deployed
in a remarkably decorative way over the
whole surface.
This freedom of disposition was sometimes
obtained by manipulations of considerable
torsion, achieved, however, with perfect
ease in the figures themselves. Grace,
not tension, was the result, and every
form was refined to its perfect type.
This "Venus and Amor" is also typical
of Mannerism in its approach to the erotic:
described, more or less elliptically, but then
neutralized. In art, as in human behaviour,
"maniera" effects a sterilization of passion,
as it does of all other germs of imperfection.

101

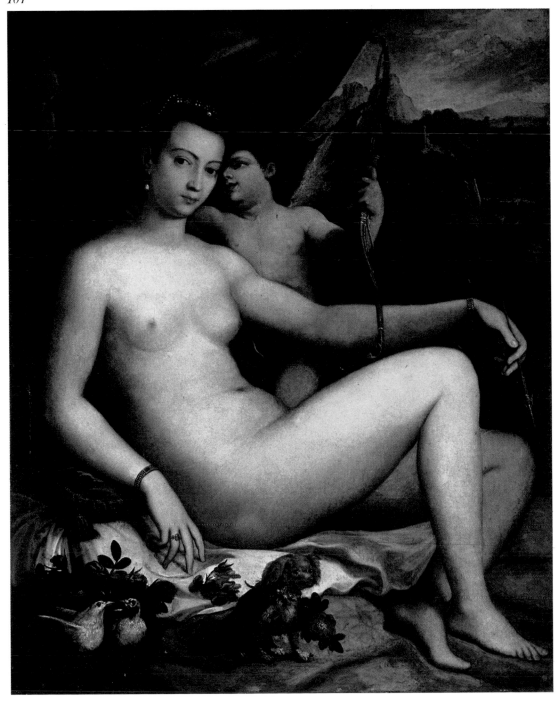

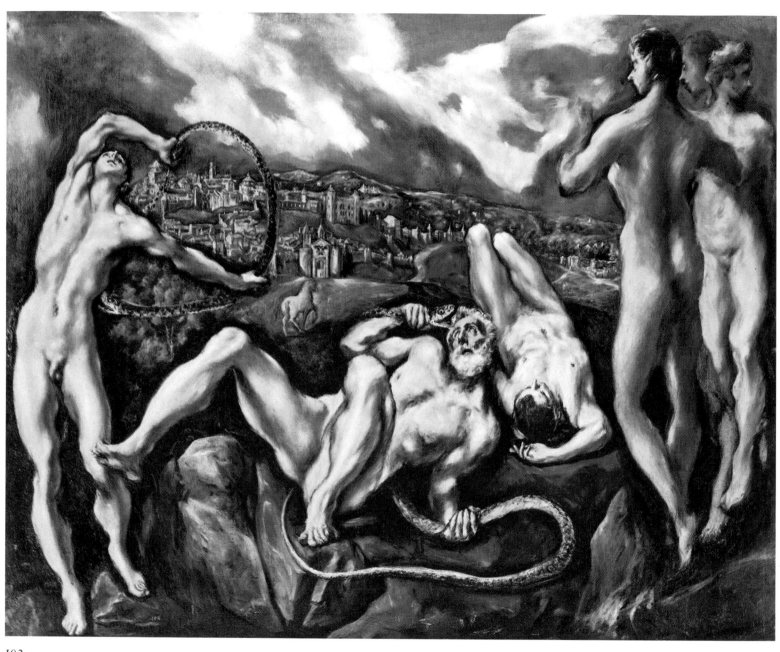

102

102 El Greco (1571-1614): Laocoön. Oil on canvas, 142 × 193 cm. National Gallery of Art, Washington D.C., Samuel H. Kress Collection.

The "Laocoön" portrays the naked body in emphatic corporeality. The male figure acquires such a vital intensity that, as Vasari wrote, it "does not appear to be painted, it seems to be alive".

103 Alessandro Allori (1535-1607): The Flayed. Drawing. Louvre Museum, Cabinet des dessins, Paris.

In Italy the principles and practice of painting and sculpture became the subjects of lively discussion. The problem of representing the human figure was not solved by mere accuracy of hand and eye. It was brought into due relation with geometry and mathematics, and then with scientific anatomy. The principles of art became, in consequence, a matter of precise and demonstrable knowledge, that could in some measure be acquired by study, and used as a firm basis for the employment of natural gifts. This intellectual progress was of course a cumulative progress. This study of the muscular organization of the human figure shows the preoccupation of Renaissance artists with scientific anatomy.

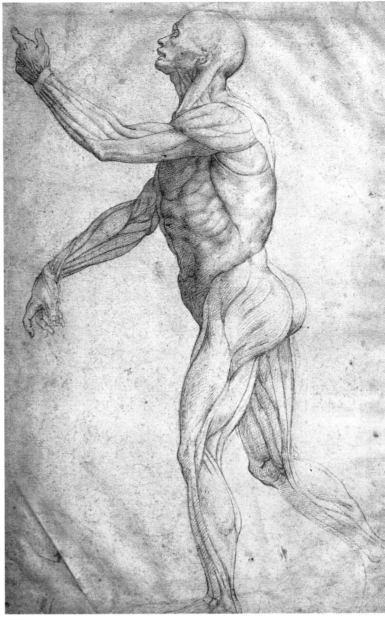

103

104

104 Study of the human figure no. 6. 1635. National Institute of Archaeology and the History of Art, Rome.

Although this study clearly is intended as an exposure of the anatomy of a human figure, the artist refused to stick to a scientific approach to the problem. He put the figure into an attractive and even slightly romantic landscape, and gave him a posture that makes one think of some actor, addressing his public with dramatic gestures. Undressed, he is clad in a piece of cloth of which a storm is divesting him, thus giving an even more heroic accent to his strange appearance. Untouched by this make-up, the drawing gives a good idea of the importance of anatomy to the artists of that period.

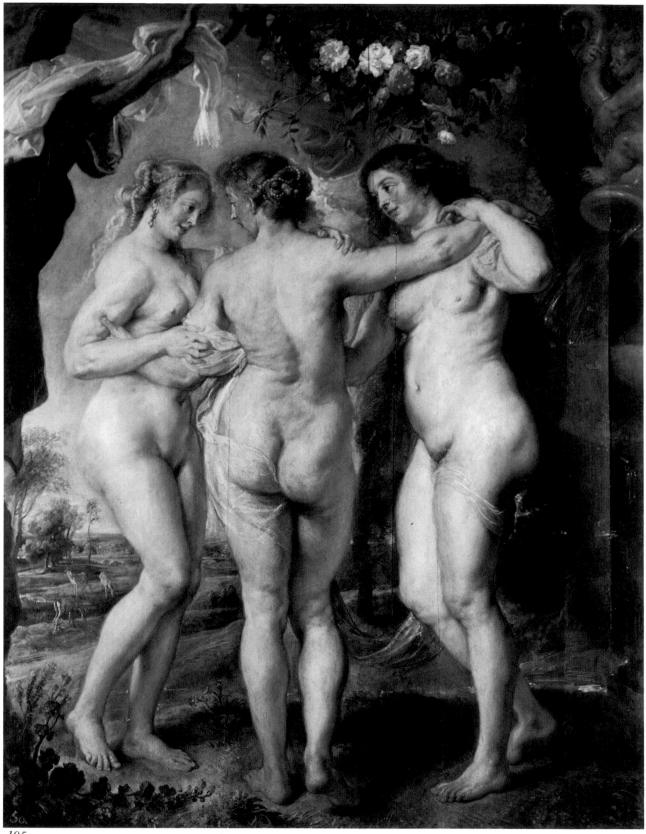

105

105 Peter Paul Rubens (1577-1640): The Three Graces. Panel, 221 × 181 cm. **Prado** Museum, Madrid.

The work of Rubens has the reputation of being the direct expression of a healthy and joyful acceptance of life; of the powerful materialism of the Flemish people. This kind of generalization could be expected in the case of this painter, whose Olympic heroes never seem to tire of their lusty bacchanals, their orgies and gourmandizing. Melancholy never appears in his paintings and weariness is never found. His women are never virgins, not even mothers, but a kind of well-formed material, fleshy monuments with provocative breasts, backs, and pelvises.

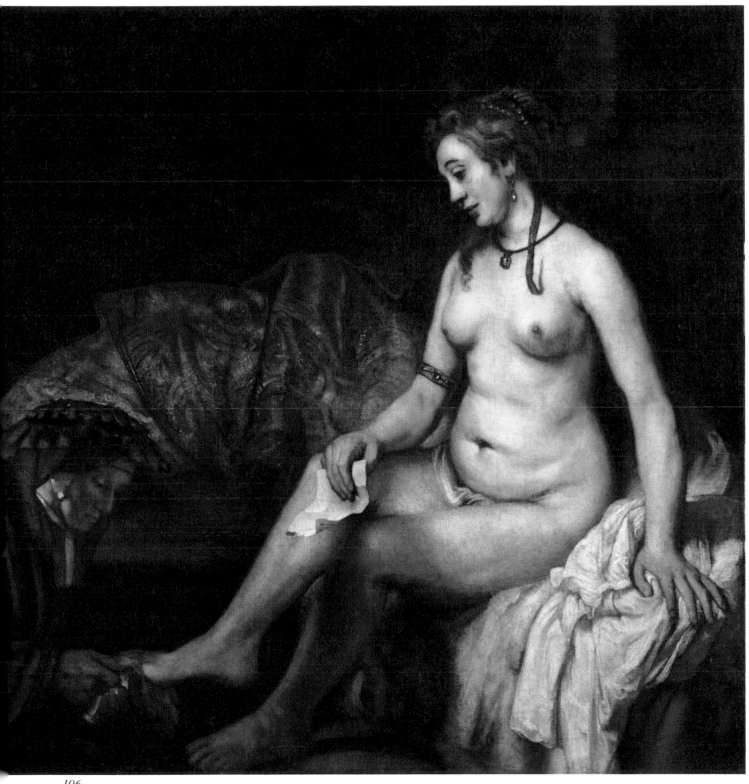

106

106 Rembrandt (1606-1669): Bathsheba.
Canvas, 142 × 142 cm. Louvre Museum,
Paris.

Bathsheba was the wife of Uriah the
Hittite, and when David saw her—from
the roof of his palace—while she was
bathing, he desired her. He sent her a letter
proposing a liaison, to which Bathsheba
agreed. Rembrandt depicts the moment of
choice on which the story—with its tragic
end—depends: the moment when Bath-
sheba has received the royal letter and is
about to yield to the flattering temptation.
The model for Bathsheba was Hendrickje
Stoffels, the young maid-servant whom,
after the death of his wife, Rembrandt
made his mistress. Hendrickje had just
borne him a child which, like Bathsheba's,
died while still an infant.

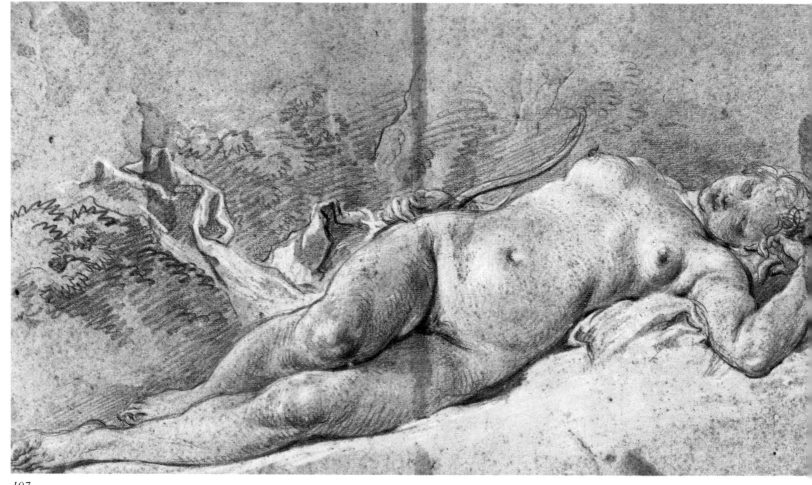

107

107 *François Boucher (1703-1770): Sleeping
Diana.* Drawing, 22 × 37.5 cm. Ecole des
Beaux-Arts, Paris.

The Goncourts said of Boucher that he
embodied the taste of his century. As a
matter of fact, he was not only the painter
of his period, he was its witness, its example.
He respected all the laws of the Rococo;
in his drawing he aimed at the refinement of
elegance, at the delicacy of voluptuousness.
What the French call "le joli" was the
essence and the formula of his talent.

108

Chapter IX
The Break in Tradition

Neoclassicism and Romanticism,
Realism and Impressionism

108 Jean-Dominique Ingres (1780-1867):
Study for the "Turkish Bath". Ingres Museum,
Montauban, France.

Ingres is condemned to be misunderstood
as a result of his being appreciated by people
who love postcards, and depreciated by
those who hate academism. Although
apparently a cold academician, a chaste
bourgeois, he painted—between the two
Empires—the most wonderful female figures.
Chastity proves to be secret eroticism.
Highest voluptuousness hides itself behind

the facade of shame, but in fact he erected
one of the most sumptuous altars to the
goddess Venus.
Another reproach and misunderstanding
from which Ingres suffers is the charge of
boring realism. What seems to be the
repetition of reality, in fact is the result
of audacious arabesques, deformations,
distortions, and abstractions.
In Ingres' case, the vulgar becomes full
of secret, the cold ardent, the clear
enigmatical, the doctrinaire a visionary,
the Classicist a Classic.

*109 Eugène Delacroix (1790-1863): Study
for a detail of the "Death of Sardanapolis".
Pastel, 21.5 × 33.5 cm. Louvre Museum,
Cabinet des dessins, Paris.*

In almost all the paintings of Delacroix
woman is present—as a degenerate mother
getting ready to kill her children, or the
female slave, half-naked and with crossed
arms, on the point of being sacrificed on
the bed of Sardanapolis. The angels of evil,
conjured up by Delacroix in his art,
float over the massacres of Scio
and of Sardanapolis; over his hunting
scenes, his rapacious animals, tearing
each other into pieces, his piles of corpses
and of strangled nudes. The female figure
is never represented in what might be
called a normal attitude; some disaster
always strikes her. This aspect of Delacroix'
romantic art reveals him as an obsessed,
demoniac artist.

*110 Auguste Rodin (1840-1917): St. John
the Baptist Preaching. 1878. Bronze.
Height, 200 cm. Rodin Museum, Paris.*

Rodin represents the final phase of French
Baroque art, and also points to modern
art. This St. John shows striking naturalism;
the anatomy of the body is studied pro-
foundly and rendered with accuracy.
Looking at Rodin's sculpture of this period,
one can understand how his contemporaries
accused him of having done nothing more
than make a cast of nature.
It is true that nature guided Rodin from
the beginning. But it did not limit him
to vulgar naturalism. He saw nature as
Cézanne saw it—through his temperament.
There is something pathetic in this
St. John, in the gesture of the arm that
creates space. But the dynamism of the
preaching saint makes this pathetic attitude
acceptable.
Typical of Rodin is the modelling of details
on the surface of the bronze that reflects
light; weals and wrinkles produce, in the
polished bronze, an ever changing pattern
of reflections.

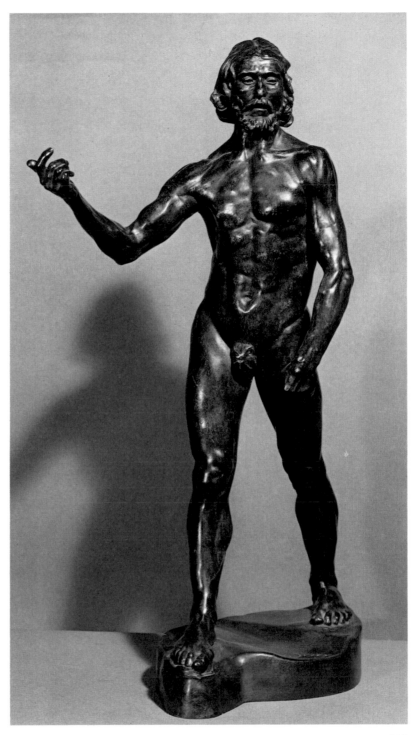

110

135

111

111 Aristide Maillol (1861-1944): Study for the "Harmony" sculpture. Drawing on paper, 36.5 × 21 cm. Collection of Mrs. D. V., Paris.

For the generation that had been accustomed to the totally a-plastic illusionism of Rodin, Maillol's work came as a revelation. Here was a sudden manifestation of the highest plasticism of form, combined with a warm sensualism, that nevertheless breathed Classical serenity. This Classicism was—moreover—not the result of a romantic nostalgia, but of a Mediterranean, Classical substance. Maillol's sculptures were constructions of volumes; closed and firm. All details were subordinate to the total form; the clarity of the volumes and their relation remained untroubled.

112 Aristide Maillol (1861-1944): Nymph. 1936. Bronze. Height, 118 cm. Annonciade Museum, St. Tropez.

The single constant theme of Maillol's work was the female body, in infinite variation, but always subjected to a formal and monumental treatment. His figures were based on a firm geometric framework, and characterized by fullness of forms and a carefully studied balance of masses. Maillol admired the simplified strength of early Greek sculpture; his solid forms and clearly defined volumes recall Cézanne's statement that all natural forms are based on the cone, the sphere, and the cylinder.

112

113 Pierre Auguste Renoir (1841-1919):
Bathing Girl. 1870. Canvas, 184 × 115 cm.
São-Paulo Museum.

As a boy, Renoir painted designs onto
unglazed porcelain in a china factory.
This links him with the Rococo style;
but he also constantly studied the works of
Watteau, Boucher, and Fragonard at the
Louvre. In this painting of a female nude,
Renoir is closer to the realistic style
of Courbet than to Impressionism, although
some details already indicate the direction
in which his style was to develop.
His most important Impressionist period
started four years later, in 1874, and lasted
until 1879.
The pose of this girl bathing was taken
from an engraving of the Cnidian Venus;
the lighting and vision are derived from
Courbet. Renoir tried to combine the
wholeness and order of Greek sculpture
with a feeling for warm reality. In this
instance he has not yet succeeded in finding
that unity; the Antique pose is too obvious,
and his own temperament could not express
itself in the carthiness of Courbet's style.

114 Pierre Auguste Renoir (1841-1919):
Study for "The Three Bathers". 1882.
Drawing, 162.5 × 107.5 cm.
Louvre Museum, Paris.

Renoir worked from 1885 to 1887 at his
"Grandes Baigneuses" for which this
drawing is a study. It possesses a perfect
naturalness and spontaneity. From a tech-
nical point of view, Renoir attempted to
solve the inherent contradiction in the
Impressionist dogma: the creation of
volume through an atmospheric colour that
helps to disintegrate the very forms it
colours. He tried to retain solidity in his
forms, in spite of the broken-colour system
and small brush strokes. The large "Women
Bathing" in particular shows more carefully
worked out contours, more precise
modelling of the figures, smoother brush
technique, and a less shimmering but more
uniform tonality binding the various parts
together. Instead of his former vibrant
and gay transcription of reality, we find
here a carefully considered, almost
monumental work.

114

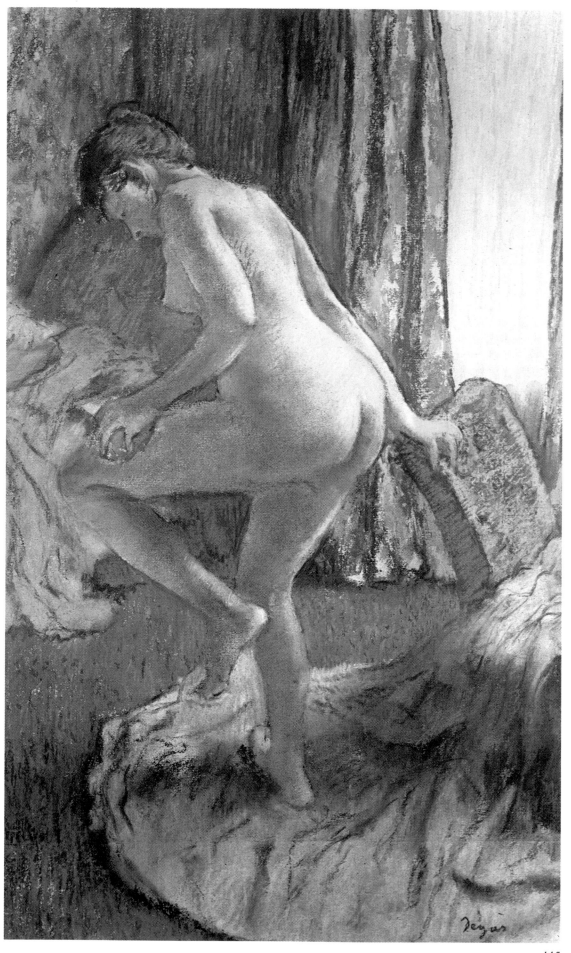

115

115 Edgar Degas (1834-1917): After the Bath. 1883. 52 × 31 cm. Durand-Ruel Collection, Paris.

Degas' most frequently used medium, pastel, had an important influence on the results he achieved. Almost from the beginning he leaned toward pastel and by 1890 had abandoned oils completely. One of the effects of the medium is a striking contrast between the ordinariness of the subject and the beautiful quality of the colours in which it is shown. Some of the more intimate bathing pieces demonstrate this in startling fashion.
Usually Degas arranged the pose in his own studio—where he provided a bathtub, sponge, towels, and sometimes soap and water—so that the face was turned away or was in heavy shadow. This pastel is a notable exception to that rule.

116 Henri de Toulouse-Lautrec (1864-1901): Woman Adjusting her Stocking. 1894. Cardboard, 58.5 × 43.5 cm. Museum of Albi, France.

Lautrec's drawing is intensely economical and the figure silhouetted, thus giving the casual and immediate effect of a Japanese print. While obvious technical similarities exist between Lautrec and the Japanese, their respective emotional attitudes are completely different.
Lautrec expressed a cruel and frequently sadistic outlook on life. In perhaps no other work of the 19th century have the clear indications of vice and degradation been presented as they are here. Lautrec deliberately set out to demonstrate the vulgar qualities.
This sketch was almost certainly executed in a brothel in 1894. Arthur Symons said of Lautrec: "His exasperating sense of contrasting colours is one of the qualities of his macabre genius. Nothing revolts him; he paints beauty and ugliness with a superb indifference; he paints vice and ignoble and exotic and atrocious and obscene creatures with the absolute insolence, the utter cynicism of some Satan or some God who created in mutual antagonism the cruel and adorable world we live in."

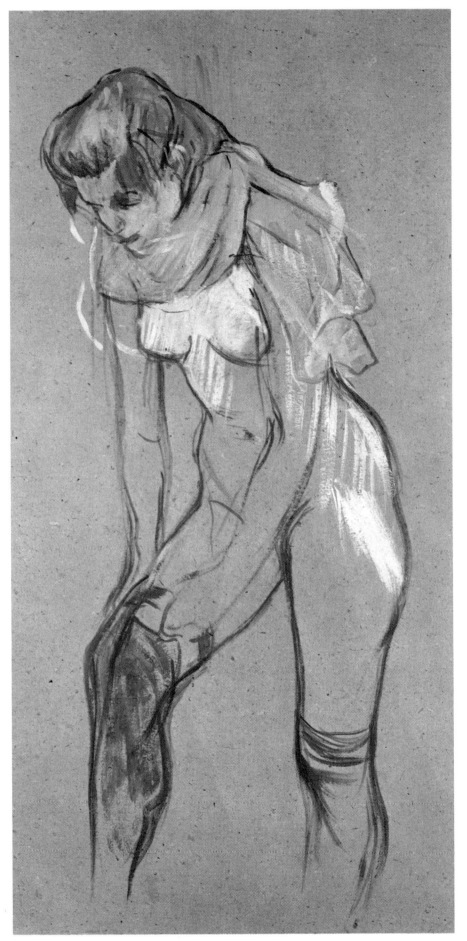

116

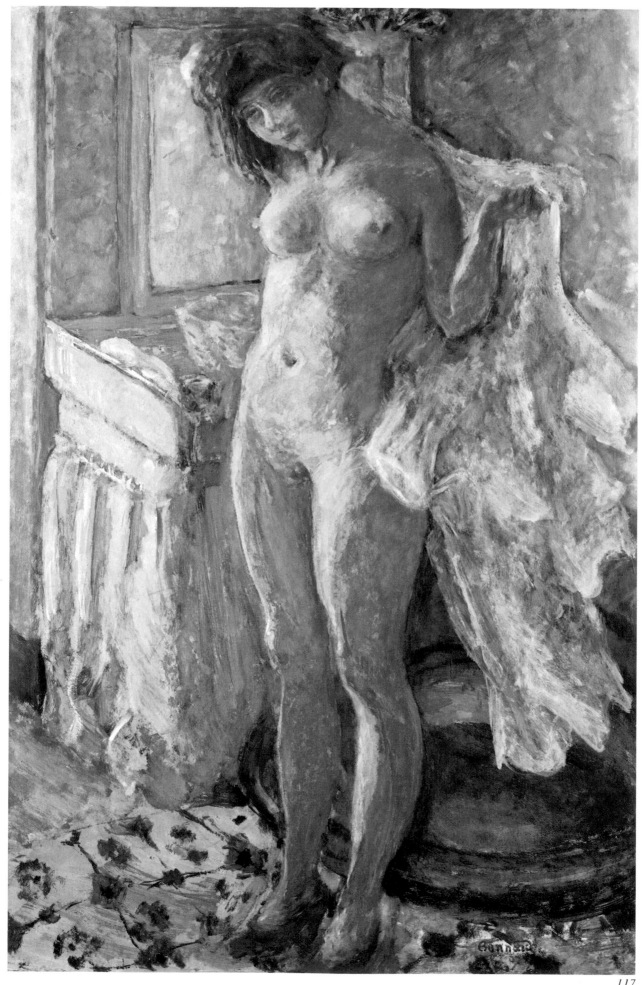

117 Pierre Bonnard (1867-1947): In the "Cabinet de Toilette". 1907. Canvas, 114 × 83 cm. Bernheim-Jeune Collection.

Bonnard never introduced subjects like work, illness, or death into his paintings. He never occupied himself—in his paintings, at least—with menace, fear and terror, or oppression. The only day of the week he seemed to accept was the last, the day of sun, and he praised the work of the Creator throughout the whole of his career. He painted summery gardens where quietness reigns; terraces and verandas in the soft sun of a late afternoon. He celebrated beauty with passion; in nuances of light and colour, in soft vibratos. His nudes delight the spectator with a mixture of aesthetic emotion and sensuous pleasure.

118

118 Pablo Picasso (b. 1881): Nude Against Red Background. Canvas, 81 × 54 cm. Museum de l'Orangerie, Paris.

Although almost nothing in this human figure indicated the revolution that was later to take place in Picasso's painting, this nude shows a stylization, especially in the face, that sets it apart from tradition. Nevertheless its inspiration is derived from the firm intellectual discipline that Classicism had set up as the ultimate concern of painting, and that African art had realized in its formal objectivity.

143

Chapter X
The Human Figure Expelled

20th-Century Art

*119 Amedeo Modigliani (1884-1920):
Full length figure. 1908. Limestone.
Height, 160 cm. Gustave Schindler
Collection, New York.*

Most of Modigliani's sculptures were
created between 1909 and 1914. They are
close to the art of Brancusi, to Cubism,
and to Negro art. The linear style, and the
stripped, dense forms in this female body
are similar to those of the sculpture of the
Baule of West Africa.

119

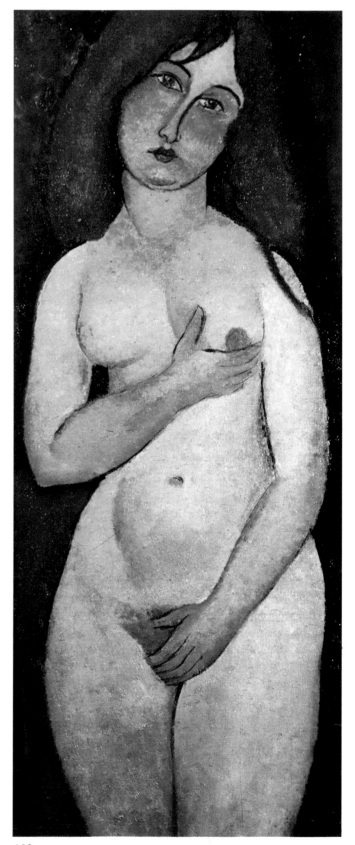

120

120 Amedeo Modigliani (1884-1920): Venus.
1918. 100 × 64.5 cm. Private collection,
Paris.

Modigliani, in his personal life, had the
gift of direct and immediate contact with
women. There was certainly, until the serene
objectivity of his final year, an incongruity
between his private sympathies and the
demands of his evolving styles. This is
particularly evident in the great series of
nudes that he began in 1917. It was bound
to be so, for two reasons: first, women's
faces look different when they have their
clothes off; second, Modigliani employed
for their bodies a kind of stylization that
differed subtly from that which he employed
for their faces. When painting the face and
the body together he withdrew from the
face the psychological complexity that could
be given it when the face was the
main subject of the picture.
Modigliani characterized the sitters through
their bodies, not through their heads. The
heads vary considerably in the degree and
nature of their stylization, but they are
alike in that the search for a valid
representational style was never quite
completed. At the time Modigliani's nudes
were not accepted by the public. When,
in 1917, he had his first one-man exhibition
at the Galerie Berthe Weill, the police
closed the exhibition on the ground that
the nudes in the windows of the gallery
had caused a public scandal.

*121 Wilhelm Lehmbruck (1861-1919):
Standing Youth.* 1913. Caststone. Museum
of Modern Art, New York. (Gift of
Mrs. John F. Rockefeller.)

Lehmbruck's style developed in Paris, where
he worked between 1910 and 1914, and
came into contact with Brancusi, Modi-
gliani, and Archipenko. A profound
spirituality is expressed in the predominantly
linear element of the figure and in the
elongation and formal simplifications.

121

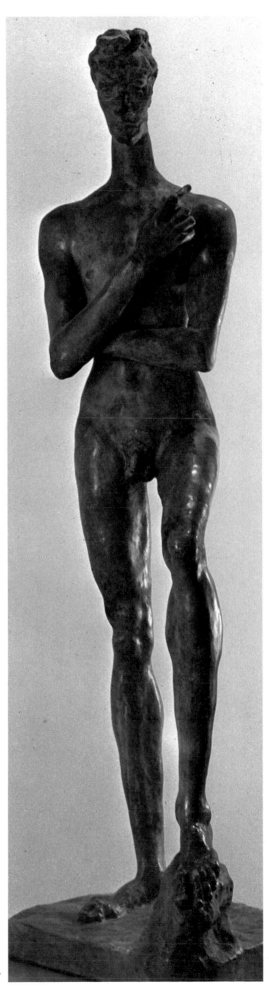

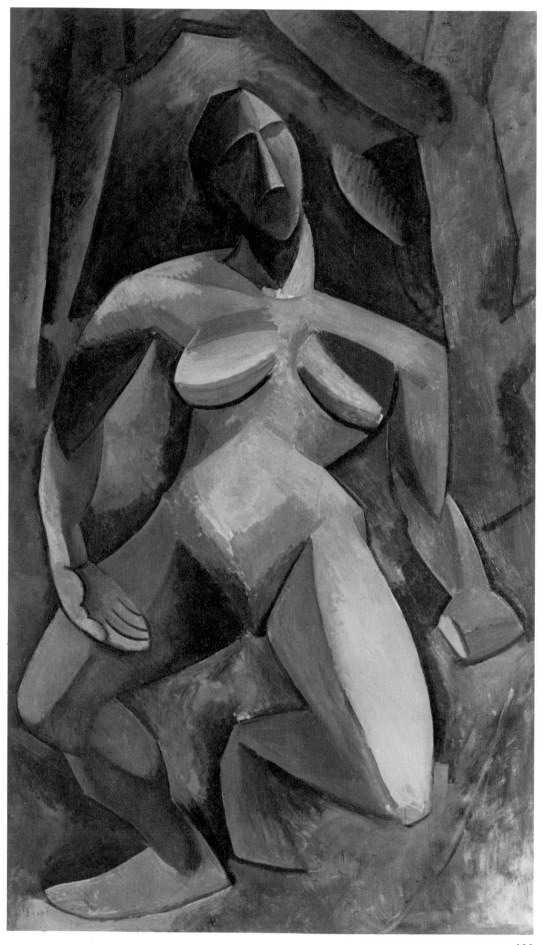

122

122 Pablo Picasso (b. 1881): Nude in the Forest. Canvas. Hermitage Museum, Leningrad.

What matters in Cubist painting is the carefully constructed form; what gives it lasting value is how objects are conceived in volume. The bases of the style were Cézanne's revelation of the underlying geometrical principles in nature and, along with this, the magical directness of primitive sculpture.
The "Nude in the Forest" is an early example of this sculpturesque style in which the concentration on essentials—characteristic of primitive art—co-operates with Cézanne's geometrical grammar to create a new and powerful monumentality.

123 Jacques Lipchitz (b. 1891): Figure. 1926/30. Bronze. Museum of Modern Art, New York.

Lipchitz arrived in Paris from Lithuania in 1909. By 1913 his work was in touch with the outlook of the Cubists. At first, his smooth, flat planes were decorative, curvilinear, and descriptive, but by 1915 with such works as this "Figure" most of the naturalness and the curves were gone, volume had been reduced and what remained was a well-proportioned, architectonical structure. The human figure attained its striking presence not by means of descriptive repetition of naturalistic forms, but by indicating some of the essentials. Evidently the influence of primitive art—such as the Ba-Kota guardians—influenced Lipchitz strongly at this period.

123

*124 Oscar Schlemmer (1888-1943): Group
of Fifteen*. Canvas, 180 × 100 cm.
Stedelijk Museum, Amsterdam.

Through the Bauhaus School in Weimar,
founded by Walter Gropius, the ideas of
the Cubists, of the De Stijl group, and of
Russian constructivism all took root in
Germany.
Oscar Schlemmer directed the stage design
workshop in the Bauhaus, and this
familiarity with man in theatrical space
carried over into his paintings; the human
figure, with every individualistic trait
sloughed off, became a component in the
architectonic order to which it owed its
existence.

*125 Pablo Picasso (b. 1881): Woman with
Apple*. 1943. Bronze. Collection of the
artist, Mougins.

During the German occupation of France
the practical problems of executing sculpture
were enormous. This may—to a certain
extent—explain why the materials Picasso
employed at that time were of the widest
possible choice. He used metal caps, wire,
and matchboxes, and turned all these
materials into expressive totemic beings, at
once magical and witty.
But Picasso's anatomical imagery cannot
be explained only by the practical problems
of that period. He clearly has retained
distorted memories of the surrealistic
bestiary, and combines these fragments
with explorations into the world of pre-
Classic civilizations.
The totemic aspect of this woman with
an apple, for instance, reminds one of the
pre-Columbian square-headed sculptures,
as well as the Ashanti figurines of West
Africa.

125

149

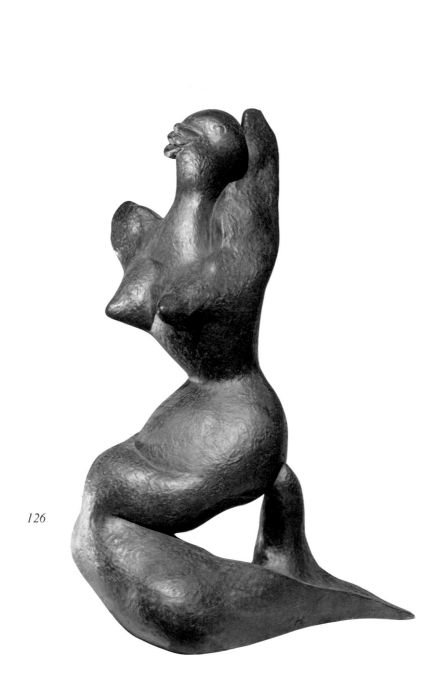

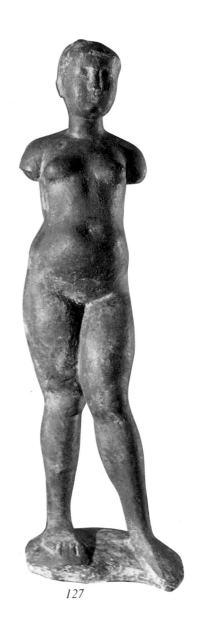

127

126

126 Henri Laurens (1885-1954): La Sirène.
1944. Bronze. Height, 118 cm. Museum of
Modern Art, Paris.

Influenced by Cubism, to which Braque
introduced him in 1911, Henri Laurens
aimed at a significant simplification of
form in his sculpture. A sensual awareness
of the presence of the female figure added
life to the powerful rhythm of volumes in
Laurens' work.

127 Marino Marini (b. 1901): Young Girl.
1943. Bronze.

The evolution of Marini's sculpture shows
a tendency toward a moderate modernism,
based on traditional achievements. The
human figure never disappeared from
his concern; without aiming at formal
distortions for their own sake, Marini
tried to produce a conception of sculpture
that combined architectonic structure
with dramatic tension. In some of his
works archaeological references can be
traced. In this standing girl, prehistoric
fertility goddesses probably inspired the
sculptor more than the idealized proportions
of Classical sculpture. This tendency attained
its fulfillment in the "Pomona" goddess
Marini sculpted in the late 1940s.

128 Willem de Kooning (b. 1904): Woman I.
1950/52. 190 × 148 cm. Museum of
Modern Art, New York.

In de Kooning's famous series of female
figures the pictures are in part

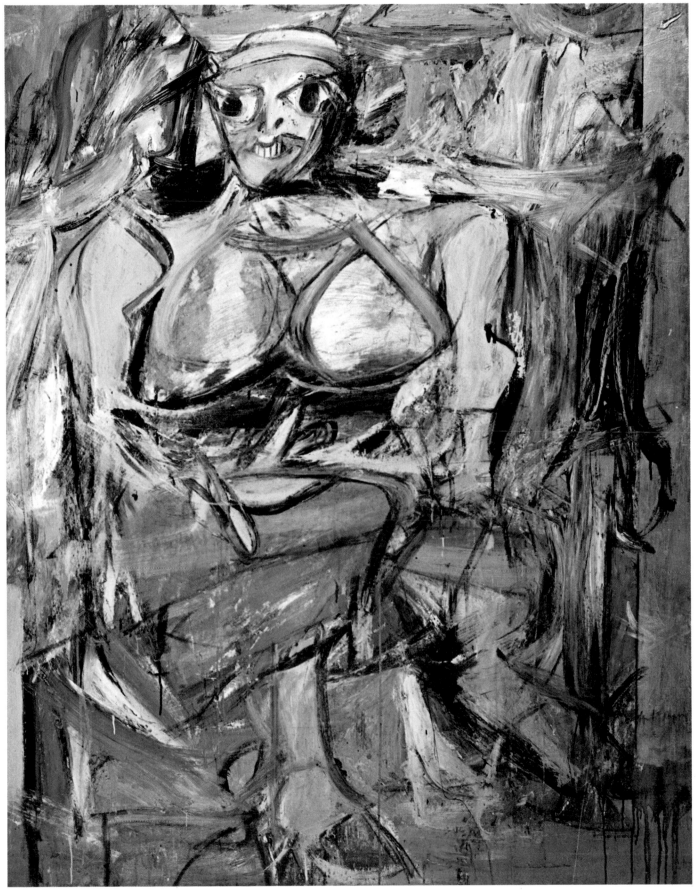

128

representational, but their greatest
significance lies rather within the realm of
abstraction, in the frenetic, agitated brush
strokes, the chaotic tangle of their crooked,
gnarled lines. The savage restlessness of
his brush-work seems to fight against the
chaos that lies so close in his paintings and
threatens to engulf them. The real content
of de Kooning's art lies precisely in his
struggle against the menace of existence.

*129 Henry Moore (b. 1898): Reclining
Woman.* Stone. National Gallery of Canada,
Ottawa.

It is evident that Henry Moore was
inspired by pre-Columbian imagery when
he executed this sculpture. But although
he has absorbed products of different
cultures, his works remain genuinely his
own. He appreciates in pre-Columbian
art exactly what he seeks in his own work:
the liberation of sculpture from all surface

excrescences that completely conceal shape. In his opinion sculpture deals with the relationship of masses. It can use organic rhythms to construct the human figure. And the human figure is what interests Moore most deeply as a subject. But he discovers principles of form and rhythm in the study of natural objects. In his view, long and intense study of the human figure is the necessary foundation for a sculptor. "The human figure", he said, "is most complex and subtle and difficult to grasp in form and construction, and so it makes the most exacting form for study and comprehension. A moderate ability to 'draw' will pass muster in a landscape or a tree, but even the untrained eye is more critical of the human figure—because it is ourselves."

130 *Alberto Giacometti (1901-1967):*
Standing Female Figure. Bronze. Collection
of H. E. Smeets, The Netherlands.

"My figures", Giacometti said, "never were
compact masses to me, but more something
like transparent constructions.
It was not the external form of those
figures that fascinated me, but the role
they played in the deeper part of my
life." Besides, Giacometti was convinced
that it was totally impossible to grasp
the whole of a human being in a sculpture.
He believed that we are too much attached
to details, and the whole is more than the
summing up of all the details. That is
why Giacometti gave up working with
reality and tried to define his fundamental
impressions from memory.
Giacometti's sculpture is born out of the
conviction that the distance between the
ego and the world is definitive, and that
there is no way of bridging this.

130

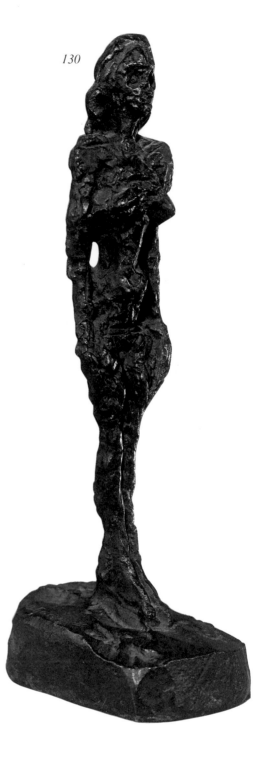

131

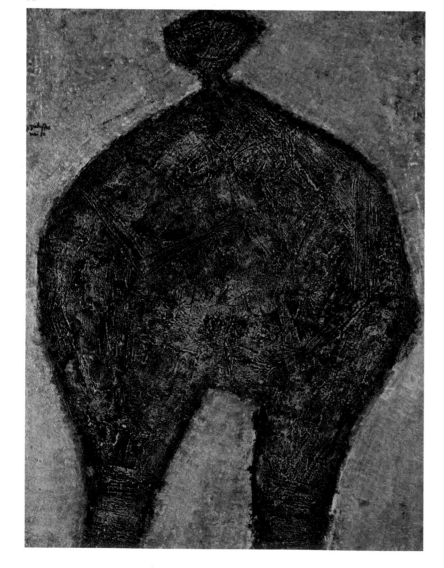

131 *Jean Dubuffet (b. 1901): Femme au Sexe*
Oblique. 1950. Canvas, 116 × 89 cm.

Dubuffet uses as his point of departure the
drawings of the mentally ill and scribbles
found on hoardings and walls, the so-called
graffiti, that constitute a direct uncensored
definition of reality.
His human figures seem to emerge from
that unexplored—by "official" art at
least—world of mental illness, and express
the opposite of the Classical, conscious art
of the European tradition.

*132 Leonard Baskin (b. 1922): Glutted
Death.* 1958. Bronze. Borgenicht Gallery,
New York.

In a wood-engraving—"The Death of a
Laureate"—Baskin expressed a total
decline—the artist, old, fat, and successful,
has been betrayed into the image of his
betrayer.
"Glutted Death" relates closely to this
concept of the decay inherent in death.
Here, too, the figure is almost frontal.
There is an almost humorously ferocious
air: the extreme length of the legs
compensates for the missing arms, and these
legs are like a caricature of Classical beauty.
With its sinuous curves and grotesque forms,
the lack of neck and arms and the pig's
face, the grotesque is heightened. The 20th
century's image of man had become a
tragic one, full of despair and sorrow.

132

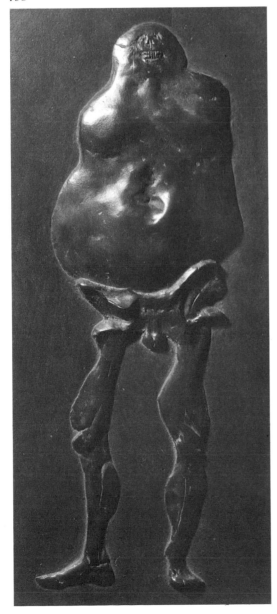

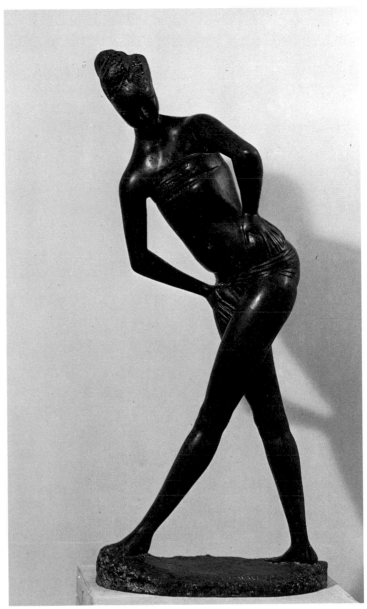

133

*133 Emilio Greco (b. 1913): Grande
Baigneuse, no. 2.* 1957. Bronze. Height,
170 cm. Museum of Modern Art, Paris.

This elegant figure represents not only a
moment in the work of Emilio Greco, but
a movement in 20th-century sculpture that
might be considered as a "conservative
revolution" against the tendencies at work
in the rest of the world. Italy suddenly
produced a group of very able and talented
sculptors, who returned not only to re-
presentational figurative art, but to themes
that were always treated in the Classical
tradition. Some returned to the spirit of
their Etruscan ancestors; Greco redis-
covered, as Manzu did, the elegance and
refinement of the Florentine tradition.

155

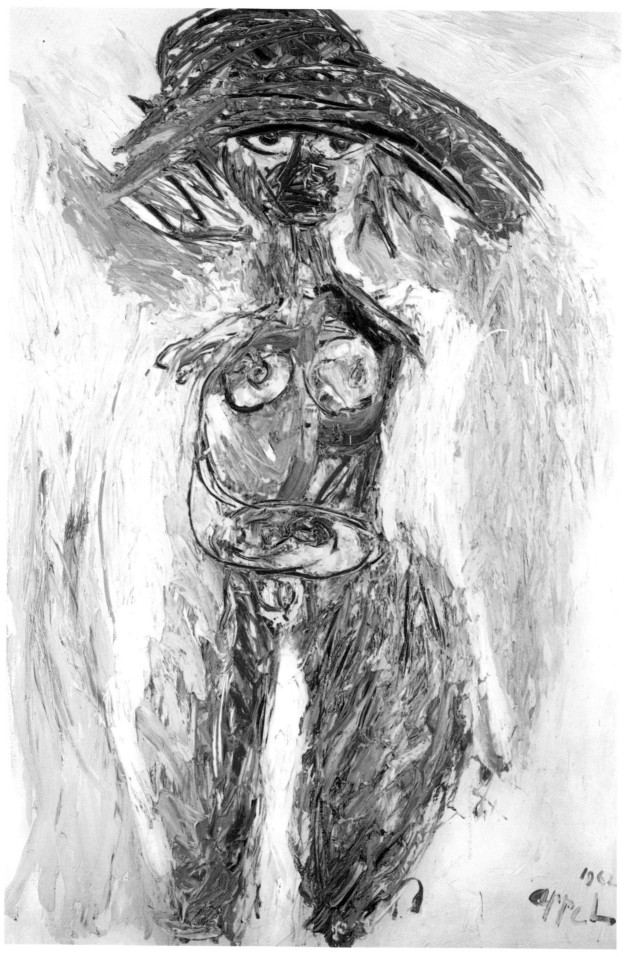

134

134 Karel Appel (b. 1921): Machteld. 1962.
Canvas. Mr. & Mrs. James W. Singel
Collection, St. Louis, Missouri, U.S.A.

Appel's work embodies an enthusiastic
revolt against any attempt to stifle
spontaneous expression, against the hidden
compulsions of rules, taboos, conventions,
and formulae. The explosion of vitality
and pictorial fury in Appel's pictures is a
protest against numb stagnation, but it
is also a shout of joy for the new horizons
opening before man. Even in his human
figures Appel has been able to combine
the discipline of the portrait with the
preservation of the energy of his first
vulcanic outpourings.

*135 Paul van Hoeydonck (b. 1925): Little
Cosmonaut.* Height, 38 cm.

To accept this composition of technical
elements as the image of a human figure
might be difficult. But one has to accept
the fact that the image of man, entirely
adapted to the life of the moment, is not
essentially different from that given by the
artist. All the natural activities—of hearing,
breathing, speaking, and making gestures—
are, in the case of cosmonauts, replaced by
technical functions. The body has no
contact with the surrounding atmosphere;
it is protected by impenetrable suits.
Van Hoeydonck gave us 20th-century man
as this man created himself: an almost
inhuman abstraction, further removed from
nature than at any other moment in
history. He composed this figure out of
rubbish and waste matter: the materials
his actual surroundings offered him.

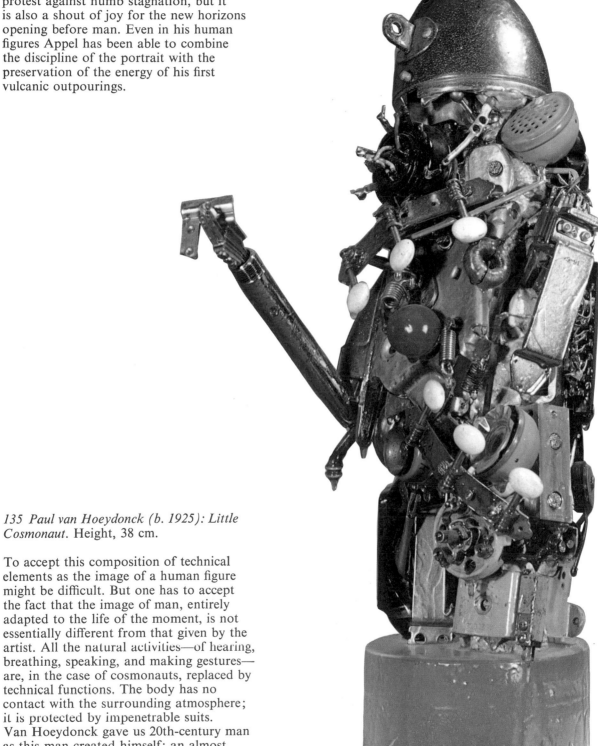

135

136 Marisol (b. 1930): Women and Dog.
1964. Wood, plaster, synthetic polymer
paint, and miscellaneous items. Whitney
Museum of American Art, New York.
(Gift of the friends of the Whitney Museum
of American Art.)

The Venezuelan-American sculptress,
Marisol, had a Paris-New York education;
she learned from Hans Hofmann; some
elements in her style can be related to folk
art, Surrealism, and Pop. She works with
life-size human figures that project wit and
chic, but are not without a sense of pungent
criticism toward New York life in the
1960s.

137 Allan Jones (b. 1937): Pour les Lèvres.
Silkscreen, 61.5 × 77 cm. Sonnabend
Collection, Paris-New York.

Pop-art painters turned to recognizable
subjects, preferably those that were as
familiar or banal as possible, such as
advertising imagery and cartoons.
Mostly they use a technique that not
only suggests the similar process used in
modern mass production colour-reproduc-
tions but one that is also as impersonal and
seemingly anonymous as could be imagined.
The human figure in Pop art reflects the
image given by advertising imagery.

136

138

138 Paul Wunderlich (b. 1927): Woman with Zebra-skin. 1967. 162 × 130 cm. Galerie D'Eendt Collection, Amsterdam.

Paul Wunderlich's world is one of sexual outrage performed in the cool thin vacuum of art. This artist combines a taste for the perverse with an ironically detached attitude toward the products of his own obsession. Somewhere behind the superficial fury of his sexual and aesthetic universe there hovers a cold and very cultivated Cheshire grin